Mississippi Artist

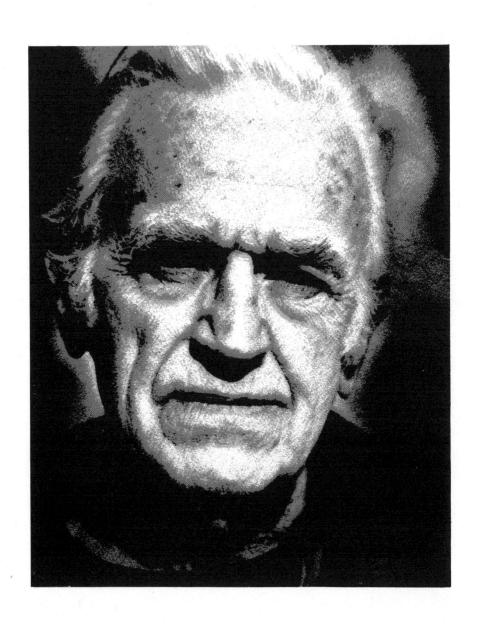

MISSISSIPPI ARTIST
A Self-Portrait

by

Karl Wolfe

UNIVERSITY PRESS OF MISSISSIPPI
Jackson

For Angelo Grasso

A brave man

The author wishes to express his appreciation to the Friends of Karl Wolfe for assistance in the preparation of the manuscript for this book.

Library of Congress Cataloging in Publication Data

Wolfe, Karl, 1904-
 Karl Wolfe, Mississippi Artist.

 1. Wolfe, Karl, 1904- 2. Painters—Mississippi—
Biography. I. Title.
ND237.W784A2 1979 759.13 [B] 79-18098
ISBN 0-87805-106-6

Contents

Mississippi Artist

Genesis

In a few months I'll have been painting in Jackson for fifty years—half a century of doing what I want to do most and where I want to do it. People seem to marvel that I made a go of it. Perhaps they underestimate both me and Mississippi. When I think of my work, two thousand pieces perhaps, in places meaningful to Mississippians, I'm glad I never underestimated either. How it began and what it's been like is what this book is about.

I was born in a house that had no screens, no electricity, no telephone, and very little plumbing. There was a privy outside, and we slept with yards of mosquito netting draped over our beds. With the post office in our block, we were near the center of the town, which may have had four or five thousand souls, and living without so many things that seem necessary now was not odd then. In 1904 we had not dreamed of radio, television, or even movies in Brookhaven, Mississippi. The Wright brothers had gotten something called an aeroplane barely off the ground, and in 1908 when I was four I saw an automobile, very likely the first one in town.

The Illinois Central ran through Railroad Park in the middle of town—a park with grass and flowers and benches for people to sit on while they watched to see who got off and who got on the trains that stopped several times a day. But there was more to do than watch the trains. The Opera House always seemed busy. When there was no amateur theatrical, with everybody in town either on stage or in the audience, a stock company might stop off on its way to New Orleans.

Mississippi Artist

And parades! Did we celebrate Mardi Gras? After sixty-five years memories get tangled. Was the Shriner's Parade a separate affair? Do I really recall being a small boy lifted onto an elephant's neck or riding between the humps of a camel? Not a camel at all but two men walking lumpily disguised as one. Did I wear a fez? My uncle, who had no children, was mayor, and I was often his mascot. Japanese-kimonoed girls under a pergola dripping wisteria still cross my vision. They were on a float that must surely have won a prize. But when a real circus came to town all local efforts seemed puny, and the circus did come— every fall.

Opposite the post office was my grandfather's store, a Mecca filled with magic for kinder. Before there was a bank in Brookhaven, people brought their savings to this quiet man to keep in his small iron safe, which stood by the pickle barrel. I only know what he was like from stories and faded photographs, but I wonder if his kind has vanished from the earth. Behind the store was his house and garden with arched hedges, brick walks, goldfish pool, grape arbor, ducks, pigeons, rabbits, and, in a bed next to the fence, red lilies that people walked blocks to admire. The Opera House next to his garden filled out the block. My uncle managed it, which is one reason our family got to see everything.

Inside grandfather's house were pillows with ruffles, matting on the floors, rugs, books, whatnots, and furniture gilded by my aunt. Too cumbersome for anything but the parlor floor were *Paradise Lost* and *Paradise Regained*, with Gustave Dore's dire illustrations. When the pictures got too scary we glanced behind us where Dresden figurines in porcelain lace too delicate to touch danced on the whatnot. It was a beautiful world to live in.

When I came down with scarlet fever and was quarantined with my mother in our own house for six weeks, the confinement may have been hellish for her, but for me it could not have been more enchanting. I was four and entertained constantly. Together we filled scrapbooks with beautiful things, and once a live hen walked on the sickroom floor, a real sunbonnet on her head. She was not red like the storybook hen but

4

speckled black and white, which made her no less enchanting; her bonnet was red, she was alive, and I had my mother all to myself.

Miss McVoy was music teacher at Whitworth College for Women. That she persuaded great artists like Galli-Curci and Schumann-Heinck to perform in Brookhaven seems a miracle. She did, though, and music seemed everywhere taken seriously. We were taught to read it in primary school. There was also an art teacher who gave second-grade students a sprig of goldenrod in a glass to draw with wax crayons. My drawing won first prize. From that moment I was an artist.

Sixty-five years later, Brookhaven looks like it has just been scrubbed and painted white. The business part of town with narrow streets straight as rulers reminds me of a chessboard set for a game. A church occupies many a strategic corner, the Baptist, the biggest, curiously surmounted by five domes. On the corner next to our house was the Jewish synagogue; it is still there, small, wooden, painted white, its dark purplish windows shaped like mosques. On the other side of us lived the Decelles with nine Catholic children; Henry Decelle and I were inseparable. Across the street were the McDorns, Catholic and wealthy, with twelve children and a burro from a silver mine in Colorado. The mine proved a fake, and Mr. McDorn who had persuaded his friends to invest in it, sold everything he had to reimburse them.

Keep going out Church Street and you run into what we called Silk Stocking Avenue, now a period piece. Under tall, straight oaks are medium-sized houses, every one old and in good repair—friendliness, charm, cordiality are still here. How many front yards did I play in?

Long ago, they called Brookhaven Homeseekers' Paradise, and back in town near the railway station a signboard still stands, freshly painted, proclaiming this legend. But for me this paradise was lost forever when we moved away.

I was a vulnerable ten-year-old when we moved to Columbia, Mississippi, and I found it impossible not to hate the town. The

Mississippi Artist

Illinois Central Railroad ran a straight line through Brookhaven, tying together the country from New Orleans to Chicago. A mainline railroad connection made a tremendous difference in the cultural development of a small town. No passenger trains came through Columbia.

In 1914 most dwellings in Columbia had been built from one unimaginative plan; two rooms and a hall in front, the hall opening onto a back porch, along one side of which were the other rooms. The raw wood interiors of houses seldom saw paint or paper, and if there were wallpaper almost certainly it covered bedbugs. Till the house my Dad bought burned we fought the bedbug scourge. If we left our front gate open, there were larger pests. Goats, cows, horses, mules would crowd the front porch, eating ferns and dropping manure. An artesian well at the center of town watered all livestock, which frequently blocked the entry of stores on Main Street. Manure was everywhere, and copulation among the beasts was a common sight, and though natural, it was unedifying if you were in the company of some nasty minded male, young or old, whose remarks could turn heaven sour. Nobody told us anything else, and a blank young mind revolted, especially the mind of a youngster who loved his mother more than anything on earth.

How my mother made me proud of helping her, I don't know. Perhaps some unconscious communication reminded us both that her care had saved me from scarlet fever only half a dozen years before. At the age of ten I was splitting and bringing in the wood burned in kitchen and fireplaces. Two years later I tended the hogs we butchered in fall and ate all winter till we were sick of pork. Each spring my mother and I made heroic attempts at gardening and rejoiced when a stock law was finally passed forcing owners to pen up all their animals, at which time we doubled our efforts. Today when spring comes, Columbia is inundated with azalea blooms—a blaze of color. But when we first moved there, no bloom could be seen except camellia japonicas which even now I don't like.

Two kinds of people were drawn to Columbia by J. J. White's

sawmill; mill hands, who lived in mean houses near their work, and men with office jobs. The white-collar people settled close to the boss man, and nearby Hugh White built his own Presbyterian church, with only seventy-five members. My sister was faithful to the Ladies Aid Society for years, and long ago, when every individual did not assume he must own an automobile, she was bothered because some of the ladies had to walk to meetings. She tried to rig a schedule whereby ladies who owned cars would give carless ladies a ride. More and more the schedule got balled up, till one lady with a car offered a suggestion she thought would solve everything. It was put to a vote and passed unanimously: "Ladies with cars can ride, ladies without can walk."

I think my mother deliberately chose not to live on the same street with the Hugh Whites and their kin. She was a proud woman and a strong one, bearing children, she said, "as easily as a healthy animal." She may have been the first woman in Mississippi to serve on a school board, which she did conscientiously and soberly. Mother was also brave. One winter night when my dad was away, she and my sisters and I were sitting close to the fireplace when an odd sound came from one of the long windows that opened onto the front porch. We couldn't see out, because the blinds were closed, but from the noise we believed someone might be raking a stick across them, making a sort of corrugated rattle, slow and deliberate.

"Who is it?" asked my mother in a calm voice. There was no answer and no pause in the rhythmic stroking.

"What do you want?" she demanded a little louder. No answer. The noise went on. My heroine got a pistol from a drawer. She went to the front door, which had narrow strips of glass on either side with no blinds. It was quite dark outside and nothing could be seen.

"If you don't stop that noise I'll shoot." The sound continued. Mother placed the end of the pistol barrel against the glass and pulled the trigger. Years later the little round hole was still there. At the gun's report the raking noise stopped, but only for a

short time. We watched from the bedroom as she checked the front door latch and listened intently. Then deliberately, even calmly, the raking began again.

"It can't be a human," murmured my goddess to herself, and as she unlocked the door, we children crowded behind her. We all looked out. It wasn't human. A child's picture book had been left near the edge of the porch. Somebody had left the gate open and our private dairy, Bessie, had got into the front yard. Maybe she was hungry, but while she chewed the book with bovine deliberation her horns got entangled in the front end of a rocking chair. The motion of her chewing made the back of the chair stroke the blind. We forgave her.

As a child I could not have named another quality my mother possessed. Now, however, I know she had *aspiration*, a rare quality in Columbia, Mississippi, in those days, it seemed to me.

My father ran the logging camp that deforested a sizable portion of Mississippi. Although the J. J. White Lumber Company has been inoperative for forty years, a mound of sawdust some sixty feet high still marks the spot where, with agonizing screams, the sawmill tore lumber out of logs that came every day on a train of flatcars built for their hauling from the camp twenty-two miles away.

I didn't see my dad much or know him well. He was a big man, so physically strong he was sure he could lick Jack Johnson and Jim Jeffries together. He was possessed by a violent temper that often exploded into fancy cussing, a valuable asset in his position as boss over other men's violent physical labor. Everything seemed violent at the logging camp when, at the age of thirteen, I began to work there: the intolerable heat at noon; the cold before daybreak when I rode the flatcars out to where the logs were loaded; the ravished earth with stumps where great trees had grown; the twelve-hour days we sweated at work; the smell of unwashed laborers who crowded into the commissary when I worked there; and the perpetual obscenity

of men with limited or no education. They were good men, however limited they seemed to me, and much of their quality I probably missed. They were intensely loyal to my father, and he never let them down. He never let anyone down, especially Negroes who loved him for his masculinity, his cussing. When he was buried, there were more blacks than whites at the cemetery.

The job that interested me was building and repairing log cars with a patient, silent man, Mr. Laird. We also built the shacks we lived in, which could be lifted by the log loader and placed on a flatcar for moving. From the bottom up we built them, and I learned the basic system of simple architectural construction, knowledge that has ever been useful.

There were no conveniences in the logging camp—not even an outdoor privy. We were all rank with sweat, and dipperfuls of cold water from a bucket poured down our naked bodies at night helped us bear our own smell. My dad the bossman somehow kept himself odorless; he didn't have to labor as we did. On rare occasions some of us piled into his Ford and went to a little river; we shucked clothes, washed sweaty bodies, and swam in the clear water flowing between high sand banks, tree-shaded and cool. There was music. The section gang working on the railway tracks timed their rhythmic swings to their singing, "Swing Low," "I Got Shoes," "John Henry," and others less polite. It was superb, spontaneous, and extremely harmonious. I couldn't get enough of it.

The longleaf pines seemed primeval, some of them ten or twelve feet in diameter. Once the saw gang, shirtless, black, and shiny with sweat, cleared in a straight line a stand of these giants. I looked into the forest, empty as a cathedral with the façade ripped off, looked into space on space, dim and hushed. Nothing grew out of the russet carpet that lay between the trees, and no birds sang as I walked, held breath beneath the high dark roof of green that the trunks supported like the columns at Karnak, spaced apart with what seemed majestic necessity. They're gone. Another time, walking back to camp on the cross-ties of the railroad that snaked across torn earth, I spied a grove

of magnolia trees that had been spared. I made for their shade. The big trees surrounded a sizable depression that was filled with leaves. I meant to cut across this and regain the tracks, and so I walked in, anticipating the rustle of leaves about my knees. Suddenly I sank into stiff magnolia leaves well over my head. I panicked and scrambled out backward. Is that gone too?

Back in school during the winter, I got fat eating out of my mother's kitchen, taking part in no sports to wham it off. I couldn't catch a ball or throw one and, like Minever Cheevy, longed for an ancient time when one gravely competed with oneself, without jibe. It was easy to get top grades, but seeing a 98, my mother wouldn't say "Good Boy," but, "Why didn't you make 100?" When marks fell, because of my boredom, to 95 she wouldn't speak to me for a week. I writhed, vowed inwardly to do better, and wondered about her sense of justice. I must have become something of a sissy, as Harry Truman described himself, though I can't say, like him, that I read all the books in the library—there was no library, except at home, and books were scarce there. However, I read about Siegfried, Lancelot, and Arthur in bowdlerized versions, more mythical than myth itself, and when I encountered Greek heroes, they became more real than the people around me going about their dull business. I dreamed of being a hero. Any kind would do as long as it showed. I dreamed of being a football hero, even thought I could do it, but no real games were played in Columbia till after I left school. I also dreamed of a place that was beautiful, where weeds did not grow as high as a man's head, and I thought of my uncle when he was mayor of Brookhaven, a big man with a shovel in his hand frantically planting flowers in every space that would hold them—public flowers, for everyone. He was called a ladies' man, and there were men's men, who carefully scorned interest in anything that could be called beautiful, worshiping brawn and violence, it seemed to me for sheer love of violence that art, taking infinite pains, had little to do with.

I don't know when beauty became all important to me or

Genesis

when I began to recognize and thrill to it like Xenophon, the great Greek general. We lived in a backwater set apart from all tradition, where, beyond bare daily existence, hellfire and brimstone were as real as grits and gravy. "You ain't going to heaven if you haven't been wet all over," Baptist said seriously to Methodist. Dancing was a sin. Some young men home from college one summer hired a band and wangled the courthouse to dance in. Maybe that was the first public dance in Columbia. I don't know; but the following Sunday fifteen young people were "turned out" of the Baptist church. *Excommunicate* didn't fit—if the church folk knew that word—but in the Baptist church there was some sort of grim procedure with appropriate condemnation. Mrs. Irma Ball, a pillar, bless her, always pink and shiny as if she'd just been scrubbed, sat in the church and listened tremulously to the proceedings. In the middle of things she rose as if compelled and, raising one short pink finger, blurted out "Judge not," then abashed at her own temerity, sank back in her pew and buried her face in her clean white handkerchief. The proceedings went on anyway, and fifteen young sinners were "turned out."

We attended the Presbyterian church. Life would not have been worth living with my mother had I not gone to Sunday school every Sunday. Presbyterian doctrine, seemingly designed by a man who hated all humanity, was generally ignored in favor of the Ten Commandments which became immutably impressed on my mind. "Honor thy father and mother," was something I could do quite willingly. It was hard not to lie; stealing did not interest me; and the other injunctions were either beyond my years or beyond interpretation. But the commandments did come to bear on my daily life.

At a time when I was rapidly outgrowing my clothes, my dad supplied me with a pair of bright purple peg-top pants some black man ordered from a sample book and couldn't pay for and "green" (of half-tanned leather) work shoes. I wore them to school, hating everything in sight, but dimly thankful I didn't have seven children to clothe, and honoring my father. One day

when I was fourteen I opened a door in a quiet house and saw my big tough dad weeping. He was writing checks to pay bills and though he made close to a thousand dollars a month in 1914, it wasn't enough.

"It's never enough," he said miserably. "I could support myself on a hundred dollars and make that shooting craps every month." Not knowing how to talk to him, I said nothing, but suddenly I was not a child anymore; I could see down a long dismal corridor a thousand male backs bending beneath a thousand heavy bonds of family. I wish I could say that I touched him, said something. I hope my face registered the sympathy I could not utter. It wasn't pure, my sympathy. It was touched with resentment against the necessity of growing up and his own resentment against the burden we were—all seven of us— but to an overburdened man, my mind said silently, out of a conscience quickly guilt-ridden, "I'll never ask you for anything."

I never did ask him for anything. With the money I'd saved from working at the logging camp, I bought shoes and pants like everyone else wore. When I graduated from high school at sixteen, I went to work at the sawmill, where my silent friend Mr. Laird had moved to a shop that kept the log cars in repair. It was heavy work, twelve long hours a day, and muscles grew all over my body, but when I'd eaten supper that body demanded rest, and I could do nothing but fall into bed, no life in my mind.

Where *was* an art school? Did one exist? I asked every adult I could in Columbia, but nobody could tell me anything. Dad said he'd never known an artist and could not imagine how one made a living. He advised me to learn something else in case I couldn't live off art. It seemed good advice, so at eighteen with the money I'd saved, I entered Soule' business school in New Orleans and there met Joe Tillotson from Greenville, Mississippi.

Joe's father had agreed to send him to the Chicago Art Institute if he first learned bookkeeping. Mr. Ed Soule' cracked our heads, which were always together, with his knuckles. We

12

Genesis

giggled through all his classes, drawing something on every scrap of paper. Joe went to Chicago, and I, my money spent, applied for a job bookkeeping back in Columbia, at the Rankin Company. I had a firm plan in my mind. New Orleans had opened the big wide world for me, with libraries, art galleries, theaters, parks full of flowers, magazines from everywhere, artists. I had also learned of the demand for art. In spite of this melange of fascination, I learned a little about bookkeeping and to write with a spencerian hand so fair that I was hired by Mr. Rankin, who said he was tired of trying to make out the hen scratching of his employees. For three years I ran a bookkeeping machine, earning eighty-five dollars a month. Bent on saving every penny, I became isolated, closed into a world of my own. A servant's house in the backyard became my studio where I spent every leisure hour; there weren't many since I worked at the Rankin Company from 7 to 7. It seemed to me that no one in Columbia could be interested in what interested me. I had to get out, and one thousand dollars saved was my goal. Joe wrote about the competition for travel scholarships held each year at the Art Institute. I knew I'd get one; where I got my confidence is beyond me, except that I was sure I could work harder than anyone. I could not imagine art indulged in as a pastime, as it now is. I read everything I could about the great artists of the past and became so enamored of their single-minded dedication that anything else seemed too paltry for consideration. When finally, one thousand dollars in my pocket, I arrived in Chicago, Joe Tillotson, kind and debonnaire, met my train, and the great adventure began.

The Chicago Art Institute

The Chicago Art Institute was heaven. Nobody asked anyone why he was there; we all knew. As soon as I'd passed through the classic entrance on windy Michigan Avenue, I felt at home and, suddenly, no longer weird. Thousands of us, more people than Columbia would ever see, were at the school for the same thing—some assurance that we were artists. Formidable were the galleries, the stairs, the arches and columns, the skylights. Wandering through them one could be crushed by the magnitude of skill represented in the collections. But I was in love with so many things I saw, and I aspired with every drop of my blood to achieve something even greater.

My most interesting first-year class was in the Field Museum. Ten million objects are in that building now. What the count was in 1924, I don't know, but each thing was informed with its own background of culture; it was a tour of the world: Javanese puppets, Japanese swordguards, African skulls with masks of clay, tattoo designs still on the skin stretched over them, tac deer, Chinese costumes and headdresses, animals from everywhere to mention only a few.

The second year in school weeded out the dilettantes. I competed; I couldn't keep it out of my mind, surrounded as I was by people who were as serious as I was. In the upper classes silences and nerves grew taut as a pose by an excellent model went into its second week, until the barest whisper could arouse annoyed shushing. A friend might pass in the corridor, head down, unseeing. If asked what was wrong, he or she would mutter, "I can't paint." I never heard the word *grind*; all of us were grinds. There was no way to "just get by" or hoodwink teachers, if we'd wanted to. One was adequate or one was

14

inadequate. Most of us were there on our own, or over some-one's doubts. We would have gone hungry to paint. Some of us did. Most male students hurried off at noon to jobs in busy restaurants, where an hour's work earned two meals. Janitors could make eight, nine, or ten dollars a week. A paint rag cost only five cents, but often I'd find myself without even that, so most of my shirts had the sleeves torn off. You can't paint with-out a paint rag.

My roommates, Bruce Crippen, Jack Weatherwax, and I were janitors at the Institute. We went to school before daybreak, over deserted icy streets, and cleaned up. A ribald, hilarious crew, all the janitors seemed one unorganized fraternity, firm in the belief that no one outpainted us. Joe got a job in a com-mercial art studio. Always cheerful, he came home from the theater he loved, merrily whistling Bach to the syncopated rhythm of his footsteps on the stair. The four of us lived behind a brownstone front like hundreds of others on a long middle-class street, very sedate, our Saturday night binges or poker games quiet enough to disturb no one and without the females we dreamed of and itched for. We liked each other very much and were seldom bored till Sunday afternoons when hangovers descended.

Joe Folzer, a city boy from Evanston, dapper and handsome, befriended me after my first month in school. He took me in hand, his tailor making for me the last gasp in suits, with wide trousers, short coat, tight about the hips, one button to be buttoned, one to stay unbuttoned, lapels just right, and shoulders padded to the nth. I wore suspenders, a vest, and bowties, and Joe showed me the right way to wear my hat. A new overcoat, and presto—complete metamorphosis. Girls said "He's cute" as I passed. I was The Klassy Kollege Kid and loved it, after purple peg-tops and fifteen-dollar hand-me-downs. The wardrobe took a hunk out of my money, but was worth it, and I found less and less to be self-conscious about. A smock, paint-smeared, was uniform in school; sleeveless shirts were covered. From this distance those Chicago years in the blithe

15

twenties are like someone else's dream. It's hard to believe I lived them. More than one instructor told me I was overconscientious, but Michelangelo's *Pieta* with its impeccable finish makes you wonder how much is too much. Rembrandt does, too, and a superb Persian rug or a Gothic cathedral seems to say nothing is.

It was my good fortune to study under Helen Gardner, whose textbook *Art Thru the Ages* is still used in many schools. I loved Miss Van Pappelendam, always encouraging; and Alan Philbrick, who had been given a money prize that had been rejected by Mary Cassatt in Paris; and Mr. Schook, from whom I learned principles I still adhere to, things that seem universal. It was Mr. Schook who held up a small painting I'd labored on—held it up before his class and said, "I love it." For this accolade, he could have owned my soul. I couldn't leave him; when I'd bring him a painting he'd invariably say, "Wolfie, did you do that?" In his class I painted three nude women sunbathing beside an idyllic little river I'd swum in at home in Mississippi. Many of the faculty came to see it, as they had looked at a painting of bottles I doggedly labored on discovering for myself some solution to the mystery of color. I asked Philbrick what was up. "Your painting has charm," he said. "Oh, charm," I was disappointed. "Young man," he said seriously, "Don't ever underrate charm; it's rare." But I wanted more. The dean had said, when I asked why he looked the second time at my bottles, that they wanted the painting for the school catalogue and were watching to stop me before I got tired. I delayed fatigue for a whole month, but it got me, so the dean and I trimmed two tired inches off the edge of my canvas. It sold out of the school show for forty-five dollars to a teacher in Kansas who paid five dollars a month for it.

I went to art school to learn to paint portraits. I learned that painting one, a good one, is the hardest job in the world. I labored to the point of agony trying to find out how. I still don't know. I have painted more than seven hundred portraits over fifty years and I can still get lost.

The Chicago Art Institute

The Institute drew students from every state and many countries, and I fairly wallowed in the joy of being liked by so many kinds of people, after Columbia. The most fascinating man I knew was Ove Bergen, who lived from hand to mouth in true bohemian fashion. Weiss's restaurant was seven blocks from school, a distance that left each gastrocnemius jumping when I breathlessly arrived there to enter a kitchen become a madhouse at noon. There were three floors, and three thousand lunches were served every day on each floor. Ove and I worked there as busboys. Tall and handsome, free and healthy as a wild animal, he looked like a sleepy black-maned lion. His deep plangent voice was a pleasure I can hear yet. He could roar with laughter or talk with the deepest seriousness. Most fascinating was his absolute inability to lie. He was the son of a Danish nobleman and a chambermaid, and his testy pride marked his dealings with stupidity as if his noble heritage were dominant over everything else. He liked me, he said, because I never pretended to be anything but what I was. I assured him that I'd be lost trying to be anything else. It seemed to me he tried, and it may have been his undoing. Once in Obertauffer's class, he changed two square inches of shadow by the side of a nose thirty times. Obertauffer's silent eye watched and his sour disposition asked Ove why he did it. Ove replied that he couldn't get it like he wanted it.

At birth Ove was placed in the care of two abysmal peasants in the country, grew up thinking them his parents, slept on straw, and ate cabbage soup and black bread in a Grimm's fairy tale. At fourteen, after learning his name from his schoolmaster, he ran away to Copenhagen. At eighteen, he found out where his mother lived, and without disclosing his identity talked to her for an hour. The more he talked the more she appealed to him. Finally, he told her who he was. He remained with her for a year, the happiest time he'd ever known. After that he came to America. I finally lost Ove; he was last seen going into the Chicago Public Library.

The whole world changed for me at the Institute. I fell in love for the first time—blindly, madly, completely. She was a

Mississippi Artist

Chicago girl; I was a hick. Her intense blue eyes said things I hardly dared to hope for, and by the time she told me of her engagement to a handsome athlete—a young millionaire away at Amherst, it was too late—we were together every possible moment; but I did not forget that there was a scholarship to be won and that my last chance at it was at hand. Wouldn't love work itself out, somehow, if you loved enough?

For the scholarship competition, contestants were immured and instructed to make a design for a mural that would hypothetically decorate a high wall over a stair. I knew I would paint women in a landscape at one with nature. I had drawn and redrawn my figures, memorized them so they could be arranged in any format. My preliminary drawing was accepted. I parted with my love and went back to my brownstone. Now that the size and shape of the painting were determined, I fixed my figures in the space, working without interruption. I wanted no suggestion from anyone. But how to paint them, right out of my mind? I came back to school and wandered through the galleries, seeing everything with a new eye. To my surprise old Chinese painters solved things for me. Figures in a landscape; a neutral ground with dark and light on it. I tried this, tried that—on a small scale. Finally it came right—I discarded a dozen colors, keeping not more than six. I knew why every nuance on my pallet existed and the place for each one. I gradually became engrossed in holding in check all my impulses to experiment, to show off, even to win. Maybe I wouldn't win; who'd care? In this painting that I made only for myself I was compelled to say, for once, exactly how I felt.

My picture? A hackneyed theme as old as time, yet as new to me as love was—women waiting beside water, under a low moon, preparing themselves for the embrace of men who, as fate decreed, might or might not come. At least that was in my mind. What you could see if you didn't go that deep was a patterned surface of dark and light in muted color with sinuous line. It palpably expressed my longing for what I could not have; I loved the wrong woman.

The Chicago Art Institute

I won first place. My friend Philbrick said I won way out ahead of everyone. "It was the only painting that had feeling. The whole jury went for you."

"That's what painting is for, isn't it, to express feeling?"

"Of course, but you had a goddam woosy composition."

Obertauffer said I was lucky. No one knew whose preliminary sketch mine was, since they could not be signed. I puzzled over this. Was he thinking about the time I had been suspended from the Institute? Tossing apple cores into Persian brass pots when I, with Madge Foeller from Alsace-Lorraine, wrote up the Ardibil rug. She brought the apples and like Eve tempted me, and the pots, shiny outside, looked as if tobacco juice had splashed inside for centuries. Because it was the first time I'd ever kicked over the traces, I had been proud of myself. But misdemeanor was on my record.

Obertauffer notwithstanding, I floated. My feet walked as usual, but euphoria carried me through space as if they never touched ground. It wasn't possible to move more than a foot or two without being congratulated. My hand was wrung till it was sore. How marvelous that was!

School was out, but I could make some money if I stayed on another week to help give the place a scrubbing. At the end of the week my love and I would have one last ecstatic night at a hotel before I left the next day, to say goodbye—perhaps forever, if we could. I could hardly swallow; all inanimate objects swam under my gaze to join my levitation. Would Friday ever come?

Thursday night I found a telegram waiting in my room: "Liz has been killed in an automobile accident." I cursed God, wired my girl; packed, and boarded a train for home. Liz was my youngest sister, fourteen, the brightest spirit, adored and petted by everyone.

We watched, helpless, as our mother grieved, her mind crushed by its weight of sorrow, enormous beyond our sharing. Like a lofty mountain isolated by miles of sea, she could not be reached.

19

Mississippi Artist

Did she pray, as I could not? Was God just? Was He jealous? How did she survive? I would have died to erase what had happened, but my death could have been no gain to her. When three brothers went back to school at the end of summer, a sister to her job, another to her husband in New Orleans, my dad to the lumber camp, I was asked to delay going to Europe for a year, to be with my mother in the hope that I could divert her. I took my assignment to heart and did all I could with it.

Slowly she recovered, but no longer did I see the great all-embracing love that had comforted fears; it was now she who must be cared for, she who needed every tenderness. I faced this great reversal—forever reversed—but all my fiber longed to weep its private pain against her breast. What to do? We both kept our hands full of busyness. Instinctively we avoided contemplation, which might turn the whole world askew and make existence intolerable. I felt cursed by God, but worked, slept, ate with untouched vigor, and though our possibilities seemed limited, I led her interest into what we could create together; it was creating she'd enjoyed more than any thing and this was a bond between us. A rock garden filled with objects of concrete, a cockatoo of the same material, feathers erect, still whole years later, a handsome shell for a fountain still in my possession remind me of our ceaseless activity. She would not abdicate feeding her family, so in the kitchen we experimented with food. When we sat for rest, I brought out her "fancy work" and praised the designs she made in appliqué. I spent every waking hour with her and wept at night alone.

Perhaps her mind never regained its original sharp edge, but time passed and the look in her eyes changed. She saw us now, her children, with affection at once so fierce and piteous it shook me. Remembering that look, I mailed her a postcard every day from wherever I was in Europe. For at last I left Columbia again, but I still had unresolved questions about the goodness of God on my mind.

Sailing on the *Minnekada*, a tourist ship, all one class, we were fourteen days at sea, ample time to discover inanity and

20

how prevalent it can be, even among people who looked glamorous enough in midocean. One person not inane was Thomas Jefferson Jobias. He'd had a job with *New Yorker* magazine, saved his money, and now was on a jaunt to Europe. We were almost instantly friends, flirting with the same girls, discovering common interests, and deciding we should see Paris together.

For me Joby was a Godsend.

Europe, 1929

I remember loneliness in London. I remember tulips, too, pale gold, luminous, and waist high in Hyde Park. April rain made big conifers almost black, pavement gleamed like wet silver, and I had no one to talk to. Paintings in the National Gallery kept me busy till it closed at five. What a treasure-house that museum is, every object superb.

London was loaded with things to see, but not to eat. Breakfast at my hotel was good—oatmeal, ham and eggs, coffee or tea—but the only other thing I found at all decent was a meat pie bought from a cart in a park. Loneliness is bad and at mealtimes it becomes acute.

When rain stopped I walked in pale sunshine and deep history along the Thames, watched the king's swans float with inborn majesty on its placid surface, visited the Tower with its appropriate ravens, admired the Beefeaters' costumes, unchanged since Henry VIII, climbed to the small room where the crown jewels are displayed, and quivered at the sight of such concentrated wealth. The famed Cullinan diamond at the top of a scepter refracted light rays as solid as icicles. But nobody said a word to me. I began to think of solitary confinement and wondered what it did to the brain. London was the most peaceful of cities. Its policemen went unarmed, no evil intent anywhere, but people did seem to stare at me as something curious, and under this scrutiny, I was lonelier than ever. One could tell a man's profession by the clothes he wore—bank clerks in cutaway coats and wing collars; taxi drivers in stovepipe hats, highly varnished; school boys invariably in suspenders unless they attended a special school like Eaton. Then I saw the famed

English complexion, pink and white above wide white collars out of blue coats. Working girls, flooding the streets at noon, wore white cotton stockings. Many men, however, were dressed in coats and trousers that didn't match, and their hatbrims were not rolled like mine, but snapped down in front. I snapped mine, went back to my hotel, and put on my other coat. They still stared. And then I heard two men unmistakably talking about me.

"Yes, he's American—flat feet."

They were flat. Too flat to match an Englishman's bouncing walk. One bright afternoon I went on my flat feet to the Mall that leads to Buckingham Palace. Debutantes, each with three white plumes in her hair, sat in spanking carriages out of fairy-tales. Each carriage was the color of the horses that drew it. The horses, always at least two to a coach and sometimes four, were matched, and the livery of the driver, footmen and lackeys who rode high up on the back matched both horses and carriage. These menials wore tricorn hats, white wigs with pigtails, and silk stockings. The girls in snowy white, with much tulle, were eating sausages in buns. My credulity leaped several notches, as, with the crowd on the sidewalk, I gaped. Nothing looked as if it might move—a frozen spectacle—and this gave the bolder members of the hoi polloi opportunity to poke heads into carriage windows for a closer look at the occupants. I heard one burly old fellow say, close to one young face, "Blimey, she's a pretty one."

How surprising they did not giggle but talked to each other, unconcerned, or stared in that unmatched English way. In spite of the air of immaculate festivity that breathed over everything, trees lined up like soldiers, each blade of clipped grass at attention, there seemed to be some sort of solemnity to it as if the queen's levee was serious business, which even the solemn-faced children on the sidewalk unconsciously admitted.

Of Westminster Abbey I remember only its magnificence and the Ancient Throne of Scone irreverently scratched over with countless initials, but the old woman picking over a garbage can

near its regal doors I see each time my mind says Westminster. Her face was long, noble, very English, and quite handsome as if she were kin to the people painted by Reynolds or Gainsborough, but her ears were grey with accumulated dirt as if she washed just to their edges; her hands and wrists were filthy.

I ran into three girls from the *Minnekada*, and we visited Middle Temple Hall. Built in Shakespeare's time, it has steep roof, triple hammer beams supporting it, quite an architectural feat. Law students ate there and it was filled with the smell of boiled cabbage. It was good to hear American voices again. We talked about baths, how hard they were to get, and how much we needed one after fourteen days of salt-water showers on the ship, each leaving us sticky. My hotel in Russell Square was a small one for students, quiet and decent. Before I had set my bags down I told the proprietor I wanted a bath. His face showed interest, and he said it would be ready in a half hour. In due time a maid knocked on my door saying the "bawth" was ready, "bawthroom" on the first floor. The proprietor stood by the door as if at attention, warmed towels over his arm. Opening the door, he ushered me rather grandly into a large room, rich with majolica-tiled walls. A tub, big enough to float in, filled with steamy water took me for a long soak. Next morning I woke remembering its luxury. I wanted another bath, cold this time. I went down to the first floor and tried to find someone who'd give me permission, but seeing no one I took another bath anyway. When I emerged the proprietor stood by the door with a frown and, I think, patting one foot, Was I trying to steal a bath? He was quite serious. It hadn't occurred to me that a bath, anywhere, shouldn't be free.

"Oh no, they are a shilling each, a hot one two shillings."

That was the last tub of water I saw for months. I managed to wash myself in bowls, in bidets, in basins, out of pitchers, with only an occasional splurge in the real thing. Luckily the climate was much cooler than sweaty Mississippi. My one-thousand-dollar scholarship money had to stretch as far as it would, no matter how I smelled. I guess I smelled like everyone

else, except for one student from the Institute who with the same money managed to stay in Paris two years. He was rank six feet away. I went with him to a Communist kitchen once. The menu was boiled chestnuts, raw cabbage leaves, and something like hay with gravy at a cost of four cents. I didn't see him again.

In London, the Tate Museum half-bored, half-fascinated with its large collection of pre-Raphaelite paintings. The Royal Academy show was a solid bore, and when rain began again, with no sign of letup, I thought of leaving the city. But I'd seen little of it, so I spent a day riding on top of double-decker buses. In memory, London is black and bleak. Something seemed wrong with buildings in the classical style under a northern sky. Gothic and Elizabethan architecture looked right, especially in the rain, but the heart of London seemed filled with columns and porticoes, dark and very gloomy. I didn't know till I reached Italy how happy the same buildings could be in the sun.

I felt that I must see Tussaud's wax museum, having heard of it always as something peculiarly English. What I recall of it now is unearthly quiet, as if the walls, hung with blood-red velvet, were muffled. Criminals, statesmen, kings, and queens spotlighted against that grim color, looked equally ghastly and sinister. The thing I loved was centered in a separate room— Sleeping Beauty in a gold swan-shaped bed—a wicked black witch gloating over her. Her filmy white dress needed laundering, her profuse blond curls needed some tender care, or else she should have been moved away from the stringent spotlight that was focused so that the large cross set with glass diamonds between her heaving breasts glittered with every movement of those delicate orbs. Yes, she moved as if air filled and left her lungs, but with a scrunging sound inside, now loud, now soft. Her breathing machinery needed oiling.

All the way to Dover, pansies bloomed between the crossties on the railway tracks, and irises flowered on the banks above the tracks' level. I watched the garden that was England from the observation platform. Every available bit of earth was filled

25

with bloom. At Dover the sun dazzled on the White Cliffs, and I saw again the sea that forever washed the tidy island. How blue the water was. The same sea that was exactly the color of pea soup when I first saw England. We'd stayed up all night to watch land come in, and the first thing the sun dimly revealed was a cherry-colored sail against solid green, like a Japanese print. There was no way to tell what was water, what moisture-drenched air. Everywhere was green, yellow-green. Gradually the sun shone on fields, emerald green, concentrated, an impossible green, spotted with buttercups, then hedges, streets, roofs, spires, and, finally, whole villages, everything looking manicured and patted. I could see why an Englishman loves England, that neat, neat island.

The channel is little more than twenty miles wide. Strange things happen in it. We sailed from a peaceful sea into a storm as black as night. The small boat tossed. Water poured over her sides and swept the deck. Passengers huddled green-faced with nausea on the cabin floor. There were times when the boat seemed perpendicular, her bow in the water, her stern somewhere in the violent sky. I stood as I'd been told to do with my back to the mainmast and held on for dear life. The ends of the boat flew up in the air, then dropped sickeningly down, but in the middle I only had to bend my knees to keep my head level, like standing in the middle of a seesaw. I felt no sickness and saw it all, the lashing fury of the elements, the toss and heave of the sea and as we rode out of the turmoil, the sudden sun shining on the fields of France.

The first time I saw Paris I must have walked fourteen miles, from Place St. Michel to Sacré-Coeur and back. A delightful way to see things—it took all day. In 1929 French automobiles were a lot like Model-A Fords, with shiny brass trim. They waited for pedestrians to move out of their way, horns sounding from squeezed rubber bulbs as in Gershwin's music, constantly honking. Midinnettes tapped quick heels on every sidewalk making American girls seem like cows. Shop windows were fas-

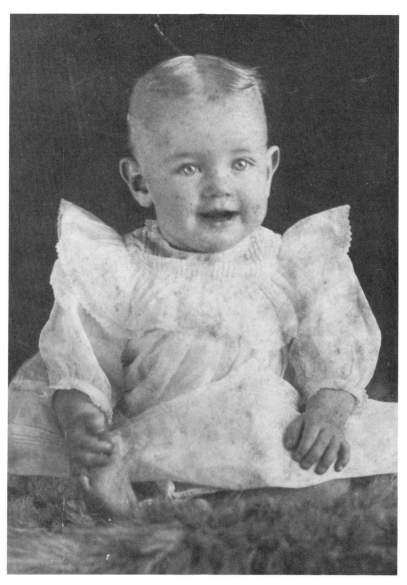

Probably my first photograph, 1904, Brookhaven, Mississippi, the town of my birth.

Clifford and Augusta Nungester by their daughter, Mildred Nungester Wolfe.

My mother and father, Elizabeth and Wiley W. Wolfe, a conte and an oil sketch by their son.

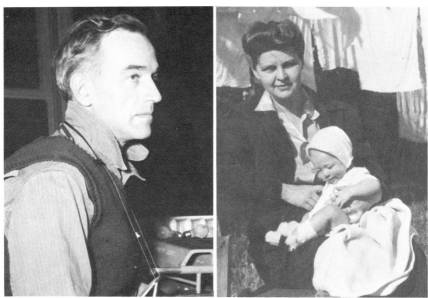

The photograph on left was taken while I was in the Army (circa 1943), at right is Mildred holding Michael, 1946.

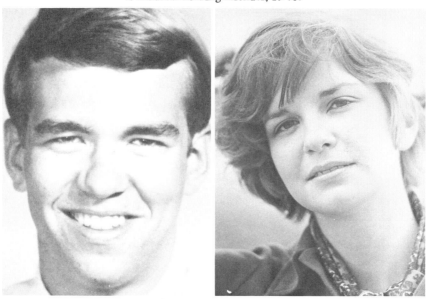

Michael and Elizabeth (Beebe) Wolfe during their teens.

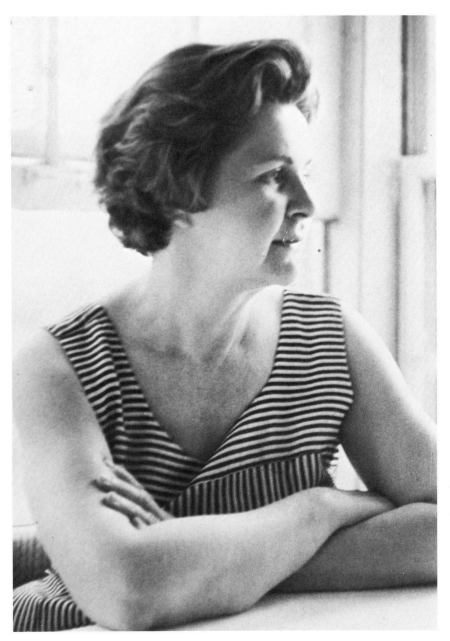

(Above) Mildred photographed by her daughter, Beebe. (Opposite) At my easel
during the 1960s.

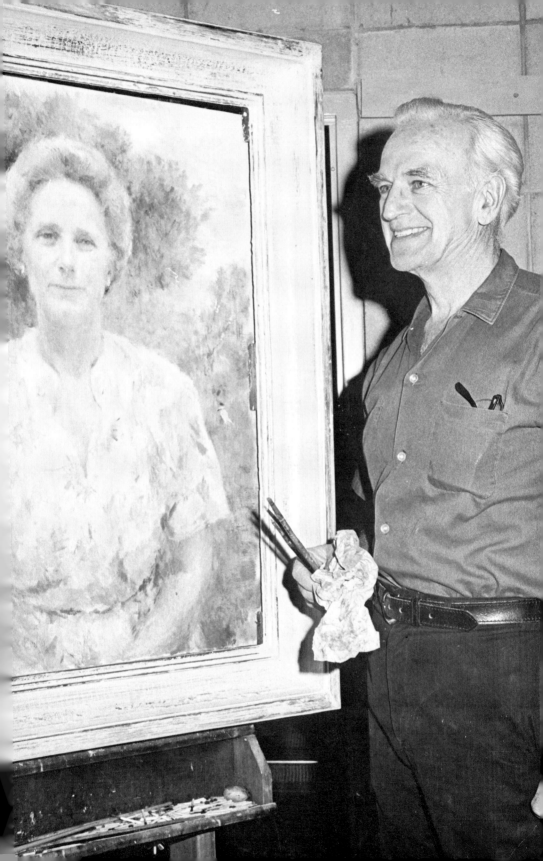

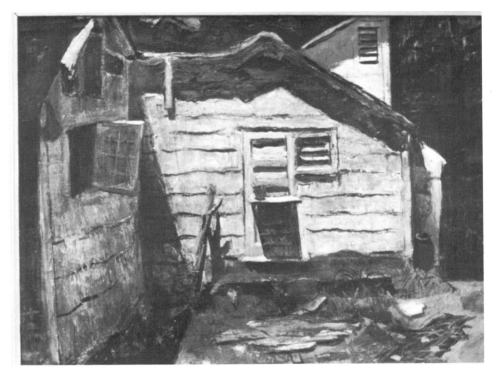

Old studio painted by Mildred.

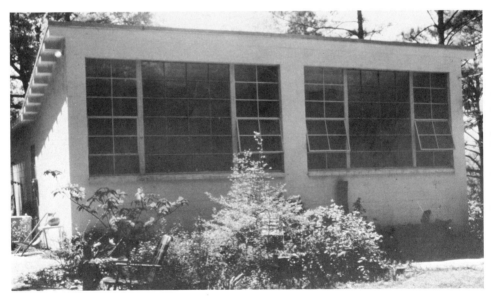

Our new studio build after fire destroyed the old one in the 1940s.

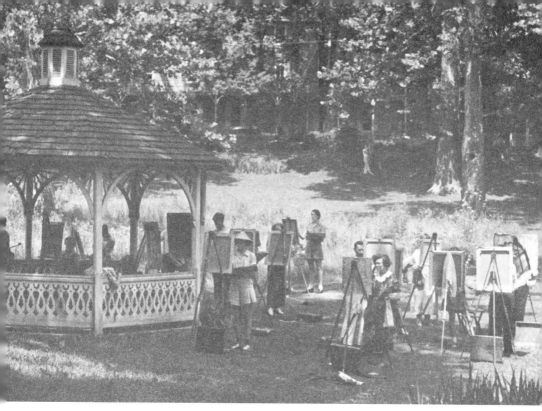

(Above) A view of painters at Allison's Wells Art Colony where I taught during the 1940s. (Below) During the 1930s I attended summer art sessions at the Pennsylvania Academy of Art near Chester, Pennsylvania.

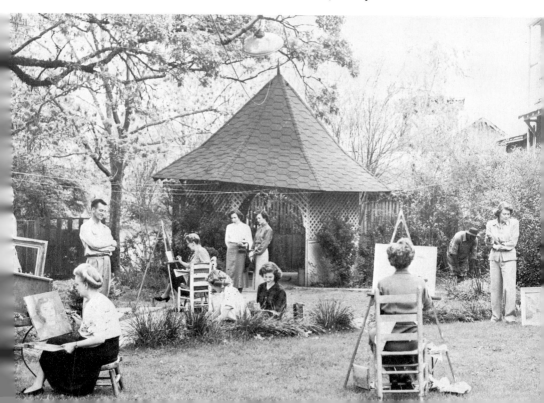

A recent photograph of myself.

cinating with objects I'd never dreamed of—larks, naked and gutted, their heads hanging in a circle from a compote. Larks! Pastry shops piled with goodies; a minute store that sold only chocolate; chamber pots displayed on sidewalks, with eyes painted in their bottoms; flowers; fishworms; exotic birds; snails; and of course paintings. In clothing stores manikins were recognizable celebrities—Josephine Baker, Maurice Chevalier, Fugita, Lindbergh, and Valentino.

In the company of a pretty girl from the ship, I was determined to fall in love, if possible. Nina was attractive, had been in Paris before, was a charming guide, understood the French swirling around us. But I felt no heart flutter, and she left for Rome next day, a tourist.

I was not a tourist and was not tempted to follow her, though I was perfectly free. Instead, for three weeks, I had lone breakfasts of café au lait and pastry in a shop near my hotel. It took three weeks to eat one of every kind. The shop was presided over by a motherly middle-aged woman, and there I learned the politeness of the French and, loving it, did a fair imitation of it. I spent a morning in the Jardin de Luxemboug listening to a small boy who played he was the vegetableman selling madame (his nurse) her choice of *légumes*. I listened and learned to pronounce all the vegetables one is apt to confront on a menu. That helped. People corrected my pronunciation, kindly, or noncommittally. A good book on instant French helped, and after four months when I left for Italy, I could make noises like a Frenchman makes, but I had no vocabulary or grammar.

Of course the Louvre was inexhaustible. I must have been in it three days out of five and never saw all of it. I climbed all over Notre Dame, loved Cluny, quivered through Ste.-Chapelle, walked from the Tuileries to the Bois de Boulogne, visited Montmartre, discovered Le Dome on Mt. Parnasse and the inanity of American students who sat there, including one girl longing for a bridge game—in Paris!

There were 150,000 American students in Paris that summer;

Mississippi Artist

I was one, and schools were everywhere on the Left Bank. I tried L'Académie de la Grand Chaumiére. A hideous naked man posed, then a worn-out woman, then a girl with pearllike skin. When she rested, all the males rushed to the model's stand for her address. A plain girl sat next to me. Her English was good, her drawing bad. I asked her to have a drink. She drank Menthe Sec without alcohol, leaving no lipstick on the small glass. I looked at her closely. She did not have even powder on her face. Girls everywhere in America looked like poppies then with all the color they could pack on cheek and lip. Why didn't she wear makeup, I asked. "No nice girl does," she said with something that sounded like mild indignation. We took a long walk for blocks around her father's imposing antique shop. He must not see her with a strange man and no chaperone. Her English? She'd learned that during a summer in London. I was quite surprised and interested. Three blocks from her house she said goodbye. No flutter here. She was plain all the way through. How, when, would I meet a nice French girl to fall in love with? I was here to study, I sternly reminded myself. Demimondains I'd encountered were dumb and impossibly crude—or had I been completely spoiled? What was I doing here? Would I ever see again what there was to see? Not likely. Would I understand instructions in French? Not a chance. School seemed a waste of time. I gave up the Academie and the plain girl, without regret.

There is a game the French play. *Psychologie* they call it. One looks at a person, just met, and in a word sums up that person's character as it appears. When I was looked at the verdict was always the same, "I don't know what you are." I didn't know either. They might have said "puzzled," but I suppose that didn't show.

Loneliness was crowding me when Joby showed up. We looked for the quaintest hotel we could find. Pseudoquaint was not yet in vogue. We found something real on a short crooked street, rue Git le Coeur, something Haussman overlooked; Notre Dame and Ponte Neuf were in full view. *Git* they put on tombstones. It means *here lies*, so our street was Here Lies the Heart.

Europe, 1929

We got separate rooms in case either of us found a girl who'd spend the night. I managed to get a girl I'd known at school in Chicago into mine, but she wouldn't and I couldn't, so I gave up and grew a beard. I never liked her much anyway. It looked like shredded wheat, the beard did, and girls stopped looking at me except for Olive Block.

Joby found her. She was from London, her father a professor in the university. Joby's family were Sephardic Jews, who lived in a Charleston house they'd owned two hundred years. They knew Olive's family, also Sephardic, and hoped she and Joby would like each other. They felt he should be married. Olive was slim, elegant, and almost beautiful. She was in Paris learning the massage her father's neck always was in need of. Ardently studying the language with a French family, she'd spent the summer before in Berlin doing the same with German. How easily a European becomes multilingual. She and Joby argued most of the time in French, so I couldn't tell what it was about, but I knew he wanted sex and brought all his considerable charm to bear on his persuasion.

Lady Chatterly's Lover by D. H. Lawrence was just out in all the Paris bookstalls. Joby, whose knowledge of the literary world far exceeded mine, got a paperback copy and proposed that we three read it aloud, each taking his turn. He'd looked the book over beforehand, knew what was coming, and elected me to begin reading it. I started innocently enough, but saw the word *shit* staring at me from the middle of the third page. I had ample time to decide I'd read it as casually as any of the other words, which I did, but I didn't look up—I still hate the word. Before we finished the book, which impressed me deeply, Joby and I were well seduced, but Olive seemed unaffected. She agreed she'd sleep with Joby, but he must promise she'd remain "inviolate." Early next morning she shivered into my room. Joby had taken all the covers for himself and she was freezing. Could she get into my bed just to get warm? There was no heat. I got her warm and kissed her, kissed the pillow she lay on, but she left my bed as she had left Joby's—inviolate.

Mississippi Artist

Before she left for home, she asked me to shave off the shredded wheat; she wanted to see what I looked like. I said I would if she'd get hot water. Joby could read French but could not express himself so well verbally; I was worse, but Olive rattled it off like a native. Hot water was there in no time. She held my hand all the way to the train station, got home, and sent me a big box of lavender from her garden. *Je regret.* Joby kidded me about taking his girl, but didn't really care.

Our separate rooms remained chaste after Olive, while all around us sex in some form shook the air. I can't understand why it is called making love, when love has so little to do with it. Actual copulation lasts only seven minutes on average, excitement can reduce those seven to near zero, but love is forever. Much as I wanted sex, I longed more for love, and deep inside me was an emptiness lonely as hell. So I grew the beard again and in the midst of Paris tried to forget women, directing all my attention to the world's great masterpieces piled one on another in this most beautiful of all cities, reluctantly resigned to my own fastidiousness.

When I think now of what I absorbed in Paris, one painting stands out beyond all others, Titian's *Entombment of Christ.* There is a calm nobility in it, without show, as if what it depicts were eternally happening, as in some way it is. The breath of humanity could have done it. It doesn't look painted. Georgione's *Fête Champêtre* is a lesser moment in serene idleness like that we enjoyed at St. Cloud, lying on soft grass by the placid Seine, talking great ideas, or charming nonsense, or not talking, all desire stilled for the nonce. Corot makes me feel as if I'm levitated. I looked long at Rembrant's *Bathsheba*, but longer at his "flayed beef." Did he know he painted hot life itself into this dead animal that sustains us carnivores and transmutes dead flesh into all the superb products of our joint imagination; all the lusts of our lusty flesh? A small painting of a French woman's head by Degas I've carried in my own skull for years, as I have many of Renoir's joyous paintings. Michelangelo's bound slave is unforgettable. He makes me uneasy even

30

in reproductions. Why does his beautiful, too slick body give up instead of dying in a fight for his freedom? But oh, *The Victory of Samothrace*. At Musée Rodin I could have stolen all the erotic small pieces; moved by the *Thinker* unmoved, prowled round the burgers of Calais till closing time. A trunk with walking legs even when I think of it raises hackles on my neck, like a good strong drink of whiskey.

We were by no means idle. Joby awoke at seven-thirty, and his typewriter tapped out short stories all morning. These he tried out on me, and naïvely, I'd believe them true till he laughed and confessed his ruse. He introduced me to the writing of contemporary giants like Norman Douglas, Hemingway, Dos Passos, Lawrence, Cummings, and Pound. All of them had something to say to me. Lawrence who had much to say I thought never said it too well, and Hemingway's masculinity seemed too guarded to be real, though he carried the masculine part of you deep into his stories. As for me, I had fallen hard for van Eyck after drooling over his Arnolfini painting in London. The Louvre had other van Eyck paintings, positively magical. I wanted to learn to draw and model as he did. It was hard work, but I managed to accumulate enough drawings and ideas to keep me busy for three or four years afterwards. Many of the paintings that resulted from this study were sold for good prices. Van Eyck painted as if your fingers touched his surfaces and you could feel them with your eyes closed. *Tactile value* the art books name it. My work in Paris sometimes before a mirror, myself as model, has affected all my painting up to now, for better or worse. Afternoons we haunted some outstanding monument to French spirit. I could give Joby information about paintings, but it's hard to absorb and inform at the same time. I widened his perception, without altering his taste, which, bound so deeply to personality, shouldn't be tampered with. He loved *Bain Turk* by Ingres with its mass of squirming female flesh. I liked Ingres's lone bather for its austerity, its calm balance like a woman who is a woman and not a thing. Joby said he'd always wanted to be buried in women, while I, having absorbed Lancelot very young,

longed to give my whole soul and all my passion to one woman.

I looked at Joby then for the nth time. He was not Nordic, not Levantine. Sensuality left little trace on his face. It was impossible to imagine him chopping wood. He was "imperially slim," his head refined to a degree just this side of effeteness, suggesting in its dolicosephalic proportions considerable mental power not unlike Voltaire's. It was clear he'd never been tortured as I was. I found him as dear to me as David may have been to Jonathan. I think he never knew what I owed him, and if he had known he'd have laughed.

He went to Azay-le-Rideau where he had French friends. After a week he wrote urging me to join him and share the delight of cultured French people in a village with no tourists. I found him the pampered darling of the village. He delighted in the small château, built into the river with turrets, drawbridge, and portcullis and an interior more beautiful than any home I've ever seen. The weather was delightful and the smooth placid river invited swimming. No one else was interested, but we must get into it. People with clothes on, the same kind of suit another man wears, have a dull sameness to their looks, covering either shocking ugliness or rare glowing beauty. Joby, undressed, was as beautiful as a sword, as unselfconscious as a forest deer in the subtlety of his musculature. I tried not to embarrass him with my staring—but the image of his tapering physique walking through fern knee high is with me yet. He looked like Praxiteles' lizard slayer. "What a piece of work is man!" Would horses say the same of themselves if they could?"

M. Davreau was Joby's special friend. He was stalwart, erect, and forthright, his blue eyes penetrating. When I was introduced as an artist, he said simply, "I am a peasant," exploding in my mind a dozen myths from a lifelong acquaintance with Millet's paintings. Dealing with Americans in the wine trade, he'd learned some English, and his simple directness made conversation a pleasure. He couldn't for the life of him make any sense of prohibition in America, and he was sure Germany and France would fight a war again—in ten years. We could not understand

prohibition either. When he said "war," we recoiled. His fatalism, however, would not be moved; he was sure. We'd sneered everywhere at the monuments to the men who'd died "for the glory of the country." There was no glory in dying for anything, we thought, so young we were. We knew without dispute that a dead body was not glorious, but an ugly stinking mess. It was ten years after the Great War, but cars in the Paris metro still reserved seats for men wounded in battle. Four million young men had died in four years and left four million French girls without mates. No wonder they swarmed the streets of Paris selling their bodies to live. I pitied them.

In 1939, exactly ten years later, Frank Boggs came to see me in Jackson, Mississippi. I had known him and Milt Hull in summer school at the Pennsylvania Academy of Art. Frank had been in Europe on a Cresson Scholarship from the Pennsylvania Academy, traveling with Milt. They were too busy scouring the Continent to know what was going on—neither knew French— when someone told them to get out of Paris, the Germans were just outside the city. They found the American Express office deserted, every man with the army.

"We tore the place apart, till we found our bags. Then got out on the sidewalk. All taxis had been commandeered. A gendarme said he'd get us a taxi; an American doctor had saved his life. He was glad to repay an American. Sure enough a general got out of a taxi and we popped in. The gendarme gave orders— Gare du Nord. We couldn't get within blocks of it, people were so thick, so we went to Gare du Sud. It was about the same, and we wormed our way into a subway entrance hoping we'd come up inside the station. We did, and squeezed into the jam. When we got to the tracks, there weren't any more coaches. They were loading people on flatcars. I saw a man put his little girl on a car and turn to find his wife. She'd gotten shoved so far away he couldn't reach her and then the train pulled out, everybody screaming. It came over me. It was their country. We got out, bought motorcycles, rode to Tours. No place to sleep but

33

the floor of a hotel lobby. Next day they mustered out the local troops. Hot, but they had on all their gear, heavy overcoats, big boots, packs and rifles with bayonets. The streets were lined with people all staring in dead silence, no cheers, no flags, nothing. One old woman screamed. Someone clapped his hand over her mouth. All you could hear were the boots hitting the cobblestones. It was awful."

How did they get home? They went to the coast, slept on the beach and frantically wired Washington till they were picked up by a boat.

Joby and I visited châteaux along the Loire, came back to Paris and saw Les Halles at night. It must have covered miles with more miles of potted plants in bloom neatly placed on the sidewalks' edge that led to it in every direction. No matter how mountainous the produce there at night, it was gone by eight next morning. Vegetables stacked in cubes the size of small houses: beets, carrots, cabbages, radishes, and nothing helter-skelter. The orange ends of carrots all pointed outward as did the red ends of beets or any other shape or color that could be arranged in rows, pyramids, circles, or blocks. The orderliness was as astounding as the abundance; great piles of cut flowers in blinding color, fruit like jewels. We could buy for a few cents all the ripe cherries our two arms with a newspaper over them could hold. We ate till juice dripped to our belts, and one old woman laughed and said "gourmand."

We saw Folies-Bergère, delightfully imaginative, Moulin Rouge, the Café of the Dead Rat, some banal pornographic girl shows, picked up *femmes de joie* like any tourist and let them go. Did you ever look in a book of Toulouse Lautrec's paintings for a genuine smile on the face of any woman? There are no smiles in that part of Paris, only grimaces, and no health, while Renoir's people all bloom with health and joy. Where were the people he painted? We never found them.

Joby said goodbye and went to Switzerland on his way home,

leaking spermatazoa, he said, from nose and ears. A note from Lucerne let me know he'd found a girl who would. Wistfully I rejoiced for him and went on wanting. Merlin Pollack, with a scholarship from the Chicago Art Institute, came and took Joby's room; tonguetied, slow, a darn good painter with a face like dough, and in the *Psychologie* game "faithful hound," "salt of the earth," or "substantial." In a miniscule restaurant that rented napkins, we met Fritz whose last name I can't remember. A graduate of Micheljohn's experiment, Fritz was in Europe to write a paper on Flemish primitives. *Abonnment* tickets for train fare anywhere in Belgium cost $7.50, good for two weeks, if you went third class, and whoever heard of going another way. He'd be glad if we went with him.

In beautiful old Bruges, if a man wanted to build, he could, but his building must conform to the prevailing style of architecture. So we saw a medieval town, to all appearances as it was centuries ago with canals, stone walls of houses rising from the water, every inch enchanted. A new museum with apple trees circling it contained some of the world's most priceless paintings, and again van Eyck bowled me over. Color everywhere in Belgium looked wet, saturated, leaves, tree trunks, stones, earth, and moss-grown bricks. The colors people wore, black, deep blues, reds, and purples, dark clear green, and lustrous brown were echoed again and again in old paintings as if nothing had changed for centuries. The van Eyck brothers, Hubert and Jan, created a miracle of painting in the great altarpiece at Ghent, intensifying the saturation point of color. From a window at St. Bavon's where the altarpiece is located, the scene outside was almost exactly the same as that outside the same window in Jan's marvelous painting of Chancellor Rollin adoring the Virgin, seated in the same church—five hundred years before. I loved proud old Ghent. It had a masculine flavor. Even the flowers were mannish; sober dark blue, rich red, and pale olive everywhere.

Reluctantly we moved on to Brussels where Breugel, one of the most individual painters of the Renaissance, captivated us

with his earthy imagination. Never knowing how long we'd stay in a place, we always found a hotel first, dropped our luggage, and free of that burden, spent every other minute absorbed. A long line of cheap hotels stood near the station in Brussels, and we picked a tall narrow one for its name, Sportsman. It was only one room wide, with a curious arrangement of stairs to get up and down and expensive for us, two dollars a day. Rooms engaged, we left our bags and went to see sights till 9:30 at night, returning to the hotel completely beat. We'd engaged two rooms, but by some fluke they'd let someone else have one, and now that someone was fast asleep. There was no space for an extra bed or cot; two people could sleep in the double bed we had left, but what about the third person? We sat in the small bar of the hotel and ordered drinks, undecided. A prostitute at another table raddled and old enough, we thought, to be the mother of any of us offered to share her bed, especially with the sad one. Fritz interpreted, my French not going far enough and Merlin having none. The sad one was me. She moved to our table, regulation grimace crinkling hideous mascara, and digging her elbow into my groin, looked searchingly into my face. I escaped to the latrine and bolted the door. When I came back she was gone, and Fritz said I owed him a dollar. They'd paid for her drink, given her money, and advised her to look elsewhere, the poor one.

It was then after ten, and bone-tired we pled for another bed, anywhere. The concierge said yes, in the attic. He'd take us up to see and we could decide for ourselves. The attic was dark and somehow expansive as if it covered three hotels, which it might have. Under a dim dangling lightbulb, propped up at one corner with a packing box, a thin soiled mattress on it, was a bed. We all said yes rather delightedly, thinking of mild adventure. Then we went down to the bar again and drew straws to see who'd sleep in the queer place, while the hotel man took clean sheets up. I drew the attic, at which the other guys began a lugubrious conversation of murder and blood in strange places, till smugly, at midnight, they wished me *bon soir* and good luck. I climbed

the stairs, undressed, turned out the light, lay gingerly down on the dubious bed, and promptly went to sleep.

A dry, rustling sound woke me. I lay rigid, directing one eye's gaze toward the cavernous darkness at my feet. It was filled with dim shapes, packing boxes maybe. I looked to see if they moved. They didn't, but something I could just see from the corner of my eye did. Behind my head was a window. a casement. Suddenly I knew it had blown open and the newspaper tacked over it rattled in the wind. I turned on the light, shut the window, and, finding the bolt, locked it securely. In the dim glow the light made, the place was spooky enough, dust on everything, dark and shadowy, but the objects I could see were familiar, no alembic or retort, no alchemist's broken crucible. Instead was ruined furniture, baskets full of odds and ends, iron bedstead, clearly 1900, an ironing board, a clothesline with a sheet on it.

With the light on, I lay down and looked at the underside of the roof. There was no ceiling; the roof was made of tiles supported on wooden rafters, and I wanted to see how they were laid. Just over my head a tile had been removed and a sheet of glass placed in the opening—I guessed to let more daylight into the place for whatever work went on there. Dirty as the glass was I could see stars through it. Three other gaps were in the roof, and when I looked back at the one over my head a pair of eyes looked back at me for an instant and then were gone. I realized they did not look quite human and thoughts of demons, incubus, and succubus with hideous allure converged on my mind, as if some evil were aware of my persistent concupiscence, and I grew rigid again thinking of this superstition invading my normal instincts.

Immersed as we were in the middle ages, any strange thing was believable. Just that day we'd turned a corner in the middle of Brussels and had seen, occupying a whole city square, a moat, with a bridge over it leading through a portcullis, into an ancient donjon, with a stairway of stone winding itself around the inside of the great tower. We got to the top, past instru-

37

ments of torture fastened to the walls, and high above the city became ten-year-old Arthur, Lancelot, and Gawain, shooting imaginary arrows through real crenelations, pouring boiling pitch through real holes on imaginary foes below, lacking only our trusty wooden swords.

In the night-hushed square outside, a taxi horn beeped. Yesterday collapsed. Demons were not real, I told myself, except in paintings of St. Jerome, and desire, the source of life could not be base. Forgetting my Darwin, I thought of praying, but God and I were not on speaking terms. No prayer came.

My mind returned to the thing on the roof. Poe's murders in the rue Morgue had been committed by great apes, and I was about to decide that the eyes and what I could see of the face did not belong to an ape when I heard a faint "meow." Cats on the roof, their own domain! Now one was looking in at every opening I could see. I turned out the light and went to sleep.

Leaving Brussels, we rode over miles of earth that was still torn, ragged, and covered over by mollifying green grass, through miles of white crosses, all eloquent of war's insanity. Since there was no place for us to stop, we went on till night and got off the train when it halted at a station covered with flowers. Wooden shoes with trailing petunias were hung on the white-washed walls. The hotel we found had rambling porches, windows to the floor, and woolly blankets smelling of sunshine. Two wide beds cost us $1.50. From the terrace back of the hotel we looked across a placid black river to a street lined with pastel-colored houses, each surmounted by a stepped gable. In their midst was a dark church with an onion dome soaring over its tall spire. Back of this a limestone cliff with twisted strata rose dizzily to a ruined fortress, a pennon flying from its top; all was lit by floodlights. This was Dinant, a place we'd never heard of.

In Louvaine an obscure painting put my mind to rest on one score: Tolstoy's *What Is Art?* which I had read on the *Minnekada*, had added another bother to my already puzzled state; something I could not wholly reject or wholly embrace. His thesis

was that no work of art was worth creating if it didn't delineate the brotherhood of man. This is a grand idea, but there must be other equally valid reasons for spending a life producing art. The brotherhood of man was a plain fact, however one looked at it. Why was it necessary to comment on it, when you could live it? "To be or not to be," had not yet entered my mind. I was going to *be*. But what? Being was doing. What you did *was* you; what you loved as well as what you hated was you. I—to hell with it. If I could find one painting whose sheer intrinsic beauty, regardless of subject, message, or preachment could convince me, of itself, that a whole life spent in its making was well spent, I'd forget Tolstoy. I found that painting in the ruined cathedral at Louvaine. By Dirk Bouts, a stranger to my education, it was a Last Supper. In a Flemish interior, skinny figures, looking as if they were cold, posed as Christ and his disciples. Their table sat on a tile floor, most beautiful. The robes, the architecture, the view out the window were all jewellike in colors that nature took centuries to produce in previous stones, all making a harmony containing in itself the utmost sincerity. I forgot Tolstoy and rejoiced in beauty, relieved.

We took a boat along the Rhine, blue as turquoise, to Cologne, where the curiously pedantic cathedral was disappointing and strangely cold in its magnificent perfection. But somewhere beside the great river I found the *gemutlich* I'd left in Brookhaven. My German Grandfather Heuck's grandfather was there--beside me. Nothing was grandiose like Haussman's Paris, no planned effects, clipped trees, endless avenues, and monuments in an imperial design that bent your mind to its unreality. Instead, nature at its gentlest, easy, serene, and lovable; each rock, bench, sculpture, or flight of steps fitted into what the natural elements had created before man took over. This was what I wanted and some day would have.

Back in Paris, our two weeks gone, Fritz left for the States, and Merlin and I went to fairy-tale Chantilly. We looked at Leonardo's small miracles stroked in silver on scraps of blue paper, and on to Rheims to prowl the cathedral, stupendous and

majestic, like a king—an earthly one. Then we went to Chartres. By this time we ignored anything we'd read or been told about a work of art, or anything else. It had dawned on us that the French try hard to make a celebrity of anything or anybody, and that the emperor's new clothes must have been made in Paris. We looked and we're convinced or not, bowled over or indifferent. We had said to Mona Lisa, the most celebrated painting in the world, "Move me." She didn't. So we were in no way prepared for the cathedral at Chartres.

Its luminous green roof soaring over ripe wheat fields took our breath away. Nothing is dearer to me than the figures representing the ancestors of Christ that flank the entrance like columns. How could they be at once inanimate and yet so alive, their stony faces giving the affection that a grandparent gives a child. How could they return me to the very beginning of life, when in all innocence, I took enveloping love as the sum of existence. My knees shook as I moved inside. Suddenly I had to sit down as tears wet my shirtfront. What was the matter with me? Color quivered in the dark everywhere. It was so powerful I felt pierced with it, shook all over, had to remove myself from its reach. I had not been inside longer than ten minutes.

Deeply shaken and very puzzled, I gazed on the wonders attached to the outside of the building which with every passing moment took on more reality than anything around it. How many saints looked at me kindly and whispered in stony mute voices, "We want you in the kingdom of heaven!" Back inside, color shook me again. Tears flowed quietly now instead of in floods as I moved from glorious window to even more glorious window till I peered full into the face of the Mother of God, who gazed back at me with a penetrating, unforgetable look full of serenity—full of sympathy that said, "All is forgiven," and I found myself praying without words or thought, in abject surrender to overwhelming love.

We searched our pockets for every centime we could spend on reproductions, loath to leave forever so gorgeous a vision. It was like losing a part of ourselves. The small guidebook I read

Europe, 1929

on the train back to Paris averred that any degree of sensitivity would find itself as shaken as we were. Another told the unbelievable story of men and women, highborn or low, people of all sorts, who unhitched the oxen from the carts dragging stones to the cathedral from a quarry seven miles distant and hitching themselves in place of the beasts dragged the stone, singing hymns as they went. It was love that did it. Not love coming from God and heirachy of saints and angels, not even the Mother of God who blessed my sore heart, but love that was generated once in bits of humanity to redeem all our sins, heal all our woes.

(It has been impossible to forget this great and wonderful building. For years, assorted facts concerning it have been added to my mind, and a visit to it a few years ago left me stunned again by its ineffable grace.)

Rain in Paris and leaves falling from chestnut trees. Four months I had lived outdoors and now the streets were too wet. We tried to buy a trench coat for Merlin, but everywhere they held the biggest garment against his large frame and laughed. Nothing was big enough. We went to Italy, by way of Switzerland, without a coat for Merlin. I don't know enough words to describe Switzerland; that land of wonders we saw mostly from a glass-topped train and during a stop at Lausanne.

After half a century I have no trouble remembering everything I saw and every tremor the sight provoked in the narrow circumference of our sojourn in Italy—from the lakes we saw from the train, to Rome which was too much for us. But what shall I write of Italy that has not been written? That I was homesick for it for years afterward? That's ordinary, a well-known malady. That a man overtook us, between Ravenna and Classe where we hunted mosaics, a man driving a high green cart painted all over with tiny flowers and drawn by two great white oxen, long red tassels swinging from their widespread horns? That's ordinary. That the man said, "Buon giorno," as if he bore no grudge against anyone and, spreading his arms wide to the blue dome of sky, burst out with "Bella"? Still ordinary, or

was then, in Italy. But the man's feet were two of the most beautiful objects I've ever seen. He was strong and young. His trousers were rolled to the deeply bronzed calves, his feet like fine architecture dreamed of by a creator who, one fine day, might have said, "Now I'll make something for a man to walk on." We walked with him a mile or more. It's hard to imagine the whole thing in America or any place but Italy, where things seemed exactly as they should be; dreamlike in Venice, not yet shaken by motorboats, more of a dream in Assisi, which climbs a horned mountain, stern and enduring in Arezzo, and Florence the center of our civilization, as D. H. Lawrence put it.

We lived there a month. If there was anything we didn't see, it very likely was not worth looking at. Out our window were Ponte Vecchio, the Arno, and, around a corner or two, the Uffizi. We had incredible meals served by a waiter in tails and white gloves, in an old palazzo, for thirty-five dollars a month! The landlady was sweet, her French no better than mine, and for the first time I could be proud of the few words I could speak in that language.

The palace was built long ago. The bathroom facilities we used were in a corner of someone else's kitchen, a big room with cooking arrangements, with blue and white tiles facing one wall. When we came in to wash our hands and perform other necessities before lunch, a little old man and a neat woman, both elegant, would be beginning their meal at a long table. He could have been a professor—immaculate in frock coat, wing collar, moustache, and clipped beard—and always he'd invite us with a bow and a sweep of his hand to sit at his table and share his meal. Like bumpkins we could only grin our thanks, murmuring, "Le ritirata," and point to the bathroom, since we knew no Italian.

We pored over Baedeker at night and mapped the next day's activity to get the most out of our time, hot in the pursuit of all our minds could digest. Great masterpieces were everywhere around us. For a week we'd passed a beautiful fresco by Botticelli without seeing it. It was above our line of vision, and we

42

discovered it in Baedeker. The wonders of Florence are not sur-
passed anywhere. Only some of its marvels are in museums. The
rest are built into the fabric of everyday life. You can expect
your hair to stand on end every time you turn a corner in the
heart of the city. Nothing there was trivial, nothing shoddy,
everything deeply serious. Even a laughing putto, like Verroc-
chio's on a fountain, is executed with sober honesty. Donatello's
choir boys, one big rascal tangling his hand in a smaller boy's
curls as they lustily sing, is completely true. You feel the pulled
hair you felt once and feel the urge to pull it that you felt when
you got bigger. It is not cute, but noble in its veracity. No story
is more typical of the great Renaissance than the one about
Donatello's commission to sculpt the head of a corn merchant.
Cosimo de Medici was his friend, so when the piece was done,
Donatello took it to the palace, where it was much admired.
They sent for the corn merchant and placed the sculpture on a
parapet to catch the most favorable light. When he saw it, the
merchant began to cavil about the likeness or the price, I don't
know which, but in the midst of his griping, Donatello pushed
the thing off into the street, saying art was not for corn mer-
chants but for princes. A princely city is Florence and princely
is its art. Again and again you hear, with indrawn breath, "Bella,
bella," as if what was beautiful was also holy. How easily holi-
ness combines here with beauty and is dependent on it. Here
beauty stands erect and proud, century after century, like
Michelangelo's *David*. Much has been written about this figure,
universally admired, but I wonder how many people know that
David is the patron saint of Florence, that the sculpture was
commissioned to be a rallying point in its defense against all
enemies, and that it had to be beautiful to insure its acceptance.

I never saw a prostitute in Florence. Merlin had a beard like
mine, only worse. We were mistaken for Germans, who were
disliked there, and I suppose that is one reason we attracted no
women. It was a relief. I like to think that in Florence, where
they must have existed, one went to them as need or inclination
directed, but they left men alone on the streets. In Paris, sex

was a commodity sold with pressure and ballyhoo that put to-day's television commercials to shame. I was too idealistic to accept the narrow animal pleasure of sex without soul or poetry. I was me again, wherever I was and however peculiar, but in Florence I could laugh once more and enjoy the pursuit of beauty without thinking about it twice, and gradually the void inside me began to fill up.

By a long stretch of imagination one can fancy the first step toward our century's walk on the moon occurring in Florence. Without any thought of space travel, we felt our minds expand to take in every phenomenon under the sun, even our own idiosyncracies. This seemed a place to be what you were. Sinless saints like Francis, whose history is so affectionately celebrated, were loved everywhere in Italy. Gifted or plain, bastards had been endured, loved, or celebrated like Leonardo da Vinci. It seemed as if all conditions of men could find their place in this calm and luminous air, where man as he happened to be was still the measure of all things. Some of the happiest-looking people we saw were monks in garb a thousand years old in style.

In the hills above Florence was Fiesole. From the funicular we looked down on roofs covered with small flowers. The monastery with Fra Angelico's frescoes in the cells took my whole heart. It was superbly built with grace, restraint, and strength, the air inside so quiet I knew that here was peace, and I envied the monks who could embrace it. Another day we walked a corkscrew road—cypress trees on one side, a stone retaining wall on the other—to Certosa, another monastery on top of a mountain. The cloister here was even more graceful, with della Robbia bambini in the spandrels, held up by delicate columns. How did they do things so exactly right? What I'd like to see one more time though, is nothing grand like the Duomo or the Loggia, the Baptistery, *David*, or the Bargello, but the gentle magi in the Medici Chapel painted by Benozzo Gozzoli.

We got off the train when the conductor said Assisi, but there was no sign of it in the low flat plain the railway ran through. Outside the station was a horse-drawn landau with a driver wait-

ing for a customer. *Dov'é sono* meaning *where is* are the first words you'd better learn in Italy, so we said, "Dov'é sono Assisi?" He pointed and we saw, still some distance away, a fairy tale in stone trickling down from a mountain top.

If Florence is audacious mind, Assisi must be soul. How I loved it, moving in a dreamlike daze by the stream that flows round its base, through high-arching bridges, where men bathed naked, where great white oxen plowed brown earth, and poplar trees shot yellow flame toward blue, blue sky, where ancient olive trees, some a thousand years old, writhed and twisted, their small leaves in neat classic patterns of grey-green, and farm houses built of natural stone were so simple and beautiful we wondered what modern architecture could discover. Enchanted, I moved nearer the top of the mountain and sketched in a field sloping down from one of those houses, two stories high with arched entrances and a stairway of stone outside. It was then midafternoon.

A woman came to me, a bundle of reeds on her head, her face still pretty and full, like Italian faces are. She laid her bundle down and politely not looking at my sketch began pointing in many directions to the landscape spread out below us, breathing "bella, bella" wherever she pointed. Waving her hand toward the house up the slope she said "Casa mia," which I understood and realized I was on her property and was her guest. Then she launched into her personal history—with graphic gestures when she saw I understood few words—crossing her abdomen twice which I took to mean an operation since her forefinger moved like a knife. That was to get out of her *due piccolini*, two little ones, one in each arm, and she rocked her body gently, loving them. Then they died, and I saw her bury them with tears and brave resolution. Four words I understood, beside *bella*, yet it seemed I knew her as well as I knew anyone, for since the death of Liz anyone touched by grief had now become brother or sister to me.

We must go to her house. We went and she opened two large doors under the stairway where in the dark, black cows munched

hay. She offered me a drink fresh from their udders but I said "Grazie" and shook my head. We went behind the *casa* where she found a ladder, and this we took to the high retaining wall surrounding the peak of the mountain, ruins of a fortress on its very top. We both climbed up, and she pointed again into the great panorama around us on all sides. I gave her a lira which I knew she expected; then, feeling stingy, I gave her another from my dwindling hoard. I thought she would kiss my hand, but put them both firmly behind me, stifling an impulse to embrace her. Her *grazie* was breathed out with profundity as she left me. I love Italians.

Light at the horizon turned orange, then, growing red, it glowed like heated metal in a pure half circle at the earth's dark edge while overhead the wondrous sky turned purple; and I walked in the dark to our hotel, at peace with all I had seen and felt. How much more could one day's living give?

We went to Arezzo to see the frescoes of Piero della Francesca, done in a manner close to van Eyck but saturated with Italian light. Merlin had done fresco, and he devoured, inch by inch, the great ruined paintings in the apse of the rugged church. We'd been hidden for several hours, undisturbed, behind a large baroque altarpiece of swirling clouds and floating angels when a priest let us know he'd like us gone, so the church could be used for another purpose. The nave, dark even at midday, was full of people who'd come in without sound, each dressed in black, hands pressed together, hands and faces softly luminous in a stillness that doubled our self-consciousness as we stepped carefully around a large black velvet pall on the floor. At each corner of the dark square was a candlestick, head high, a burning candle soaring even higher. The pall more than covered a coffin, the shape visible underneath, and on this shape gleamed a wreath of white roses. A human skull lay inside the wreath. We were glad to ease out a side door.

Outside we found a bold masculine town on a mountaintop surrounded by an old Roman wall ten feet wide at its apex, its base many times thicker. Higher than Assisi, Arezzo's peak

looked on mountain country cultivated for thousands of years, the roads lined with poplars, golden yellow, and fantastically shaped because their twigs had been clipped for making charcoal. From the highest level we sketched geometry of house and field, orchard, vineyard, shapes of earth, and dark cypress trees like exclamation points punctuating everything.

Arezzo was famous in Roman days for its delicate clay products. We found a new pottery in operation on the ancient spot where a studious elderly man showed us its wares. There were few originals. Old molds, made by Roman artists and as hard as granite, were used to shape cups footed like flower stems, covered with human figures two inches high that surpassed in delicacy all but the rarest cameo. Many might have been called pornographic, being marriage cups and quite explicit about how a marriage is consummated. But the studious man assured me that the pornography was in my mind, not the cups, which were undeniably beautiful and cost only $1.25. I would have bought many cups, but my money was dribbling away, so I bought one, a bear hunt design, for my mother.

Rome was noisy, fast-moving, crowded, and dirty. We didn't like it. After the hill towns, from which we could walk into a peaceful landscape, Rome was too much for us. If we had known more of its history, we might have taken it more to our hearts. Lacking knowledge, we saw only with our eyes; a great number of churches, Christian churches. You could see how capitals and columns, marble facing, and even plain stones were filched from the magnificent pagan buildings of ancient Rome. We wondered who had done the most damage, good Christians or wicked Vandals. I think only one Roman building is structurally intact—the Pantheon. It hulks on a street like any other city street, but is unlike buildings found in London, Paris, New York, or Washington. It's walls are twenty feet thick. Without steel the Romans relied on massiveness to raise their buildings to grandiose height supporting domes or vaults of stone, buildings echoed in Paris, London, and Washington, where domes were

once significant. The half-ruined Colosseum bored us with its endless repetition of arch and column, but we were staggered by the size of the stones inside that form its massive anatomy. How did they get one on top of another? We found no more of ancient Rome to look at, except the triumphal arches and the melancholy fragments in the Forum. Is there more? Trajans' column? The sculpture on it compared poorly to Rodin in Paris and to the vital energy of Florence. The lettering, though, was elegant.

History is piled on history in Rome, most of it brutal. The religious face of Rome left us unthrilled. Ostentatious swirl of baroque and gold leaf, part of the mood that prevailed when the Church emerged triumphant over heresy, seemed a continuation of brutality. We smelled corruption wherever a stone angel sprouted, and they were everywhere! Canova was as insipid as Raphael in spite of the undeniable skill of both, and Bernini we detested. Skill is not the aim and end of great art. What is? We could not quite name it, but we knew Michelangelo had what we wanted to see. We got on his trail and looked at all he did in Rome. Now when I hear from tourists who walk in lockstep beneath his thunderous ceiling, I think of those days when we broke our necks looking at it, no one else there. December must be a good time to see it; the best year was surely 1929. The Sistine Chapel had been so great and powerful, so full of gigantic conviction that it was a letdown to feel nothing in St. Peter's except disgust for its ostentatious display of power without love. Even Michelangelo's beautiful *Pietà* failed to move us, its elegant dead-and-live gestures seeming more like ritual than actuality. I thought of Chartres with nostalgia. How does a religion with love left out of it exist? When I read Michelangelo's irate declaration that he'd take no more inferior mortar for this house of God "even if it were delivered by angels," I could sense the frustration of this giant who walked among pygmies, and smell again the cynical corruption of Rome, with its theatrical display. Gold leaf and swirling decoration filled endless corridors in the Doria. We used our hands as blinders to keep

from seeing it, till we found the pope that Velasquez painted with a simplicity and directness astonishing to the Italians and to us.

Rome is full of copies of Greek scuplture. It is possible to view them with varying degrees of interest, but when I encountered something that filled me with an intense excitement, I discovered I could be sure a sculpture was original Greek. Such was the mutilated Belevedere torso in the Vatican which Michelangelo is said to have loved.

Who wrecked the great ruined baths of Diocletian that now house a museum called the Thermae? Here we found other Greek marvels, and here we were flabbergasted with the building itself—walls twenty-four feet thick that once supported a vaulted ceiling as high as that of Grand Central Station in New York and as wide. All this just to take a bath in! In one of the smaller rooms was the joyous serenity of Venus rising from the sea, carved on what is called the Ludovisi Throne. As beautiful as Botticelli's Venus in the Uffizi, it, unlike his painting, is without any hint of sadness. The Venus of Cyrene stood in another room, young, and lissome as a reed in the wind, her head and arms gone. Merlin and I were both undone. She was unspeakably beautiful. He watched at the door for a guard while I climbed the pedestal and embraced her. I did the same for him, and Merlin, tongue-tied, heaved a great sigh. She was not *a* woman, but *woman*, not alluring, but powerful, her power a natural force beyond her manipulation, and our maleness responded. We learned later that another man foreign to Italy was once found embracing her. Jailed and beaten, after the Italian fashion, the culprit was presently discovered to be Auguste Rodin—in his maturity, at the height of his fame.

I was leaving an ancient city dominated by one man. Michelangelo, who for all his unrelenting toil and supernal genius was not happy. He didn't love a woman. And strange Leonardo! He loved women, but how? As saints? I felt I'd rather be me than either of those giants; and Raphael's saccharine sweetness disgusted me.

Mississippi Artist

Titian was something else, so normal, touching things inside you—things you were hardly conscious of. His love for women was normal and so was mine. What was my love doing now, and what was she thinking? Damn Charles with his cool million! No use asking why she'd married him; her family! Had they locked her up? How many times we'd said goodbye, then slammed together like magnets—no power to resist. Then I at the foot, she at the top of the stairs, people passing, she trying to look away, wringing her hands. I was still tortured, not making any sense— O God, just one time more to touch her!

I looked in my bag for Dante's *Divine Comedy* to try to rid my mind of futility. No more romantic coastline to watch out the window, too early to doze upright on a hard seat, though one old man, with hooked nose and fierce eyebrows had bent his bronzed head into his beard and mercifully was gone. His thick coarse hair was gleaming white. He wore a voluminous cape of brown wool, his broad-brimmed hat clutched on one knee. Putting Dante aside, I sketched the man, but my mind was not free of its bondage, and I couldn't get it right.

Then the door of the compartment opened, and a young man, the brakeman I guessed, put his head in, a nice head with teeth as white as paper. He saw my book and, seating himself beside me began saying Dante got all his ideas from Vergil and Vergil derived from somebody else. I could barely understand him, for he spoke only a little English. He asked what part of America I lived in, and I said Mississippi. He pronounced it Missy-Pee-Pee and went on to name the states he knew—Massacutes, Novo Yorka, and O-hee-o. He wrote in my sketchbook the Italian names of things I'd drawn. So friendly, so open he was, I thought again how I loved Italians, and when a lurch of the train sent the old man's hat rolling to my feet and I handed it to him and he said a profound "Grazie," with a wide flourish, showing teeth as white as the brakeman's, I loved Italians more, and thought of God without cringing.

What had happened simply happened—coincidence. I'd seen too many painted deities in Italy to believe that God had a

man's face. Man had created God in his own image. That He'd approve anything done to clear one's own conscience, guilty even as Lancelot's, I could believe. But why do we say "He"? Why don't we say "we"? I could do portraits. A knack for likeness I *had*. If I could make a living at it, would she divorce Charles? Everything would be all right then. She must—she must. At last I slept, sitting bolt upright on a hard third-class seat, all thought dissolved. I was healthy. Then someone sang a snatch of Verdi, and I was back in Milan on a long street with clotheslines across it, doors and windows open, music from La Scala, by way of countless radios, stirring the air. When they came to "Donna e mobile" everyone, everywhere sang—as Verdi knew they would. Ah Italy!

Return to Mississippi

From the time I was in the sixth grade I wondered where my land was. Brookhaven? Chartres? Green England? Italy? I felt homeless as New York's tall buildings loomed larger and larger, like stacks of money piled into the sky. The sky was the space around the globe, a portion of it Italy's luminosity. Here, it was thick, smoky, soiled; I was not thrilled, but homesick.

We heard about the Wall Street crash on the *Olympic*, but we gave the news little attention. We were too busy telling each other how sad we were to be leaving Europe, or trying to squeeze one last bit of adventure out of a four-day crossing of the Atlantic. But the stock market had fallen to the bottom, and after we docked we read the newspapers: fortunes had tumbled, men were committing suicide. I was not concerned for myself, possessing almost nothing. I had just enough money to get home if I took a day coach and didn't go near the diner. With two Hershey bars to allay hunger, I boarded the first train out and got to Hattiesburg, still thirty miles from Columbia, with five cents in my pocket. Investing that in a phone call, I got my sister Mary to drive the thirty miles to meet me. I was flat broke, and I stayed that way for six months.

Prices of everything went to almost nothing, banks failed, and servants worked for a dollar a week for anybody with a dollar to pay them. There was a job opening nowhere, and a job might be lost any day. In my old studio in the backyard was a hoard of paints, brushes and, canvas, picked up, derelict, when I janitored at school; I had rolls of wallpaper to use when canvas gave out. I painted myself over and over, using a mirror to learn all I could about painting a head. My mother said flower paint-

ings might sell when nothing else would, so from her yard I painted larkspur, mountain laurel, roses, poppies, and nasturtiums. Occasionally someone in Columbia sat for me. After six months of this the Mississippi Art Association asked me for a show in Jackson. I couldn't believe it. I borrowed thirty dollars, and my brother Wiley drove me to Jackson with a carful of paintings. It was August, 1930, and the depression was at its nadir, but seven of my paintings were sold. The highest priced work brought thirty-five dollars; suddenly I was rich.

Mrs. Ruth White was hostess of the Art Gallery. She was then seventy years old, a fact now hard to credit. Her father had operated a private school in Jackson, and since my father, as a small boy, was a student there, she was particularly interested in me. A cultured lady out of a bygone era, passionate, with an inner drive that wore her body out, she never gave up on anything. She'd once been round the world with a wealthy uncle and had seen many of the great paintings. After my first show she became the most important factor in my life, and though she has been gone many years, I am still conscious of the great debt I owe her. She sold nearly all the things I painted and almost as soon as I brought them to her, still wet. They were flower paintings, and she inundated me with flowers to paint, making women eager to contribute their most cherished blooms from their gardens.

There was no real art gallery. A Mr. Gale, disgusted with his family, had willed his home to the city. It was on North State Street, where "quality" people lived. Opened to clubs eager for a place to meet, the Art Study Club, moved by the ardor of Bessie Lemley, who taught at Belhaven College and worshipped art, siezed the opportunity to hang exhibitions there. It hopefully was called a gallery, and immediately complaints rose about club women cluttering up the place when one wanted to see pictures. Mrs. White maintained her own small gallery at the back of the house, dragging in club women to see my stuff and anyone else's she might have. Thus, she was my main source of attention.

Mississippi Artist

In Italy art was as masculine as Lorenzo himself. It was hard to adjust to the femininity that sustained me here, though I could hardly quarrel with it, since sustain me it did. But I discovered many staunch friendships with women, even when it seemed I breathed in the atmosphere of Ingres's *Bain Turk*, with all the harem clothed. When William Hollingsworth came home from art school with a wife and a child, and yearning to go somewhere else, with no funds beyond pay from a WPA job, I was glad to have another male to talk to. When I convinced him that there was something worth painting right outside any window of his father's house, where he lived, he painted from every window in watercolor, with a style immediately personal. Onto the sidewalk, the city streets then into the country, he painted, with more and more depth, a poetry as masculine as Whitman's. We took over the gallery and tried to make it interesting to all tastes; the results were not encouraging.

My cousin Francis Wills, winsome, gay, and poor as a church-mouse lived in a house that was falling apart, with her husband, two children, and her mother. She was my favorite relative, and sometimes I thought I was in love with her. I could have an empty servant's room at the end of a back porch; I moved in, cleaned up the backyard, paid her thirty dollars a month, ate with the family, became one of them. With the backyard clean, and a garden planted, we tackled the house. We covered all the roses on the wallpaper with calsomine and did over the nondescript furniture she'd inherited. Willie, her husband, took an interest in refurbishing that he's never lost. We removed a partition, with much labor and with every penny we could scrape made an interior, high ceilinged and dignified that everyone called beautiful.

Meanwhile I painted. I may have made a thousand paintings of flowers—painting as if my life depended on it, which it did. I was learning much about light and color—the primary problems of portrait painting, and flowers didn't talk back. A Mr. Hodson, from Chicago, came every year to my studio, and,

gradually, he acquired nine of my best paintings. He interested Chicago galleries in what I did, and I got an invitation to show there, making a great hit. Mr. Schook took his class to see it. Elinor Jewett, critic, raved in the *Tribune*, and a new market opened for me. I inquired of the most prestigious gallery in New York in 1935, how one could get shown in such a place. The woman in charge said she recognized me as an artist by my Renoir clothes, and asked where I was from. I told her I was from Mississippi, and she asked if I sold my paintings there. I answered yes, and she said, "What do you want to send them here for? We don't sell them." After that I stopped looking for real support outside Mississippi, where I could see my advantages.

Then portrait orders began to come in; debutantes by the dozen, most of whom had little on their minds other than themselves. How beautiful they were. My full-length painting of Anne Sullens, daughter of the prominent newspaper editor Fred Sullens, moved him to give me publicity as a man who'd pulled himself up by his own bootstraps. I was conscious I had, but couldn't forget all the help I'd gotten, nor the fact that everyone I knew seemed to want me, a home-grown boy, to be great. This feeling I still strive to live up to. I painted the editor's daughter twice; the first canvas did not satisfy me.

Since that beginning I have painted all kinds of people who have told me things about themselves. I painted Colonel William Davis, a West Pointer who had lived in every country but Australia. A large, handsome man, he sat in full-dress uniform with sword. He'd been a young officer in the Boxer Rebellion and, when that was over, took troops into Tibet where the natives had never seen an occidental. In a Tibetan chief's tent, he packed his pipe for a smoke. The chief's wife produced her pipe, but it was so small she could take no more than three puffs before she had to refill it. He saw her envy and hoped she'd not ask for his pipe; he'd have to give it to her. She didn't ask, but she called three of her children and lining them up, told him through an

interpreter he could have any one he chose in exchange for his pipe.

"What did you do then?"

"I didn't want any of the dirty brats. I was free to say no and kept my pipe."

Painting people told me things that flowers never could. I worked hard, made money. Many people were working as hard who earned practically nothing. Mrs. White, for indefatiguable work at the gallery, got forty dollars a month. Schoolteachers' salaries dropped to the same figure. When I had enough funds to enlarge the place I slept and painted in, a seasoned carpenter with a family was glad to get twenty-two dollars for two weeks' work. For me, life was a picnic. Painting was fun, building a reputation an adventure. There was no pretense in our household. Frances ironed Willie's shirts in the handsome living room. When friends dropped in, she'd say, "Sit and watch me iron." They brought her their children's outgrown clothes, which her small boys in turn outgrew. Then the garments were traded for vegetables hawked on the street. We bartered everything, and nothing was thrown away.

With friends we had picnics at night, as simple as we could make them. Taking the food everybody contributed and something to cook, usually hamburger, we went beyond the city into the dark, which enclosed the firelight, shutting out everything else. We lay on blankets, talked, sang, or simply relaxed far into the small hours. There was no liquor—we couldn't afford it—no drugs and no sex. Instead we had a healthy comradery that exists where friends are cherished for what they are and everything is natural. We could hardly have a picnic without Louise Green. Few people have her capacity for enjoyment. She was true as the plumbline that seemed to exist at her core. Without a single affectation, she was large-hearted and beautiful, without vanity. I fell in love with her in spite of the difference in our minds. I wanted to know all I could, "beyond the utmost bounds of human thought." She was content to be what she was without knowing anything else. For rare people this may be

wisdom, a wisdom that outdates philosophy or even thought; it may be aristocracy. She wisely married a man who was much like herself.

When Jack Weatherwax, who had been my roommate in Chicago, came with his wife to visit me and to see as much as he could of the Old South, we organized a picnic for them. His curiosity about the interior of an antebellum house brought an invitation from Louise to visit her grandfather's 150-year-old North State Street mansion. There were, among other things, Chinese matting; bronze statuary; carved teakwood; and, upstairs, a bed, monstrous and wide, with posts, carved roses, and a ladder that came out of the side so you could climb into it. Jack paid little attention to anything, however, but Mr. Green giving his undivided attention to us. Up to this, I hadn't quite believed in the Old South tradition. Here it was, embodied. It took Jack, whose home was in Illinois, a half hour to stop saying as if the breath had been knocked out of him, "Nobody's *ever* treated me that way."

Talk about family and forebears, quality, and pigtracks left me cold. There was too much of it. When Natchez began its pilgrimages, there was more. Unless you had a Confederate general in your background, you weren't anything. But the pilgrimage itself was enchanting.

From her mother's trousseau Mrs. White produced an antebellum dress actually made "before the war." It had a wide skirt of yellow silk brocade. She sat for me in it, and I produced a large, glowing canvas that took several prizes. When it was bought by the state to hang in the Governor's Mansion, my prestige leaped. As a result I got many portrait orders. Such luck was convenient. In 1932 my father lost the job he'd held for thirty years with the lumber company. I gave him all the money I had, and not without reluctance; but his extremity was hard to grasp. When I realized how desperate he was I sent him money every month, and my brother Wiley did the same. Dad managed till the World War II economy boosted the business he'd started. He had sent me, bit by bit, fifteen hundred dollars

to get through art school. My contributions to him more than wiped out that debt, and I gloried in the freedom of owing no money to anyone.

I may have had other debts. I was bent on making something of myself without reference to forebears, but I wondered—not very seriously—about heritage. My father's father is said to have owned a spread of land twenty-five miles wide. Apparently he never worked, trading acres for fast horses and fine dogs, and trading all of it away, till his wife, with her truck farm and dairy had to support him. Aristocratic gentleman? Not for me.

At Dixie Art Colony near Montgomery, Alabama, to which I was invited in the summer of 1938, there was a woman, well dressed, though most of us were near naked, carefully coifed, soft skin never in the sun, though the rest of us were brown and sweaty. She looked like she had lived about forty comfortable years. Here, near the still beating heart of the Confederacy, was talk of Old South and aristocracy such as even Jackson never knew, and this lady never stopped, though there was something about her that said *parvenu*. Finally I asked her what an aristocrat was, and she immediately replied:

"Someone who is used to the finer things of life."

"What are they?" I pursued.

She had to think a minute before she answered, "O, good food, good furniture, good dishes." I looked at Sally B. Carmichael, who selflessly ran the place. She was dressed in something she might have borrowed from the cook, and she had a shovel in her hand improving the drainage outside in the rain. Her face was as grand as Lincoln's; she kowtowed to no one, completely sure of her *place*. "Junk," I decided and stopped thinking about any of it.

When I had arrived, somebody slid down a tall tree and ran into a large building. Later I learned it was a female screaming, "Girls, it's a man, get your lipstick on." Next day was Sunday. After dinner I sat in the studio and tried to talk to a girl with beautiful blond hair and no lipstick. We were alone all afternoon, during which time I saw nothing but her profile and one

58

(Above, left) Little Miss Fair, ca. 1968. 20" x 24". In possession of her parents. (Above, right) My daughter Elizabeth, 1952. 20" x 24". In my possession. (Below) Lorna Margaret and Louise Hallam Lyell, ca. 1969. 45" x 30". Owned by Mr. and Mrs. Louis Lyell.

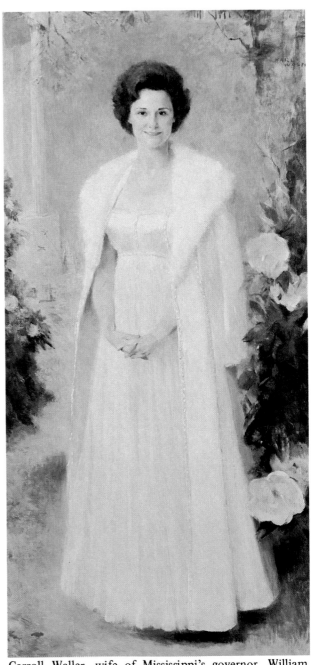

Carroll Waller, wife of Mississippi's governor, William Waller, 1972-1976. 72" x 36". The Governor's Mansion. I painted this large portrait after I recuperated from a stroke in 1975.

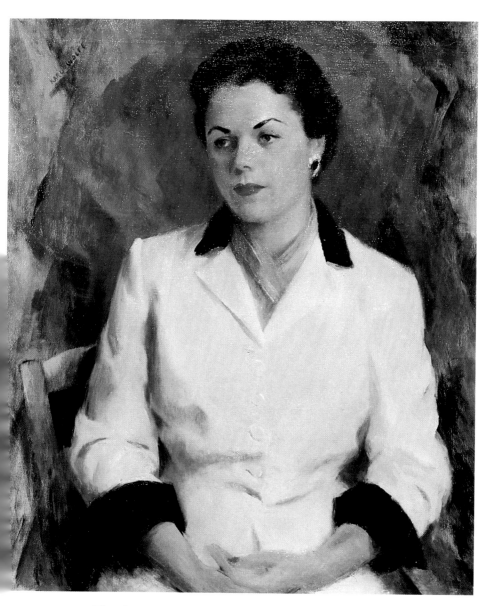

Theo Inman, ca. 1950. 24" x 30". Owned by Theo Inman.

A stained glass window that I designed for the Presbyterian
Church, Columbia, Mississippi, ca. 1950.

(Left) A glass mosaic, ca. 1955. 24" x 30". Owned by Mrs. D. C. Latimer. (Right) Ceramic mosaic made by Mildred and me, 1975. 18" x 16". In our possession.

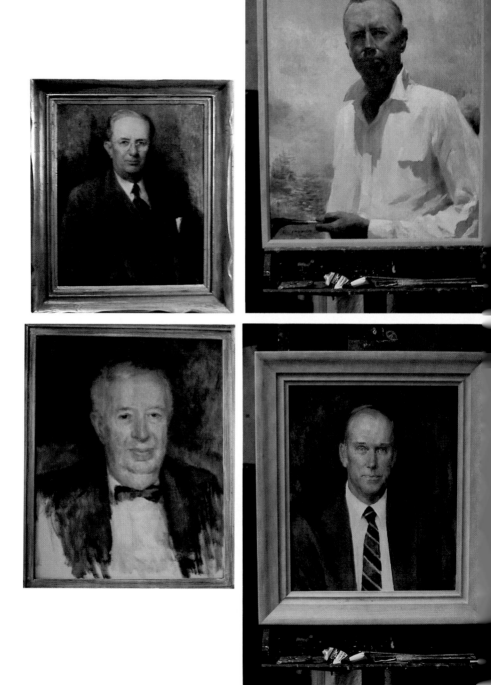

(Top, left) L. O. Crosby, ca. 1965. 20" x 24". Mississippi Hall of Fame, Old Capitol, Jackson. (Top, right) Dr. Gus Street, Vicksburg, Mississippi, ca. 1972. 20" x 24". In my possession. (Bottom, left) Garner Green, Jackson lawyer, ca. 1955. 18" x 12". Owned by Myra Green. (Bottom, right) Dr. Robert Sloane, 1979. 20" x 24". University of Mississippi School of Medicine.

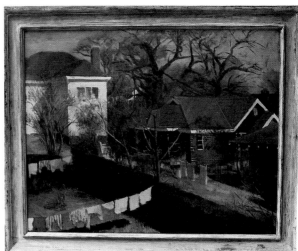

(Above) Cabin, ca. 1948. 20" x 24". Owned by Dr. Thomas Blake. (Left) Chrysanthemums, 1978. 24" x 30". In my possession. (Right) View from Congress Street studio. 24" x 30". In my possession.

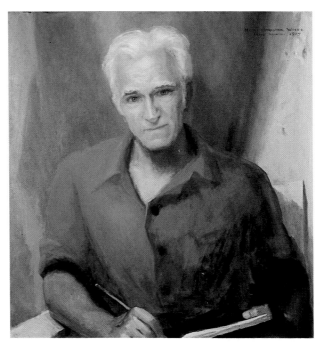

A portrait of me by Mildred Nungester Wolfe, 1976.
20" x 24". Owned by the artist.

very blue eye. I decided she was not my type. I didn't go for blondes and this one seemed frozen. Her paintings were easy to identify; they were the best there. I tried to talk to her about them, but the only thing she said to me was no, and as the afternoon wore on, her no's came before I could finish sentences. But she didn't leave, just acted as if she had as much right to be there as I had, and I could see by her work that she did.

The colony was near a river, deep in the woods, in rough buildings and with no la-de-da to come up to. I could wear swim trunks all the time and nothing else. In the powerful southern heat everyone dressed as scantily as possible. We swam in the river, and on special occasions we'd take a lunch in a motorboat and go to a deep black pool fed by water that fell fifty feet with a great roar. We loved the place as something sacred.

Kelly Fitzpatrick was the life of the colony. A veteran of World War I, he was the sole survivor of a whole company, and finding himself alive, when he should have been dead, he determined to treat the rest of his days as if each were a special gift. He laughed continually. All he took seriously were art and courtesy—knightly courtesy to people who bored him. Materialism he disdained, responsibility he'd have none of, even refusing to drive a car. He laughed at politics, business, status, ambition, ego, pride, vanity. When someone came to the colony too stilted to bend to its informality he shot off firecrackers in the fireplace or threw rocks on the tin roof, till the taut one either relaxed or left. It was impossible not to love him. He made us feel like kids at a circus.

Lucille Sharp came from Jackson at my urging. A frail, small woman, her high-pitched voice and fluttery manner belied the hard-rock stuff inside her. When we had a Chinese party, the rest of us spent a day making headdresses of paper, costumes of bedspreads, and sat on the floor in gorgeous array to eat. Mrs. Sharp came in black shoes, stockings, skirt to her ankles, collar up to her ears, a small black hat square on her head, a Bible in her hand, and announced that she was a missionary. She had a Baptist soul and seemed to be the perpetual president of the

Mississippi Artist

Women's Christian Temperance Union. When Kelly spent a day creating mint julips and we sipped his delicious concoction, Mrs. Sharp kept painting away saying calmly a dozen times, "Spirituous liquors shall never pass my lips." She died alone and unafraid in her elegant house. I felt her heroic spirit many times before her death and came to admire her very much.

Before I even arrived at the colony, a match was planned between me and the chilly blonde. That's why we were left alone the first day, why she would have none of me. I was old, she thought, fat, and a bald spot showed when my hair was not carefully combed (I was thirty-five). Mrs. Sharp, determined to see something happen between us, sewed up Mildred's torn clothes, saying, "What will Karl think, Mildred?" Mildred was quite indifferent to what Karl thought, having nothing but painting and her own independence on her mind. She was silent most of the time. Her face had an abstract far away look, very beautiful, and lying on the diving raft in the sun, she was a golden goddess, full-rounded. She painted with rapt concentration as if her world were separate from ours, seeming never to hear trivial conversation. She did a watercolor with swift intent and great economy, and she did two while we struggled to finish one.

Being snubbed was a new experience for me, and ignorant of the reason, I thought up brilliant things to say when she was within earshot. Interest might flicker in her eyes, and sometimes her swift sharp humor felled me, especially when I expounded on what I thought was incontrovertible. She caught what I meant before I finished saying it, then gave it back with an unpredictable new slant. She was more interesting than anyone else at the colony, and I could see her respond when I said anything that wasn't usual. Gradually she thawed, and we became casual friends. One night when I sat in the kitchen door, singing with the ever-singing colored help, I felt someone at my back. It was Mildred. Bit by bit we knew there was something between us, something shared, though she still made no effort to attract. We were real friends when the colony ended, but it was strictly

intellectual. I thought of the kind of wife she'd make but I never touched her. I was totally unaware of her depth of passion and never dreamed that she resented being attracted to me physically. Neither of us had any idea she'd someday be my wife, and it took years for me to realize that she and no one else should be. What she was really like would take me a long time to know and appreciate. A very exciting woman, Mildred.

So little did I know, so little. All the way to Chicago that winter in 1939 my heart sang, "You, you, you." I had received a letter saying *she* had something *she* must tell me. After ten years I was still in love with the same woman. My efforts to fall in love with another woman had come to naught. Coincidence had played a dirty trick on the mad passion that would never come to me again. Would I ever think of another woman as *she*? There was no more million dollars, the depression had wiped it out, and Charles could be lived with no longer. There was another man who loved her, would be good for her, but she had to see me. How love could be anything but blind and unreasoning I did not understand. But for a woman with two children I felt there had to be sense, somewhere. My soul said, "Love, and ask for nothing. Love is all you have to offer."

Standing at the 63rd Street station, she looked the same; waiting to be crushed by my arms that slid beneath her heavy coat. She smiled in a way that looked melted for a moment—but only for a moment. At her apartment she held me away. I must see the children. No one had any money, even her father, who could sometimes be depended on, and Christmas would come next week—what could she do for them? I could give her $150, half of what I had in the bank. She didn't protest—it was as if I had reacted as she knew I would. And she didn't melt again but looked searchingly at me.

Jim, the other man, came to supper. We were careful to be civilized, and when he left for a night class (he was a medical student), she became very busy clearing up—while I talked to the children. Her father was due at nine o'clock; she'd engaged a

room for me around the corner at the Harvard Hotel. Wouldn't I please be gone by then?

Next day we visited places that in my memory were sacred. She was unmoved. Yes, she did love me, but because she needed to be dominated she would marry Jim, and she gave me two sleeping pills. In spite of her pills the shape of hell grew in my torn mind that night, and hopeless, I slid into it.

I was living a melodramatic sort of life—half-conscious of its melodrama but *living*. I actually thought of cyanide as a poison that kills immediately. I'm not the first man who has wanted to die because he was denied love, and I can remember to this day the anguish I was filled with on the long train ride back to Jackson. I also thought about the misery my suicide would cause and how by then I was actually needed by my family. This helped to stop suicide thoughts. But Frances brought me to my senses. She said, with deepest sympathy, "Don't leave the people who love you and need you. You've got to choose to be happy, no matter what. The most wonderful things can happen to you; you will be miserable without this deliberate choice." I am grateful to her yet.

So I chose happiness and began a long fight for it. At this crisis in my life I had to decide in what manner I'd live the remainder—what would give me satisfaction. I looked at drunken debauchery, even tried it and was quickly bored. I tried an affair with a woman I couldn't love and found that too messy. Dishonesty was the trouble with that, so I embraced the honesty I had to find in my painting, an honesty that even scorned the soft and flabby image of myself that I saw in the old mirror that hung in my bathroom. Socrates spoke to me then saying what a shame it was for a man to live and die without knowing to what perfection his body might be developed. I thought I'd better hurry. A physical fitness book by Artie McGovern told me what to do and I did it faithfully. The difference in the way I looked was noticeable; the difference in the way I felt, pronounced.

I attended Dixie Colony two more summers before anyone noticed my new physique. Activity there lasted only one month,

Return to Mississippi

so for July and August I headed for Chester Springs, Pennsylvania, where the Pennsylvania Academy ran a summer school. Mississippi had no air conditioning then, and bus fare was cheap. Along the way I found myself beside a girl reading a *Redbook* magazine. Turning the last page, flipping the magazine into the baggage rack, she looked at me and asked, "Where are you from?"

"Jackson, Mississippi."

"You are? I went to school in Jackson, Belhaven College. Do you know Miss Lemley?"

"Yes."

"She was always raving about Karl Wolfe. You know Karl Wolfe?"

"Yes."

"Ever been to his studio?"

"Yes."

"I missed going when the class went. What's he like?"

"Oh, he's all right, I guess. Morbid."

We talked then of other things, herself mostly. She had a droll humor, an innocent, rather ignorant look on her face, just growing out of gawkiness. Her chatter diverted my lonely thoughts and was welcome. We stopped for lunch, and when the bus started again, everyone went to sleep. About two o'clock, as if by signal, we woke up. The girl looked at me and asked, "What's your name?"

"Karl Wolfe."

"Oh-Oh-Oh, what did I say?" and she clapped her hand over her mouth. Then, "I don't believe it."

The library card in my billfold identified me, and we both laughed and enjoyed the situation. When we got to Washington, we were laughing as if nothing but fun existed. But looking from the bus station at the traffic, and listening to the noise, she was terrified. She held my arm and pleaded, "Don't leave me."

I thought she should call the old-maid aunts she was to visit and had never seen, but the dial telephone was new-fangled to her. Again she didn't know what to do. I dialed the number,

hailed a taxi, and made her promise to meet me at the Washington Monument next morning. That night I thought of some perverse satisfaction to be gained if I, like a character in a Chekov story, should seduce her. But I wasn't quite sure how to go about it, and next morning when I saw again her innocence, knew I couldn't. We went on the Potomac to Mount Vernon, had innocent fun, and when we got back, I felt that she loved me as an uncle. For twenty years I got her Christmas cards from Booneville, Mississippi.

A year later I sat on the frontseat of a bus going through Tennessee. A girl with red hair and a face as old as mine got on, her arms loaded with ripe peaches in paper bags. I was neatly dressed, wore horn-rimmed glasses and a new hat, and read *Time* magazine. My temples were graying. The girl got inside the bus and, looking at me, said, "Either you are an intellectual or a movie star. [Movie stars wore horn-rims; intellectuals read *Time*.] I don't care which; I'll sit by you."

In less than ten minutes, after we settled the peaches on the floor, I learned she lived in a decaying hundred-year-old house with her aged mother and invalid sister, taught school, had just been to the dentist, and all her teeth ached. She hated her life, and I urged her to stay on the bus with me, willing for an instant to throw our two sad fates together. She was alive, very alive, and not even at her best.

"What would I do for clothes?" she said, taking my proposal as seriously as I gave it, and for a minute her eyes looked wild, as I hoped they would.

"I'll buy you some."

She looked away from me and said half under her breath, "What would they do?" then back, her eyes full of decision and regret, "My house is only a few minutes away. Hold still while I look at you."

She took two peaches from a bag and held them on her palm. "I'll give you these if you promise not to eat them till I'm off the bus."

"Why?"

Return to Mississippi

"I like the way you look now. I'll never see you again. I don't want to remember peach juice running down your chin."

Then she was gone.

Chester Springs was idyllic, lost in green hills with pre-Revolutionary buildings, but the females there were girls. I needed a woman.

Would I be forever haunted, everywhere, by that face turned to mine at the Chicago station as I waited for my train back to Jackson?

"I'll never see you again," I had said and her eyes grew round as her mouth dropped. What did she expect? Was she doing me a favor? To erase, to erase, to erase, all her looks—how was it possible? Another woman to love? I tried. A gorgeous brunette was at Dixie the next summer. I knew nothing about her, but a powerful physical attraction was immediately between us. I tried to stay in love, but the infatuation didn't last six months. Suddenly, I knew Mildred was in love with me. She shouldn't be. Why couldn't she stay lost in her own world and become a grand painter, unbothered by the itch we call love.

Then I was drafted into the army.

The Army:
Bad Times, Good Friends

When the long train out of St. Louis began slowing for a stop and a young voice said, "Maw, we gonna git off here?" and a woman's voice answered, "Ain't gonna git off here, ain't gonna git off there, we gonna git off yonder," with the yonder as long and sustained as an old-fashioned train whistle, I let go my sour, insistent thoughts and looked at them; girl about fifteen, baby clutched under one arm, a dark, quiet girl beside her, a midden of newspapers, bottles, and candy wrappers under their seat, across the aisle from me. Had they slept on the train? To be assured of a seat I'd waited an hour and a half in the station, was the first person through the gate when it opened, but they were settled in the empty coach when I got on, the trash under them then.

"Maw" reclined before me, her face turned up to the ceiling, her head on a pillow over the arm at the end of her seat.

"Eleanor," she said, "gimme a drink o' water—don't pitch it this time, just hand it to me."

How do you pitch a drink of water, I wondered, suddenly alert to them. I stood up, ostensibly to straighten my jacket, but really to get a good look at the woman in front of me. She was hardly more than thirty-five, I guessed, her body as lank as a cut weed, her eye-sockets deep and hollow as a falcon's, the dark, round eyes in them moving with a hawk's fierceness.

The drink of water came from under the seat in a Coca-Coca bottle half full. The girl held it and the baby with her right hand, saying, "Maw, pitch me a orange first."

A paper bag rattled, an orange ascending almost to the ceil-

66

ing described a perfect gothic arch plunking solidly into the girl's left hand. She transferred the fruit to her lap, then stretching her slender left arm as far as it would reach, held the bottle just behind the woman's head, which didn't move. Instead a lank arm raised itself and a long hand groped for the bottle. The girl said, "Take it Maw. Franklin's about to fall out of my lap."

The woman's smallest finger found the bottle's neck. The girl let go and the woman's arm started lifting the bottle over her head, slowly, like a hoist. When the arm was almost perpendicular the bottle slipped from the precarious grasp, rolled across the aisle, and disappeared in the midden. The woman slid off her seat. On hands and knees she reached into the trash after the bottle. A sailor stepped across her middle. There were thirty people without seats, squirming up and down the aisle or sitting on luggage—I'd counted. Bottle retrieved, she said, rising, "I'm going to the tawlet, don't let nobody git into my seat and step on Warren or Judy, it'ud kill em."

It must have been Warren who stood up then, a pale empty-eyed child in awkward, too-big pants, sucking a Baby Ruth. I couldn't see Judy who evidently slept in the pile of small garments on the floor in front of Maw's seat. The woman returned, beat her pillow, and sighed, "I gotta get me some rest," and resuming her supine position, slid her stockinged feet slowly up the window glass as far as they'd go. In this position she rolled, one-by-one, three small garments into tight balls and pitched them expertly into the baggage rack overhead, seeming thoroughly to enjoy her skill.

"What'd they name that new calf over to the Bilbo's, Eleanor?"

"Eleanor Roosevelt," both girls said, at once, with indignation.

"Aye Gar, I wouldn'ta named no animal that. That's what I almost named you. Yo' name is Eleanor R., I just left off the oosevelt."

But Eleanor was talking to a young soldier who sat slimly on the curving arm of her seat.

"Yeah, this is the first time I been on a train, but I've rode buses, lots of times."

The soldier laughed and moved on.

"This is a lot better than a bus, ain't it Maw?"

"It dang shore is. Wisht I had two seats put together, I'd sleep all the way to Springfield, Utah."

"Wisht I was Eleanor Roosevelt, have my own private aryplane. Hey Maw, make Frances and Perkins let us play with the cards some."

Two faces looked over the back of the seat in front of Maw's. They were identical.

"You got to give us the cookies," one said.

A tired box of cookies was exchanged for a tired deck of cards, and Maw sat up, suddenly eager. "I'm gonna play too," she said.

"Aw Maw, we gonna play casino. You don't know how." Deflated, the woman sank back.

"Sin to play cards," she remarked to the ceiling.

"Aw Maw, tain't no sin to play casino."

"Yes 'tis too. Your paw said t'was and he's a preacher."

"He ain't my paw, he's Warren's paw, but he ain't my paw."

"Well you better start calling him your paw afore we get Springfield, Utah."

They held me spellbound, but the pain girdling my pelvis called for another aspirin. I left cap and jacket in my place and went for water, pushing by a woman in a fur coat who was saying to her husband, a major, "I thought they were supposed to give you a seat." I knew he was her husband—he looked embarrassed.

"They're not," he said grimly. "We'll have to stand."

They'd have to stand for me. Soldiers had their own secrets; no one outside the army knew about my mumps but my own doctor.

"There are two parts to a testicle," he had explained, "the orchis, that's the soft round ball and the epididymis, those wormlike things you can feel along side it. You've lost an

orchis. Well, that has the function of secreting spermatazoa, thousands of them, when you only need one to produce a child. So you don't have to worry about that. The epididymis gives you male characteristics, deep voice and so on. It's unharmed so you don't have to worry about that."

"When will the pain go away?"

"That's hard to say. You'd better take it easy."

"You've relieved my mind," I told him. It was a vast understatement.

The aspirin down, I eased back into my seat. I could see them standing, the major and his wife, a peeved look on her face. When the train began to lose speed again, they, with other passengers, edged slowly toward the exit at my end of the car. The woman had taken off her coat and was now waiting for a chance to put it back on, a very handsome coat. Warren, the pale child with a Baby Ruth in his mouth, stood halfway in the aisle by his mother's head. Her eyes were closed when it happened. The coat finally on, the woman had edged past the child when she took the front of the garment in both hands, giving it a vigorous shake that would settle it around her body, and it was this movement of the coat's tail that enveloped Warren. I couldn't believe it, two high heels followed by two small bare feet all under a handsome fur coat were moving, inch by inch, past me, without sound.

"Wha's Warren?" Maw shrieked suddenly awake. The GI next to me was asleep. Nobody knew where Warren was but me, and I, convulsed, could only point to the bare feet just visible under the coat's edge. Maw gave me no thanks, not even a glance. Stealthily she knelt in the aisle and grasping Warren's ankles in her two hands managed to pull him out from under the coat, without a backward glance from the woman who wore it. Warren emerged still sucking his candy. Maw hugged him violently saying,

"Law, child, yo pa'd a whipped me if I'd a lost you." Warren made no sound. His vacant eyes seemed to see nothing, the Baby Ruth glued to his mouth. Everyone near me dozed as

night fell. Maw's arm was around Warren in a lock-grip now, and I gave myself up to furious thought.

I was almost glad to leave Columbia and go back to Lowry Field in Denver. In less than eight months I had become a soldier, which meant that my closest attachments were to other men who were soldiers. Civilians had become a strange breed, people who still believed in fairy tales, to whom the truth had become unacceptable. I hated the army and said so. Anyone can say it now, but during World War II everything military was holy. Only Dad had sympathy. He said, "It's all hard to believe, but I'm here, you're there, you see it, I don't." To my mother, with her mystical ideas, I was blaspheming.

I didn't tell the people at home that the mess hall smelled like a hogpen at Camp Shelby where I was inducted, that it smelled a mile away; or how miserable it was to sit for four days and nights upright on a train from Keesler Field to Lowry in December. Nobody believed the United States Army could lose track of men who still lived on the post, but six sheets of typing paper filled with names single spaced were posted outside the squadron office begging the men to report. I would have gladly gotten lost with them, but I couldn't bear to be idle like Bill East who lay on his bunk all day and figured how to act crazy enough to get a section eight discharge.

A nice guy, a captain at photography school, sent me to Major Hill at the Film Strip Preparation Unit. Hill took me on as soon as I said "professional artist." Then there was Al Amman, a real honey, in charge of the retouch room where photographs of gadgets on airplanes were sharpened to register on the film strips that Major Hill mailed round the world. Al hated a dull moment, egging on an argument when things sagged, but getting the work done so well that visiting brass said we should all be commissioned. Commissioned!

A towheaded boy about nine now was nudging Maw awake with his knee. I let go my thoughts and watched. He looked sturdy and independent, chewed rhythmically. He held what must have been a bag of caramels.

The Army: Bad Times, Good Friends

Maw opened an eye and said, "Whatcha chewin?"

"Candy."

"Whar'd ya' git it?" Suspiciously.

"Bought it."

"Whar'd ya' get the money?"

"Gittin' cokes and stuff for soldiers." She tried to look into the bag, but the boy held it higher, higher, as she tried.

"Hoover, gimme a piece o' candy."

'Unh unh."

"Aw Hoover, please gimme a piece."

"Unh unh."

She turned her head away from him. Hoover chewed and swallowed.

"Hey Maw," he said, nudging her again.

"I ain't gonna talk to you; you wouldn't gimme no candy."

"Maw, I got to tell ya somthin," the boy persisted.

"Go 'way."

"I got to tell ya, Maw. It's important."

"Well, what is it?"

"They's a soldier in the next car says a man can't have two wives in Utah."

Maw sat bolt upright.

"Go tell him he's a damn liar."

Hoover turned slowly, too slowly for his mother. She gave him a push and pointed a straight arm and finger.

"Go on, tell him," she commanded.

An old lady clutched my seat and swayed. Her face was sweet. I gave her my seat and went in search of a place to lay my head. We'd be going all night to Denver. I slept on the restroom floor, and at eight the next morning when the train was in the Denver station, all my muscles were stiff. All my bones ached. I fell into the first taxi I saw. The driver was in military uniform. In front, next to him, I said, "Lowry Field."

"You don't mind if I get other passengers, do you?"

I didn't. He got two women, both fearfully overstuffed, and a little girl.

71

"What are you doing in uniform driving a taxi?" I asked when we got going.

"Doctors orders," he answered. "I've got tropical malaria and they thought I better have fresh air."

"You're a patient?"

"Yeah, ambulatory."

"What're they doing for you?"

"Well, I get shots once a week, but they said I'd always have it. They can only check it."

One of the ladies was saying, "I know they don't want you to travel, but I just had to see my little niece graduate."

"And you brought your little girl."

"No, she's my granddaughter. I thought she'd love the trip to Denver, but the train was *so* crowded. We made it though, didn't we darling?"

Driver: "See my fingers?" They were twice normal size at the ends. "Can't feel a thing," and he beat them on the steering wheel. "My name's Jerry Scaglione, by the way."

"What a darling dress."

"Isn't it. We got it in Kansas City."

Jerry: "But I got to stay cheerful."

Ladies: "You know that Chinese embroidery shop in Kansas City?"

"Yes. They haven't got a thing anymore?"

"I know it. My husband makes more money than he ever did, and there isn't a thing you can buy."

"There sure isn't. I guess we're all in it together." (She *couldn't* have said it, but she did.)

Jerry: "I hate for the night to come. Oops, here's one address." And we lost one lady. The one with the little girl got out in the next block. Lowry Field, outside the city, was still some distance away.

"Where were you?" I asked.

"I don't want to tell you, I don't want to think about it; I can't sleep with my wife."

"My God, why?" I knew I was prying, at the same time I

72

thought he might want to tell someone. He stopped the car and said, "Hope you're not in a hurry."

"No."

"I saw a whole company of men blown to pieces by one grenade. Blood was all over the trees; it ran in the ditches. I can't sleep in the same room with my wife because I dream—nightmares. I'm afraid I'll kill her before I wake up. I kill, I kill, I kill, I hate killing! I gotta stay cheerful though," and he smiled at me, somehow. "All of my friends were dead, I can't think about it. What do you do?"

"I sit all day and retouch photographs."

He started his taxi, picked up another fare, a girl from Pittsburgh, whom he knew, and they talked as if nothing were wrong with him. When she got out, he turned to me and said, "Thank you, I can't talk to everybody." And when I got out he shook my hand and wished me good luck, as if he had plenty of it.

At Lowry Field, Angelo Grasso and I ate breakfast together every morning, and nearly every morning he asked a question hard to answer. He was nineteen, and I, thirty-nine, was old enough to be his father. He thought I knew more than he did, and I guess I did, this being before the young were positive they knew everything. He asked once if I'd ever been acquainted with anyone who was great. Born in Philadelphia, he'd gravitated to a commercial art job in New York where millions of bodies moved over asphalt and concrete, infested countless buildings, or sped encased in metal of automobile or screeching subway in endless, enormous anonymity. His was a New York question. I said "yes," thinking of one man. Since that was all he wanted to know at the time, I wondered if Dr. John W. Provine, past president of an obscure Baptist college in Mississippi, could possibly come near Angelo's idea of greatness. That's who I'd thought of. *Great* and *famous* were separate words to me, with separate meanings. Dr. John Provine was not famous. He'd served one school for forty years, and I was commissioned in 1938 to paint

a portrait of him which would commemorate his retirement.

Mississippi College at Clinton was a "hick" school, a fact that Dr. Provine admitted. Once, long before integration, he invited the president of Alcorn College for Negroes to address his student body. The president brought with him another Negro, who, he said, had more to tell than he himself had. Could he turn the program over to him? Nobody at Mississippi College had heard of George Washington Carver, but that's who talked that long ago morning to a bunch of hicks. There was no sound from the audience, not even a cough, till two hours later when Carver stopped; then they clapped, screamed, whistled, and stomped their appreciation of the man who spoke barely above a whisper.

"Like a cloudburst," Dr. Provine said. "I've never been prouder; country boys! Nobody told them the man was great; they knew he was great."

"Does it take quality to recognize quality?"

"It certainly does. Rough as they were, my boys had it."

In 1938 Hitler had begun to eat Europe. The German people, a puzzle to the rest of the world, were still admired for past achievements in the arts and sciences. At the turn of the century, or before, when Dr. Provine had been a student at Heidelberg, German culture seemed the most advanced in Europe. How could they stomach a lunatic like Hitler, I asked Dr. Provine. What he told me suggests how easily the human mind, en masse, can be made to believe anything.

He was a shy country boy at Heidelberg. In the cheapest seats at the opera he sat with a scullery maid, who took her score along and sighed over the music, while he strained to enter this ecstatic German world so irrevocably closed to him.

"It was easier to talk to menials with my scant German. I socialized with the servants at first. The choreboy at my boardinghouse for instance. Later I made the acquaintance of an English girl. We were both glad to have someone to talk to. She lived in a respectable *pension*, run by a woman above reproach. Girls came there who had no social advantages at home and

were introduced to the most select society of Heidelberg. Alice and I were friends only, simply because we could laugh at the same things, never anything more. Never. One day I passed the house when the girls were sitting in the front yard. Impulsively, I asked Alice to go for a walk with me. She, with no more thought, joined me, and we walked into the beautiful countryside for maybe two hours."

Here Dr. Provine, looking very solemn, raised his hand.

"I swear I never touched her," he said tensely. "But when we went back to the house, her trunks were packed and on the sidewalk, outside the fence. The gate was locked and the mistress of the *pension* stood there. Alice would not be allowed to set foot on the premises; she'd disgraced herself."

"How?" I burst in, incredulous.

"She was out two hours with a man unchaperoned."

Dr. Provine's hair was nearly white and age resided in his wrinkled face, now troubled with infinite regret (fifty years of it?).

"I argued till I was blue in the face with the landlady. She wouldn't budge. Then I saw I'd not only got Alice in trouble; she had no place to go. I had to find her a room. I did that. Then Alice: she thought of herself as a fallen woman. I said all I could to make her stop. It was no good; she was ruined. She went back to her parents in India. I put her on the train. She couldn't stop crying. I corresponded with Alice for thirty years and never changed her mind. She died in Canada, still a fallen woman."

I could see in his eyes an intense losing battle, fought with stubborn courage. I think that's in my painting. Then he said, as if he'd revealed a shame: "You will see how even I was affected by the prevailing pressure there to conform. Alice and I were both innocent, but this is the first time I've ever told anyone this secret, over forty years old. I could not even tell you her name. It was not Alice."

Conrad's Lord Jim came to mind. Are monuments of fortitude built on compensation for mistakes? What could fame add

to one whose clear singlemindedness lifted him above all consideration of custom, prejudice, or applause.

For myself, even in 1938, nonconformism was an odd path to follow before it became stylish. An artist was not just an artist, the word *artist* was coupled with *queer* as *yankee* was with *damn* in Mississippi.

In the army, there seemed no standards at all, and against this arbitrary indifference we committed all our powers to maintain each his own integrity. When your mind got fuzzy with the effort, you could still gripe and say "I hate," but there were times when your mind ached from thinking, as Dr. Provine's might have. In this, I was not alone. On long trolley rides into Denver, more than one quiet-faced boy asked me quietly, almost numbly, "Do you hate the army?" My answer was always yes. The question that inevitably followed was, "Do you hate the army more than you hate the Germans?" My answer to this was yes. It was simpler that way. But often I asked myself what it was I hated. The war? Of course. Only men could have plunged us into this fiendish insanity. Did I hate humanity for it? Always, the answer kept coming up, *yes*, even when I thought of Chartres or St. Francis or Jesus. Were we incurable? Could we ever be innocent after Hiroshima? Dogs display forbearance, magnanimity, even rudimentary ethics. We name things; animals feel them. "Thou shalt not kill" was in their natures long before any commandment was written. It was necessary only to think of horses, sheep, goats, cows, and all the herding animals of Africa to see they did not kill their own kind as we did. How many men in the army were troubled by this ancient taboo that was deep inside their ancestors before there ever was what we call a mind or writing? How otherwise could we have endured, abolished slavery, built hospitals, or celebrated Christmas? How could we love?

"You will hate the army and love men in it," Kelly Fitzpatrick, back at Dixie Art Colony, had said, and I could get no further than this linked phenomenon, as if love counteracted the poison of hatred, was an organic necessity to it as systole is to diastole.

76

The Army: Bad Times, Good Friends

So I gave my affection to men who suffered my condition—
Al so much like a monkey, lovable, fair, and big-hearted. Bob
Quick, a Denver boy, serious and troubled with our whole col-
lective conscience. Guerin, so handsome the big brass always
gravitated to his desk to ask if he were in the movies. Milt, like
a dark cherub, Dillon—a farmer with a face made for laughing,
Sandy—a born Russian, the most sophisticated man I ever
knew—he loved Shakespeare and Beethoven! Bill Gold whose
beautiful wife said he couldn't eat in company when we asked
them to dinner—a clever artist who must have a million dollars
now. Schneeman painted with a brush in each hand. It was im-
possible to like him and Grasso whose gentle presence I enjoyed—
whose pink skin, gold curls, and blue eyes belonged to an angel
by Botticelli, whose head, not filled with bliss, was never empty
of inquiry. Indeed if you hadn't seen his halo, you mightn't
have known he was an angel. In spite òf his name and looks or
perhaps because of them, Angie's voice was tough, and he'd
built good shoulders and chest lifting weights. You walk mother-
naked many times in the army, and in a long line of nude men,
all looked as if each were a different species. Properly developed
bodies were surprisingly rare. I seldom showered without some
GI remarking, "You got a good build," and every time I heard
that, I said, inwardly, "Yeah, Socrates," with some iota added
to the confidence most of us needed in the army. The same
thing could have happened to Angie.

For confidence as well as identification, Milt Wright talked
about his famous uncle, Orville, whose achievement resulted in
aerial warfare and the shattering of beautiful cities like Dresden.
Milt and Angie, both nineteen, were friends, Angie's family had
once been evicted during the worst of the Great Depression,
when his father came home day after day with no job. His
father loved Caruso, and I could see on a long city street their
furniture, clothes, and Caruso records spilling across the side-
walk into the gutter. Angie seemed marked by a bitterness
connected with this event, a bitterness directed toward the
world's richest country in which such a thing could happen.

77

Mississippi Artist

Milt's mind spilled over with advanced ideas, half digested from two years in college. He read Proust, adored Picasso, and wanted to paint. What he said might have been new to Angie who seemed to have been raised a good Catholic boy in an Italian neighborhood. Many of Angie's questions seemed to reflect conflict between his narrow Catholic world and other concepts fomenting beyond it. Once he asked me why Renoir's nudes were not sinful. It was a surprise that anyone, even in the Vatican, could think they were, and I can't remember my answer, though it's impossible to forget the question, which more than thirty years, Hugh Hefner, and Linda Lovelace later, still lacks a definitive answer. Left alone, our normal lusts seemed all right to me, but when was anything left alone—especially lust? What the heck was sin anyway? The Presbyterian Catechism said it was "any want of conformity unto or transgression of the law of God." What was the law of God? "Don't dance? Don't play cards," as in Columbia? What about "Don't kill?"

A decade later, my own son, eight years old, shot a stream of questions at me like a firehose. One night as I slipped home in bed, my wife said, "Mike's looking at Billy Graham on television, and he is going to ask you something." Sure enough, Mike knocked. Prepared, I said, "Don't come in, just ask through the door."

"Think I ought to repent?"

I had an answer this time. "No. You're too young to be sinful; you just make mistakes. I'm sinful because I'm responsible and know better. OK? You go to sleep, now."

Mike read over his head incessantly and stayed awake much of the night trying, with his eight-year-old mind, to solve some problem already a thousand years old. At breakfast I asked if he'd slept. "Sure, you told me to," he said. I gasped at my responsibility. The next night he cornered me in the bathroom. "Daddy," very serious, "do you believe there is a hell?"

I could give my son the truth, always, even when I had little else to give him. "I can't believe anything I can't prove. I can't prove hell exists or that it doesn't. But I have a theory. We love

justice, you and I? We like for things to be fair? It looks like the human race thought up the idea of justice, but we hardly ever see it. Maybe hell and heaven were invented so we could imagine there would be justice somewhere, sometime. Do you understand that?"

"Yes."

"Do you think the idea is OK?"

"Yeah." Mike slept that night too. It was the best I could do for him.

At Lowry Field just after daybreak I could see from my bunk in the barracks, across snow, endlessly stretched as uninviting as a frozen bedsheet, the far-off peaks of the Rockies, delicate and pink as a meadow rose. As the sun mounted, the apparition faded into blank, enveloping haze as if it had never been. Calmly, the peaks were there next morning, above hate or war or sin or question. Not an apparition, they were, they existed, as we, made of flesh could never exist. More animate than mountains, my pine trees at home were never more noble than when in full bloom their fecundating pollen fell from spring-born candles tipping branch ends, like a thousand phalli, as they obeyed a law man could not alter with ten thousand sex manuals. Oh to be a tree calmly adjusted to the plan that governs all life and all death, eons removed from modern warfare and every army of hoodwinked, puzzled men. Looking at a noble tree, one says, "Sure God made it." And there is God in one's mind, if nowhere else. What could God think of war? Would His law be found in any man's opinion? Or in any church's dictates? Or any nation's laws? I thought not. Perhaps inside one's self in a sane mind, a sound body, the law of God lived in health and sanity, and sin consisted in not being everything you could be, exactly to the hilt. If a person could say "this is my best," could God oppose him? If there were a God. If there were not, and sin persisted, then sin had to be against one's best self. Being human is dilemma. It was not possible to answer with any satisfaction to either of us all of Angelo Grasso's questions.

Mississippi Artist

From my meager correspondence with him, mostly notes on Christmas cards, I can tell his questions still match mine and that the answers supplied by this world are more puzzling than ever.

One morning when Angie was told to put on Class A's and report to the field commander we were agog with curiosity. Two officers had been stealing our sheets, even those we'd asked folks to send us from home. Lieutenant Cron had led us to the barracks with orders that each man lie on his bed—in the middle of a morning! Before long the officers showed up. They began taking pillowcases from the bunks nearest the door, in the big room. Cron cleared his throat. The officers dropped the linen and hightailed it.

"They'd have taken your beds if you hadn't been on them," Cron said. "They've come up short. They're quartermasters."

Before this crazy episode Angie had griped loudly about his loss, and we wondered if the field commander, who was new and reputedly liked to see things for himself, would talk to Angie, and we reminded him of a dozen things to gripe to the colonel about. When Angie came back, his face was so pale and stricken no one wanted to ask him anything. I watched from across the room as he sat staring and motionless at his desk, tears running down his white cheeks. I hurried to him and said low, "What is it?"

"The son of a bitch shook my hand and said, 'Kill a Jap for me.' I'm being shipped out to infantry." My arm went around him. He wept.

"Angie, write me, write me every day, will you please? I care." Then he was gone. Days passed. A letter came. He was at Fort Knox. I wish I had his letters. I don't know where they went. Lost in our studio fire? One letter I can never forget, said, "Today in bayonet drill I threw my gun down and swore to myself I'd never pick it up."

The drill sergeant took Grasso to his captain.

"Go ahead and do what you have to with me. I'm not going to kill anybody." But nothing was done to him. He sat in some

space, guarded or unguarded, like a rare specimen which officer after officer came to examine.

"We feel the same way, but we carry on. Suppose every man did what you did," one said reasonably.

"We wouldn't have a war then," Angie replied. There was no firing squad, not even a court-martial as man after man looked curiously at a boy whose simple, uncomplicated courage had made connection with his deepest instinct. I loved him with all my heart. I'd like to salute the commanding general of the field who finally came to look and ask, "You're an artist, huh? Well, what are you doing here?"

"I don't know," Angie replied, "I was doing what I could, but I can't kill a boy just because he's got a gun and is on the other side."

"Think you could draw a map?" the general asked.

"Yes sir."

"Come with me, then."

In the general's office Angie mapped Fort Knox, made signs and posters; I remember that he did placecards for the dinner parties of the general's wife, till the war ended.

Dodsworth Pomhern was big, round, ugly. He looked fat, but you couldn't make a dent in him with your finger or your fist. He was champion weight lifter of Buffalo, New York. One day, to win a bet, he lay on the floor and let Al, Gold, and Denny jump from a table onto his stomach. He made Milt, who was next in line, take his shoes off so the heels wouldn't cut his skin. He tore a deck of cards in two, did the same to a telephone directory, slamming the sundered pieces on the floor, a gesture he said was just for show. Everyone was convinced. But the stomach-bouncing episode was the climax that certified his identity.

Like many strong men he seemed innately good natured, but deep under his affability and outrageous humor something said, "I'm not really your friend," as if he didn't need a friend, even in the army. But he was nobody's enemy.

Mississippi Artist

Fourteen men penned up together, each at his own desk, talked incessantly about anything they could think of. We examined "Do you ever pray and does it do any good?" but we didn't get far with it.

"It's no good to pray." Pomhern, the biggest, talked loudest, though crushing a mosquito might have been an ordeal to him. Challenged by a Catholic boy, he bellowed, "I prayed when my father died, prayed when my mother died, prayed when my sister died, prayed when the dog died. They all died within a year. I came back to an empty house. Okay, maybe I was tuned in to the wrong station, but if that guy up there cares nothing about me, I don't care anything about him."

It was funny, like most everything that came out of his one-sided mouth, almost under his right ear, but a heavy silence followed, and in that silence Pomhern opened his lunch box and chomped a cookie. Schneeman, whose desk was next to his, craned his neck and looked at the pile of cookies.

"Don't ask me for any. I got 320 pounds to feed. You weigh about 150, and I can't say no." He left the field every afternoon with all the food from the PX he could carry in both arms.

I met his wife once; pretty, with a limp from polio, in spite of which, she taught jujitsu to the Denver police force. The only time I saw him gloomy he whispered to me as from a deep hole, "If you don't want to get all broke up, don't marry."

So much muscle combined with any degree of sensibility seemed odd, but he reminded me that Leonardo bent horseshoes with his hands. Dodsworth was well read. The average GI kept his nose in a comic book when he had nothing to do; science fiction engaged the attention of minds just over average, but he read better stuff. His ambition was to paint a near-nude girl so smooth and pretty she'd go on a calendar that would sell by the millions, and having got rich, he could paint whatever pleased him. The girl was to be done with an airbrush, the calendar artist's best friend, and he kept that small gadget in scrupulous condition. It had got him a place in Film Strip Preparation Unit. Our filmstrips were in demand, and Al was per-

The Army: Bad Times, Good Friends

mitted to take on any man who qualified as an expert retoucher as long as there was room for him. Cheerfully he gave anyone a try, but if he thought he'd never like the guy, he gave him a defective airbrush to try with. Dodsworth came with his own equipment and such impressive skill that Al took him in spite of his disconcerting size and bold manner. Later they laughed together at Al's defeated ruse.

Our common interest in good reading brought Dodsworth more and more to lean on my desk. One day he said, "I can't be your friend."

"I never invited you to, but for the sake of curiosity, why?"

"I had a friend," he said. "We rigged up a correspondence course in art training. I put everything I had in it and we were making money, when the bastard walked off with the funds."

One slow day he leaned on my desk and said, confidentially, "I used to be a sissy." I'm sure my eyes bugged.

"When I was little I used to play with the girls. They'd say, 'You're no girl, why don't you go away?' But I wouldn't go away. I hung around, stringing beads and playing jacks. Little boys would say, 'Doddy, you'd better come over here.' I thought maybe I'd better. Within ten minutes I found myself hung up in a tree, rope around my neck. Boy, were they tough! Their idea of fun was breaking some nice old lady's leg. I lived in the toughest part of Buffalo. School was a nightmare. Everybody would pick on me. Was I miserable! Used to have long talks with myself. I must have said fifty times, 'Man you can't live this way. You got to do something, find a magic wand, a genie in a bottle, anything!' Then I saw *King Kong*—six times. Strength! Boy! I started going to the gym and that paid off right away. I could look in a mirror and see the difference. If I could be the strongest man in Buffalo, nobody would pick on me. I used to have nightmares. One night I'd be King Kong; the next night I'd be scared to death of Frankenstein's monster. I'd wake up all out of breath, running from the monster, even after I had guys standing around watching me lift. I talked to myself. 'Nothing to be afraid of,' I'd say. 'Why don't you stand your

ground, damn it!' I promised myself every night I would, but every time the monster reached out for me I'd wake up running—I got up to lifting four hundred pounds. Then I dared him to come into my dream. He did. I broke into a cold sweat but I didn't run. I reached out to grab him before he could grab me. He fell to pieces."

Just then Al came in and interrupted Dodsworth with a rush-rush job, but we goofed off to the latrine, and he continued,

"There was a boy chased me every day. Just habit; he just had the habit of chasing! I had the habit of running. Boy, have I got leg muscles. Well, after I beat that monster of Frankenstein's I decided to do something about that boy. Ran into a blind alley, a cul de sac with him after me. I'd have it out with him, whether I felt like it or not. Turned and waited. He ran into me. I grabbed him. He cried. I laughed, I laughed till I went to sleep that night. You know I never dreamed of Frankenstein's monster or King Kong anymore. In a gym you've got no clothes on to identify you. Guys always stand around and look when I'm lifting. Nearly always some guy'll say, 'What do you do for a living?' I stand up straight, make all my muscles show, and say, 'I paint pictures.'"

The war went on. We sat in comfort and were fed, while men died or went mad thousands of miles away on islands in the sea or on beaches like Anzio. Their agony was heavy on our minds when Major Chamberlain arrived and took over the unit. He had four days' seniority over Major Hill. He was an incredible figure; even carried a swagger stick. News from all fronts got steadily worse, but to Chamberlain only one thing was important: his stamp collection. Maybe he didn't read the newspapers. But we did and we were heartsick. While the Allies suffered their worse defeats, our whole unit worked on his stamp album, by his orders. Things became still worse for the Allies. Chamberlain and Hill were shipped out. Captain Giffin took charge, and Sandy was taken as an interpreter. Then suddenly Al was gone, to the infantry! It was like turning out all the lights. Then Pomhern.

The Army: Bad Times, Good Friends

As he gathered up his belongings to leave, he was full of bluster. He said no goodbyes, touched no one's hand, but across the room he said to me, "Wolfe, stop looking so sad."

I couldn't.

In 1977 Dodsworth Pomhern came to Jackson to see us and to see Al Amman whom we loved in the army. Unknown to Doddy, Al, for whom I had gotten a job with George Godwin's ad agency, was dead of a heart attack, but Jenny, Al's honey of a wife came to our house with Doddy. For years Pomhern had retouched Clairol advertisements so skillfully no one dreamed them retouched. He had made a pile of money. Half his dream achieved, he retired to Florida where he studied painting with a man who with a big brush whacks out luminous nudes. His teacher could not understand why, with all the muscle he had left, it was not natural for Doddy to whack even more broadly than himself. But Doddy, who could hire the most expensive models and paint in the grandest of studios, found himself painting inch by inch—like "Durer, every hair. Why can't I paint like you and Mildred? Don't tell me, I know. Anyway you got to change something in your book. I got to be the champion weight man of the whole army."

With Al gone and Battaille in charge, gloom settled into the retouch room. Not a bad guy ordinarily, Battaille had no idea how to direct people, and soon we were all, in spite of ourselves, against him; so when Captain Giffen asked if I'd like to assist an officer from the Chinese army, who only a week before had appeared in the building, tall, immaculate, and expressionless, I said, "Hell, yes." Giffen had got for the Chinese a little sunporch next to the court-martial room. I moved in, had my own desk, and became his flunky and friend. He had come to our unit to translate old filmstrips used in the instruction of Chinese flyers, to whom the United States had given our obsolete planes. But I found he had more on his mind than this. Twenty-eight years old, he was a graduate of Occidental University in Peiping.

Mississippi Artist

His English was fluent. Spoken, it had a touch of pidgin. Written, it was apt to be colored by the transmutation of his Chinese thought into an unfamiliar idiom. His purpose in writing was to demonstrate how little difference there was, essentially, between Chinese people and westerners in spite of Kipling's "East is East and West is West," which he called romantic poppycock.

"When you are a child, what do you call Mother?" he asked me.

"Mama."

"What do you call Father?"

"Papa."

"We say Ma and Pa."

"We've said that too, but it's old-fashioned here," I said.

"In China we like for some things to be old-fashioned. Babies are old-fashioned. Everywhere they are born the same way, and all over the world they make the same sounds. If we don't have Ma and Pa when we are babies, we die. Same with you." I didn't know then, how significant this was to him.

Stymied as far as painting went, I tried writing my peeves. When Chu learned this, we were instantly friends. We criticized each other's efforts, and I was fascinated with the prospect of exploring a culture as old as the Chinese through one so easy to communicate with. I was reminded of Sarah Price from Pocahontas, Mississippi, and her years as the wife of a medical missionary in China. She told of mysterious incidents, unexplainable, and I urged Chu to tell all he knew about the occult. Nothing had ever happened to him that was not mundane, but his store of tales, old and new, was large. His grandfather had seen a dragon, had talked to spirits. His uncle, a product of new China, had spent a night in the deserted, haunted Forbidden City playing majong with three companions. A story from the Peiping police files proved that the police believed in spirits as a matter of course. In spite of Chu's resolution to be as occidental as possible, we both fell under the spell of the East. I urged him to write about it, and I tried my hand at some of Sarah's stories. Dr. Price had seen Chinese patients die because they'd "seen

their ancestors." No treatment could help them. In my piece I quoted Dr. Price, who called these "ancestor cases." When Chu read this he made a wry face and vomited, "Disgusting!"

"Why," I asked, unsuspecting.

"*Ancestor cases*, disgusting."

I suddenly remembered his Shinto religion. He worshipped his ancestors. I snatched the paper from his desk and tore it to shreds, saying, "I'm profoundly sorry. Forgive me, Chu."

After that we were even better friends, and it was not a surprise when one day after a chaplain had left our office, Chu sat behind his desk and reflected, "Some missionaries are nice people."

The chaplain was pink, healthy, handsomely nordic; bulging against his correct uniform. Chu's glance had met mine, and I could see our instinctive reactions were the same. We didn't like him. As with the other officers on their way to the court-martial room, the chaplain was curious; he'd also been to China. He asked Chu where he had lived, and Chu answered, "Peiping. Occidental University," etc., etc.

"Oh, you must have known Pearl Buck."

Chu replied that he did.

"Fine woman isn't she?"

To my surprise, and the chaplain's, too, Chu answered, "I don't think so."

The Christian, taken aback, tried some commonplace about Chu's brush-writing, then asked, "You're a Christian, aren't you?"

Chu stood very straight, his eyes gone opaque and expressionless. "No" he said.

The chaplain left. Chu said, "Some missionaries are nice people"; we looked at each other and laughed, then glancing at a window, he ordered, "Quit working, weather's too bad," and we laughed again. Snug in our sunporch, we watched thick snow swirl all round outside.

Chu worked as if time did not exist. With brush and very black ink, he wrote his translations on blotting paper in elegant

Chinese characters, his long fingers manipulating his brush with marvelous dexterity. Every stroke had to be right. No mistake could be corrected. If the smallest thing went wrong, he'd drop the whole paper in a wastebasket and that receptacle received more blotter than was turned over to me for processing.

"It must be beautiful," he said patiently, when I protested his wastefulness. He showed me how each character must stand erect, "like a soldier," each stroke clean and forceful. He'd studied calligraphy eight years, twice the time necessary to quell any more criticism from me.

In contrast to Chu's rigid devotion to his own implacable standard, my duties were simple. I took his translations to the photostat machine where they became white on black. Trimmed and arranged, they were ready to be registered on a film strip which was then sent to China.

"How many film strips we do a month?" he asked.

"Not more than one. You're slow."

"They want one a day. What we do?"

"There's a Chinese WAAK on the field, we could try her to help you."

"She's ugly," he said.

"Yeah, but she might be able to write. Be sensible."

When we could see her closely she was unmistakably ugly, her face covered with pockmarks. From Canton, she spoke Cantonese, so Chu had to converse with her in English. She was a good-natured girl and he teased her without mercy. But her writing was clumsy and Chu dismissed her.

"What do we do now?" he asked.

"There are Chinese people in Denver, many restaurants. Why don't you see if anyone can write?" Nobody could, but by that time I had an idea.

"How many characters in the Chinese language?"

"Thirty-five thousand, some very complex, no sound for them, can't pronounce. Why?"

"I've an idea. How many are used for translations, it's mostly technical language?"

The Army: Bad Times, Good Friends

He thought a minute, then said, "Seven or eight hundred."

"I believe I can manage that."

"Don't know what you're talking about, but go ahead."

Many of the characters occurred over and over. I had become familiar with the sight of them, without knowing their meaning. A guess could be made about some of the characters that still retain a semblance of their origin—pictographs, *man* almost a stick figure, if you drew it with a stick or a pencil, but there is something of a curve to most brush strokes giving them life. *House* was still a recognizable drawing of a house, with walls, roof and door; *trouble*, a house with two women in it, which stays in my mind for the humor of it. I could see that the symbol, *man*, could be used as a suffix or prefix to another character, altering the meaning of both, I supposed.

"Did you ever hear of a Chinese typewriter, Chu?"

"Nah," snorted the calligrapher who'd studied eight years. "Impossible."

That was that. My idea grew more and more concrete. Soon I had cut apart the most frequently used characters, about an inch high, photostated, arranging them in sections of a box I fixed. Every character that had *man* as a prefix went into one section, characters with *man* as a suffix went into another. The rest was easy, following this pattern of prefix and suffix. They were all written by Chu, but a person reading Chinese, which by no means is the same as writing it, could select the characters needed for translation and paste them side by side as effectively as if they had just been done by the master himself. Chu did not understand my plan, and I marveled at the difference between our two cultures, his old and artistic, mine new and mechanized.

"Write it," he said when I tried to tell him how it worked. I wrote it.

"Now I understand, but you have not written simply enough for the merest fool to understand. Write again." It took two more drafts before he was satisfied.

"Now a fool can understand so we try it on them."

Officer after officer was asked to read my "letter." All were

enthusiastic. Giffen read it with excitement, took the letter and boarded a plane for Washington to get authorization for as many Chinese speaking personnel as were needed, glorying in the prospect of more empire. When he came back, he told us the War Department thought we had a great idea and would give us everything we wanted. We only had to wait for their letter of authorization which would be mailed as soon as all red tape was cleared. We waited a month. Giffen flew to Washington to see what was wrong. Back again, he said the War Department had lost the letter. I'd have to write it again. He took the new draft to Washington and again we waited.

Then April came. Snow still covered Colorado as it would halfway through June, but trilliums sprang from rainsoaked earth and violets bloomed as spring marched from the Gulf into Tennessee. More beautiful than anything man-made, more intoxicating than wine, spring caressed, enveloped, penetrated with a liveness I had to wait a whole year to feel again—in Mississippi. Unconscious scissors trimmed elegant calligraphy, unconscious fingers put bits of paper in compartmented boxes while the winds of spring blew down my neck. Long after man destroyed his puny, assertive self, would the planet turn and spring come even to a desert earth?

"What did you say Chu?"

"Wild roses bloom now in China." His voice sounded far away.

"That's what I thought you said, there are violets in Mississippi."

He sighed.

"I tell you a story I must write."

Chu's voice limned a distant landscape where rose-fire blazed against green mountains, water rushed through tall bamboos in budding valleys, and birds sang. From an ancient rock he could see, still miles away, the farmhouse, his goal. Here lived the mother of his brother, not his blood brother; closer, the man who'd saved his life. He'd been reborn out of another's courage. Now his heart—where was it? He must give her the jade his

brother had worn all through battle and tell her—but how could he tell her, when he could not even think it.

Her motherly fussing over him could not be stopped. Sadness had flicked across her face at the door as she looked past him for another, but only for an instant.

"He could not come this time? But you came." And she must, must lavish all the love she had on him, a double portion she'd saved for both sons.

On a wall of the room he slept in was inscribed Confucius' sober analects, "Rather broken jade than whole tile." I couldn't understand it. Chu was unable to make the *l* sound in tile, he had to say *tire*, even more puzzling. Then he spelled it out. "Jade is rare, much quality, tile is common. Jade very hard, heaven make it. Man make tile out of cheap clay, breaks easy. Do you see now?" Suddenly I did. It was a way of life! Next morning he wakes to the sound of sparrows in the plumtrees' bloom, has breakfast in the fragrant, steamy kitchen, can't be at all sure he's not dreaming—or that behind the mountains was the nightmare, the hideous thing only man could have invented. He must be gone early, this he knows. He takes the bundle she's made for her son, says goodbye, climbs to the rock he had rested on before; jade amulet still in his pocket. He has not told her.

Chu had been deadly serious. I asked no questions, but my consciousness felt expanded to a new dimension. When could we all go home? Then came a rumor. If you were forty, you could get out. Investigation showed it was no rumor at all, and I was forty. I was also broke and had forgotten how to paint. Half my allotted span was gone, but a wonderful wife had given herself to me for myself in return.

"I do, I do, I do," I had shouted to mountain, seas and sky, to sun, moon, air, stars and all creation, but the gaunt kindly man we faced in the small chapel in Denver heard only one solemn affirmation. "Do you take this woman"—this woman giving herself so whole-heartedly—"O yes"—"My self in return I give"—"for better or worse, yes, till death do us part, yes, yes— I do, I do, forever." Mildred and I who so miraculously were

made for each other began at once to be one. She was mine, I was hers, battered as I was, only one thought in my mind: *home at last*.

I hurried to fill out the papers necessary for separation from the army, then broke the news to Chu.

"We celebrate, I take you and your wife to dinner." It was a good Chinese dinner, but Chu was scornful. "You come to China, I give you a Mandarin dinner, 150 dishes."

"Nobody can eat that much."

"Oh, you don't eat, you just taste and throw away. I do it for you."

"You are going back?"

"Yes, I open a pawnshop. People bring me cheap things that go out of style in China. I bring to America, nobody knows here what is style in China, so I sell for more."

"Good idea! We would not know. Would you bring to Mississippi?"

"Yes, I see you again. What would sell best, beautiful things or gorgeous things?"

"What's the difference, Chu?" Mildred asked.

"Gorgeous is maybe brocade, many colors, brilliant, gold thread. In my family are fans, very ancient, plain brown paper. They have great poems written on them with fine characters. That is beautiful."

"Leave them at home, Chu," laughed my beautiful wife, "and bring gorgeous. We understand that."

It looked as if I'd be discharged before Washington was heard from. I asked Bob Quick if he wanted my job. His mouth watered. Chu would like him, so I said I'd recommend him for it on one condition: he'd write at least once a week to say how the business I'd started developed. I regretted leaving the only clear effort I'd made toward ending the war.

"Old as Gutenberg, it's movable type," I told him, "there's almost nothing to explain."

Quick saw this at a glance. He was true to his word. "We have thirty literate Chinese and are turning out one translation every

The Army: Bad Times, Good Friends

day," he wrote. His last letter went, "The Chinese War Department thinks someone ought to have a medal. Chu said 'Wolfe's not here, he wouldn't care anyway. I know, we give the medal to Giffen, he flew to Washington.'"

I never heard from Chu after I got back to Mississippi.

Before I could get out of the army a letter came saying my friend William Hollingsworth, with whom I'd worked at the gallery in Jackson, had committed suicide. I mourned. His wife had made a living for them, designing clothes, so he could go full time with his painting. In two years he went far, capturing prizes everywhere from New York to California.

But he could not stop drinking, and there was no organization to help him. What torture did Holly endure, choosing not to live any longer? I *wanted* to live. I would miss him.

Life Begins Again

About 1939 I had fallen in love with a piece of wild land out-side the city. Big and little trees grew on it; so did johnson grass, two feet taller than my head, and cherokee roses, blue-eyed grass, poison ivy, and sedge, pink sedge. For $1,000 I bought two acres, paying $250 down and $25 a month. Saturdays I rode the streetcar out to the end of the line on North State Street and walked two miles out Old Canton Road, then a dirt road. How fresh the woods smelled! No cars, no fumes. With $5 worth of third-hand, maybe fourth-hand, lumber, I had labor-iously built a shack, using tools older than the lumber and half as useful. It was just eight by eight feet—but mine; I had roots. Free of the army, Mildred and I had something to dream about. Little by little, we began clearing the poison ivy. Then Michael came, trailing clouds of glory that would not fit into the apart-ment we lived in, so we began thinking about a house on our land and of course a studio. A hutment, one of the buildings soldiers had been herded into at Camp Shelby, ninety miles away, could be bought for $800 and made into a studio. It came, collapsed in eight-foot sections, on a truck, one wet day in February, and though our hill is not high, the old driveway, then completely innocent of gravel, was too slick for the truck. The eight-foot pieces had to be thrown into the grass at our entrance. By July, nothing was visible but the growth that had tangled over them.

After the war my youngest brother, Doc, became a building contractor. He'd been in Sea-Bees, stationed on Okinawa where he did much building. He would build my house at cost, because I'd sent him ten dollars a month all through engineering school,

never dreaming that without that meager help he could not have eaten. God bless him; I'd have sent him twenty, had I known, but he didn't tell me. He took one look at the forlorn pile of lumber I pulled the vines away from and said, "You made a damn bad buy."

I was not sure I had, although the mess looked pretty sorry, and after a black man, who lived nearby, had pulled and tugged the pieces with his mule and wagon to the top of our hill, I got an old carpenter friend to erect and nail the thing together with the help of me and five other men, all in one day. It wobbled. A touch made it quiver. Over a ten-year period I pulled it apart board by board and nailed it back together so it wouldn't wobble, and it served as a studio, though nothing could have been "curioser." The walls were just seven feet high; there was not much light, and when I got a triple portrait to do, the three Johnson girls from Brookhaven on one canvas—it was impossible.

I stopped painting and knocked the north wall out of the part of the building I worked in. Then, raising the roof as high as it would go, I made a window opening ten feet wide, fourteen feet high. Into this I began putting old sash left over from the studio I'd built atop my cousin's garage in town. There had to be more light so I could see what I was doing, the canvas was six feet wide. And there was light. There was also cold, because by this time we were running into Christmas. The worst a painter can do for a painting is to become frantic over it, but our funds had become almost nonexistent. I gave up fixing the sash, in favor of time for painting, which in short winter days is scant enough. Wearing an overcoat against the cold that came through the hole I had to leave, I turned the gas heater as high as it would go. Then we had snow, and I had to stop.

The house had been built and we were in it. I had given six months doing all the work I could on it. Now in this constantly wet December we were surrounded by piles of grass and limbs, ends of lumber, mud so slippery you couldn't stand in it without holding on to something; steps were yet to be built to the studio farther up the slope; groceries were two miles away in

the nearest shopping center; our ancient automobile sometimes would not start at all. Parked on the slope, clutch released, it jerked down the driveway into and out of holes, some three feet deep while I prayed that some animating miracle would make it live till my errands were done. Now the sky sat on the earth, water streaming everywhere. Disaster seemed to float on every vanished horizon, and my mind suddenly jammed, in the face of one emergency piled on another. I looked out a window not yet cleaned, at the mud outside, seeing nothing. A paralysis possessed me; my mind was utterly blank. It had never happened before, and I said inside that blank mind, "I don't know what to do, please tell me."

An answer was almost immediately there, in the void my most utter self inhabited, and I turned to see if anyone else heard it, but no, I was alone with whatever wisdom I had addressed. I heard, "Do one thing at a time, crazy."

Calmness descended on me like a winter coat. I did ten or twelve things, one after another, easily, until for that day everything was done. What did I call on? What responded? Any attempt at an answer is tainted with theory. Enough for me is the fact that I asked for help and got it.

Years went on and prices went higher. Frenzy must have settled on me. I have no other explanation. I began to have headaches. Did my glasses need changing? I checked that; they didn't. But headaches came each time I'd put them on to work. Was I driving too hard? I took a blanket and lay under our handsome sweetgum tree, trying to give up. It was summer; beautiful star-shaped leaves moved in the wind above me; mockingbirds hopped nearby as I gave my body to the earth. I spent two whole days inert. On the third morning I saw our beautiful acres again with clear vision. I felt blessed, and suddenly a consciousness in my head said, "God loves you." I turned my face to the ground and wept, "He couldn't, He couldn't."

"Yes," calmly, a calmness unearthly, annihilating resistance.

"Tell me what to do, then."

Life Begins Again

And then a voice I recognized, familiar as my own, said, "Do your work, crazy."

That was enough. I snatched up blanket and pillow and ran into the studio. Canvas stretched, palette clean, a good photograph to work from, former chancellor Powers for the University of Mississippi, and my glasses on their familiar shelf. I put them on. A headache began immediately. I was not tempted to give up, or ask a question. I had been told what to do. I laid the glasses back on their shelf, squeezed out paint, mixed an agreeable color scheme, carefully, carefully. Was He watching me? I didn't care. Suddenly I was practicing the presence of God. It was good. For two weeks I worked, with unaccustomed sureness, blocking in big planes with a big brush, establishing the highest light on the forehead, the darkest dark in the shadow behind, everything between falling into place like clockwork. It was a beautiful painting, but I could not see on the photograph the minor characteristics of the man. I rested over the weekend and Monday without thought, put on my glasses to see what I had not painted. Rapt in the work of painting it I never thought about glasses on or off, till in midmorning I automatically removed them to go outside the studio and throw a few shovelfuls of dirt, loosening up. There had been no headache, and for the moment I'd forgotten I ever had one. I have told exactly what happened. What is God? I don't know. I was conscious of His presence for a long time; perhaps I still am. Where am I when I say from the deepest part of my mind, only dimly conscious I'm saying it, as I strain every faculty to get right some square inch of canvas, "Help me?"

When Mike was two, my friend from the Art Institute, Ove Bergen, came to Mississippi. I had vouched for him and lent him $150 so he could come from Denmark to America with his son and the mother of his son, as displaced people. He came and got a job handling freight for an airline so he could fly free and visit old friends.

Mississippi Artist

It was sad to see how he had been diminished, his once superb arrogance now testiness, his splendid body weakened; he was easy to offend. But he was still one of the world's best raconteur's. He told, so you could taste and feel, how he had lived in a garrett through the German occupation. He could see the building across the street through his wall, where the mortar between the bricks had fallen out. But for a down comforter he wrapped himself in, he'd have frozen while he continued his studies. Lacking money for paints, he was reduced to drawing. He drew superbly. Gradually he accumulated a stack of papers, covered with visions from his imagination. Then the fuel gave out, the Germans confiscating it. One by one he burned his drawings to stay alive. There was nothing left—his paintings he'd destroyed or thrown away—much as Cezanne did—in disgust at their inadequacy to express what he saw or felt. Ambition seemed to have burned out his very vitals.

In this country, he named his son for me, married the woman he lived with, and repaid the loan he'd made, then with his family returned to Denmark. Later he wrote, saying his wife was a lying bitch—and he was miserable. Would I please write him how happy I was so he'd know one person in the world was content? I wrote that my happiness was complete, for we had been blessed with a beautiful girl child, Elizabeth. A glamorous period of my life seemed to close when Ove's son, my son's age, wrote me years later that Ove was dead.

There is no mystery in death. Great Alexander, bright as a star, whose sweat was said to smell ambrosial is dead, mute and unlovely after two thousand years, as are all the beautiful youth of Greece, all the storied kings and queens of yore, all our millions of ancestors. Death is our ultimate reality.

Dr. Lawrence Jones

When Mike was five, the floor of his room was covered with pebbles because he had a new book, *All About Rocks*, and each rock had been examined minutely. All summer we had pored over an old book, *The Presidents of the United States*, and he fell in love with great men. No kindergarten on Saturday. About midmorning he was in the studio. I made a formal introduction: "I'm painting a great man, Mike. I want you to meet Dr. Lawrence Jones."

Mike leaned on the old man's knee and, looking into his face, said, "You know what a rock sandwich is?" Delight broke out all over the man. His small belly shook while he struggled for gravity. "No, why don't you tell me?"

"It's one kind of rock on top, a different kind in the middle, and the kind that's on top is on bottom too. Here's one."

"That's fascinating. What else do you know?"

"You know what magma rock is?"

"No, tell me."

"It's the molten rock under the earth's surface" (straight out of the book).

"How would you like to come to my school and talk to the student body?"

"All right."

"Well, let me give you a tip. I make lots of talks. Mostly you have forty-five minutes to talk in, and sometimes you get through with one subject real quick. Then with all those people looking at you, you can't think of what to say. I keep a little book in my pocket and write in it the names of things I'd like to tell somebody about."

"Daddy, got a little book?"

"Yeah, and a pencil."

Sprawled near the model's stand, Mike wrote. His bright yellow hair glowed against the dark floor, and all the Jones teeth appeared in a wide smile. Painting stopped as we savored the moment. (We never took Michael to fill that speaking engagement. Days passed dragging with them a hundred emergencies. How do we lose that precious young confidence, when nothing in the world is to be feared, no one is beyond one's trust?)

Mike gone, we resumed our separate tasks, the small gentle man and I.

"Dr. Jones, you couldn't have done what you did alone, could you?"

Without hesitation came the reply,

"No. I've missed death so narrowly, so many times, I made up my mind the Lord had a job for me to do and he'd see I did it."

I thought, How lucky.

"We got in the habit of praying for things we needed," he said. "Once, in the middle of the morning I stopped all classes and called a faculty meeting to pray for a typewriter. We had a secretary who left plenty of notes, but absolutely nobody could read his writing. When he was gone we were helpless. For instance, I couldn't tell if we would have guests in the school dining room for dinner. My wife and I always waited on their table. So we stood around my desk and prayed for a typewriter. We got through, the teachers went back to their classes, and I got in the truck and drove to Florence to pick up the mail, like I always did. A surprise was always in the mail, an old suit or a pair of shoes. Well, this time there was a very heavy package. I was curious to see what it was, so I drove back right away and put it on my desk where we'd prayed, and opened it first. It was a typewriter."

Fresh on my mind was the clatter my brushes had made falling on the floor the day Mildred came to the studio to tell me Mike had polio, and the prayer that formulated itself in my mind:

100

Dr. Lawrence Jones

"Please give me strength to take what's got to happen." Did my mind split in two pieces, one to hold back grief while the other operated to get Mike, kicking and screaming, into the ambulance already waiting and to begin telling him a story? Before we reached the mailbox at the end of the driveway he was listening and quiet. Two miles later the attendant sitting with us was listening to the story that did not end till we reached Mercy Hospital in Vicksburg, forty-five miles away. What I said I don't know. I think I didn't' know then, except that it was about a brave knight who took pain without a whimper, or too much of a whimper. From his cot in the hospital basement, Mike said, "You can leave me now, Daddy. I won't cry." Ten thousand typewriters could not match that delivery of what I wanted most. Was it a coincidence that Dr. Jones and I had prayers answered? Perhaps, perhaps not.

"Whom did I pray to, Dr. Jones?"

"I don't know, in your case; but I think you'd better be careful what you pray for. I am. Most of the time I just say, 'Tell me what to do.'" Without a pause he went on,

"In the depression, Arkansas was hard hit. You could buy a seven-room house for seven hundred dollars. Some church people asked me to come to Hot Springs and talk to them about what to do. I ain't a preacher, but I never could turn down a call for help. The little church was on the edge of town, and I had talked to these people for two nights. On the third night I was right in the middle of a good thought when some white men came in with a rope, a hanging knot at the end of it. They marched up to the pulpit, put the rope around my neck and led me to a truck outside, then drove down the road till they came to a big tree. They threw the end of the rope over a limb and asked if I wanted to say anything before I was hung. I said, 'Yes, I do. I'd like to finish the sentence you interrupted.' I finished the sentence. They took the rope off my neck and hauled me back to the church. About thirty minutes later they came back with a hatful of money they'd collected. People don't always listen so good to what you're saying."

Mississippi Artist

No words came to me. Was I in the presence of one who constantly practiced the presence of God, with the utmost simplicity? I finally said, "You've been in the hands of God, but you kept your wits about you."

"They go together, but we're all in the hands of God; some of us know it and some don't."

"And those who do know it keep their wits?"

"I think so. That's reasonable."

Piney Woods School starts a long way back. Nearly five hundred years ago men on the vessels of Columbus smelled the fragrance of our forests before they saw land. One hundred years ago forest covered Mississippi from its northern limits to its coastal plain. Broken by small towns and smaller farms with occasional plantations, this forest, mostly pine, contained people rarely touched by changes in the world beyond them. Far away, not as miles are counted, but distant in culture and values, two people in Pennsylvania were married. One was white, the other black. It could not have happened in Mississippi then. Somewhere between Pennsylvania and Iowa a son was born and grew up in a society that accepted his presence. Somehow he got through Iowa State University with an outstanding record. He was Lawrence Jones. Lawrence was elected to an honorary fraternity that existed for the purpose of providing an audience that listened to the findings of its members on subjects each had researched. Lawrence Jones studied Booker T. Washington. He read his paper to such enthusiasm that he was granted an unprecedented extra hour in which to finish it, and Lawrence Jones got stuck with an idea. He would follow Washington. Endowed with intelligence and obviously gifted, Jones never doubted that his life must be devoted to service. His white friends did not need help, but the condition of people belonging to the dark side of his ancestry was a different story. He set out for the South possessing little more than a diploma and the clothes he wore, toward the people he *could* help. This he told me. I could sense it had been told many times, would be many times retold.

102

Dr. Lawrence Jones

"I drifted down to St. Louis and got a job ushering in a theater so I could see all the plays. I love the stage and still go to New York every year and see the shows. Course I collect money for the school while I'm there. Shakespeare? I saw all the great old-time Shakespearian actors. Seems to me actors ain't great any more. There's only one man I know who can do Shakespeare right. He's the village idiot in a small Illinois town. I go there every year. We sit on a park bench and he does Shakespeare for me."

It was hard to believe. Relaxed now and turned my way, he had avoided looking at me when he first sat.

"You are not Ole Black Joe," I told him, "but you're posed like it. I want to paint you, not a cliché. We are both men. Your color is different from mine and I don't give a damn. You must look at me so I can paint *you*, please."

(Behind the smiling mask I sensed a shrewdness keen enough to accurately assess another's intelligence. This estimate would show in his glance and that could be dangerous among people striving to maintain a sense of superiority. A bland expression and the avoidance of a direct look protected him. I had seen it before on darker faces. It was not what I wanted. The mask was too habitual for me to think I could remove it while I painted, but many glimpses behind it might catch the man.)

As soon as he settled himself the first day, he asked if I had children, and what their names were.

"Michael and Elizabeth."

"The Archangel and the Gift of God," was his comment.

"Yes," I said, thinking of him as shrewd, knowing what to ask a man.

"I want to meet them."

When Bebe was brought in he held her hand as if it were the Kohinoor.

"She's like a little flower," he said then, and I knew our minds would meet, without sham, at some point close to poetry.

"Dr. Jones, what do you think of integration?" It had not taken place, but was being talked about in 1952 with misgiving.

"Oh, we're used to integration but not on a big scale. When we have white guests for dinner they sit in the same dining room with the students but separated by chicken wire. My wife and I always serve their table ourselves. If anybody needs a place to live we don't turn them down. We've always had white orphans who couldn't get in anywhere else, and white teachers. If a Negro can help a white person it makes him proud. When I first came to the piney woods I saw black and white just existing. Nothing called them out of inertia. I was naïve enough to think I could build a school that would teach *any*body how to live better. Do you know Grey's 'Elegy in a Country Churchyard'?"

"Not at all well."

"Want to hear it?"

"Yes, please."

"It contains my motivation."

The recitation was beautiful, but he could not remember the last stanzas and was deeply vexed. Then the Piney Woods student who drove the station wagon came, and we breathed ordinary air again. The boy told the old man, "Something's wrong with the carburetta; the man say it need majustin."

The old countenance lost its serenity. "What we gonna do now?" I could sense how often he'd said it. Then, "Go and get it majusted. I'll wait here."

To me he said, "I can't get used to the way they talk. Once, way back, I sent a student to get Blue Ribbon Mayonnaise when we had company. He was new, and I should have known he'd never heard of mayonnaise. He came back with two yards of blue ribbon."

Our time was up and the boy waited for him.

"I've been thinking about integration," he said next day. "You can't teach the same thing to everybody. Our students all learn something they can do. For graduation a boy might butcher a hog, make a gate, or lay bricks. Girls learn to cook and sew or wait on tables. The school goes no farther than eighth grade, and some students have a hard time getting that far, but if a boy

Dr. Lawrence Jones

can do a good job mending shoes, seems to me that's better than doing poorly in arithmetic. What we stress is keeping yourself clean and mending your clothes. I don't see how you can have much self-respect if you are ragged and dirty." Deep in thought, the head I watched was now just right. I worked hard.

"I don't know what the NAACP wants. The only thing worth having is what you earn yourself. Black boys and girls generally aren't ready to compete with students who take for granted things *they* still don't know about. Maybe in a hundred years. . ."

I tried to catch something intangible. . .

". . . you can tell when the boys are going to forcibly bathe someone in the dorm." A smile broke out.

"They talk all day about how they're gonna solve the race question."

We laughed together and I said, "That goes a long way, but it doesn't really solve everything, does it?"

"No, You got to have goodwill on both sides, and I don't see how you can force goodwill. An old woman who'd been a slave told me once, 'You a yankee, and you got your hand in a lion's mouth. Don't you tear up the patch gittin it out, neither. Learn to ease it out, best way you can.' I was young then, but I never forgot it. She was right." Deep in thought again, and I caught some of it on my canvas. "How did Piney Woods School ever get started?" I asked. "I've heard how it was run on anything anybody could give you. Nobody in Mississippi had anything in those days."

"That's right and there was a panic too. Everybody was scared. People told me I almost got lynched trying to educate Negroes. I didn't know. I just came to the poorest state. You won't believe how we got started, but I'll tell you."

He lived with Old Joe, perhaps the oldest man around. Perhaps without a surname, just Old Joe. Perhaps Lawrence Jones helped him around his place, and that paid for his room and board; he very likely got himself loved, his charm seeming indestructible. Sometimes it's hard to paint and listen too. Old Joe had been a slave. When he was freed he was given forty acres

and a mule. The mule died, as mules do, but the acres remained, wild and hilly. Crowning the highest hill was a log cabin, long deserted; near it a tall cedar and close by, a spring of pure water. This was the favorite haunt of young Lawrence Jones, who dreamed of a school there. There, because Old Joe had promised he could have the whole forty acres if he found a way to get a school on it. He called together all the black people he knew in the surrounding territory to learn how much help he could expect. They wanted Latin and Greek, so he gave them up. He wrote fifty letters to friends up North. All he got from this was fifteen dollars. There had to be some way. On a summer afternoon he and a twenty-year-old boy lay under the cedar. Jones had two books. He invited the boy to read one while he read the other. The boy couldn't read, had never learned.

"I'll teach you! I'll teach you now!" And Lawrence Jones, schoolteacher, had his first pupil.

The next day a new pupil came, and for thirty days a new pupil came every day. Thirty pupils! They sat on the grass and Jones taught them. Then it rained. They ran for shelter to the old cabin. The roof leaked.

"'We'll fix it.' They looked at me as if they'd never heard the word *fix*."

"Did you know how?"

"No, but I found a man to tell me and we fixed it."

"But then it turned cold. There were big spaces between the logs. None of us knew what to do about them." He had a student body. What could he do?

"Old Joe said, 'You know that sawmill almost to Florence? It belong to Mr. Webster. I think he's a good man. I believe if you ask him the right way he might let you have lumber on credit and then you could build a school.' I had never asked a southern white man for anything. I spent a long time trying to figure out what was the 'right way.' I couldn't figure it. I went to Mr. Webster and told him I didn't have anything and didn't know how to ask. I was just begging. It was so simple. He said 'all right' and sent the lumber out to the hill. None of us knew

Dr. Henry Boswell, ca. 1950. 24" x 30". University of Mississippi School of Medicine.

Mrs. Ruth Roudebush White, 1933. 48" x 60". Governor's Mansion.

(Above) Mrs. Stuart Irby, Jr., ca. 1950. 24" x 30". Owned by Mr. and Mrs. Stuart Irby, Jr. (Below) Miss Ryan, daughter of Mr. and Mrs. Thad Ryan, ca. 1966. Fragment of 36" x 60" canvas.

(Above) People in church, 1934. 24" x 30". Owned by Karl Wolfe. (Below) The Venus of Cyrene in the Thermae, Rome. Pictures collected on my visit to Rome in 1929.

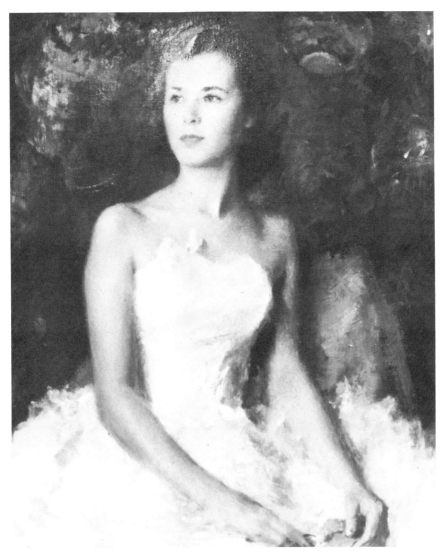

Lida Gregory, Pine Bluff, Arkansas. 24" x 30". Owned by Mr. and Mrs. Henry Gregory, Pine Bluff, Arkansas.

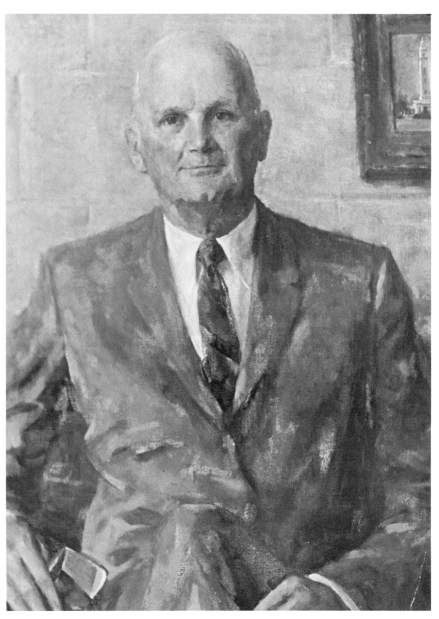

Orrin Swayze, 1970. 20" x 24" Owned by Mr. and Mrs. Orrin Swayze.

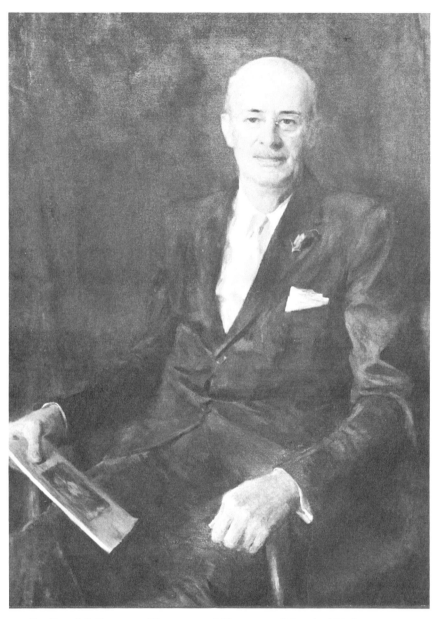
Dr. David S. Pancratz. University of Mississippi School of Medicine.

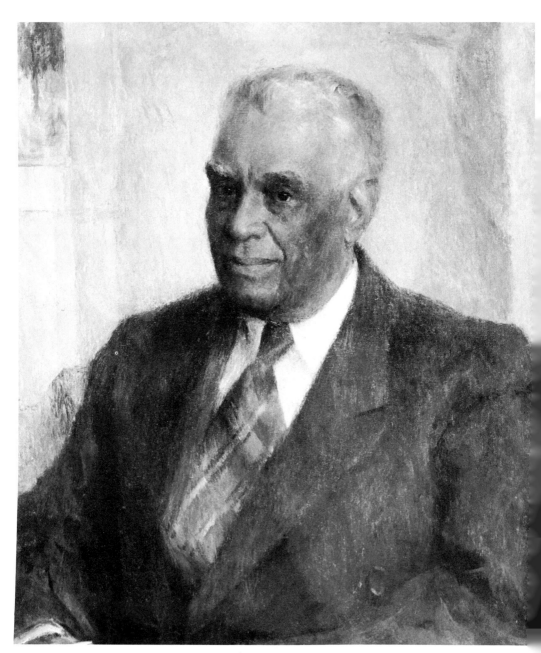

Dr. Lawrence Jones, 1951. 24" x 30". Piney Woods School.

how to build anything, but I and the students put up a building. It was crazy. Everything about it was wrong. But were we proud! It didn't leak and it was warm! I asked Mr. Webster if we could name it for him. He took one look and said, 'No.' In my innocense I couldn't figure out why. Years later he told me. He was sorry he hadn't sent someone to build it. After the school got started all kinds of people helped. A day's work, a few potatoes, a garden plowed and planted. One old woman gave us a chicken. We didn't know it was her last one till we ate it. She ought to have some sort of monument."

The good old face softened, a faraway look in the eyes. "I took a wife." He was not with me now, but gone beyond time. "Ever hear a poem called 'Laska'?"

With intense feeling he poured out the tale of a man on a wild frontier, loved by a woman with primitive passion. What do you do when the herd stampedes? Shoot your horse, crouch behind the carcass and let the uncontrollable beasts go over you. But he is knocked unconscious, and she throws herself over him. He comes to, finds her dead, and light leaves the sky. For me there are no words. In the poignant silence his voice a whisper, "She's buried under the cedar tree." Next day he seemed bent on telling me all, as if he knew how bent I was on painting into his portrait all he could tell me:

"The school grew. We got donations from everywhere. Finally, we had a guest cottage. In the meantime, Mr. Webster had sold his sawmill and moved away with his wife. When they came back old and destitute, I wondered if they'd be insulted if I asked them to live in the guesthouse. I thought about it a long time before I decided it didn't matter if they *were* insulted, I had to do it. They came, lived there, and died there."

No guitar string ever quivered more as goose pimples chased each other over my skin. It was poetry! We looked at each other, eye to eye, as I blinked away tears.

"Everything was fulfilled," I said.

"Everything was just right."

Toward the end of the painting he said he was making his will,

so he'd leave no squabble. He'd given away all the money he'd ever had. All he was leaving were some old suits, everyone of which had been given him.

"You remember an old song that goes, 'I leave the sunshine to the flowers'?" To my surprise, I did; date must have been 1910; I could give it to him almost complete. Next day he brought his secretary to take it down, and I remembered every word of it.

The portrait got finished and delivered. Two weeks passed, then one day I recognized the Piney Woods station wagon in our driveway. With a sinking feeling I wondered what I'd have to do to the portrait. Dr. Jones emerged, a wide grin on his face. Everyone loved the painting; he'd come about something else. Taking a small book from his pocket he said, "I've got to finish Grey's Elegy," as if Grey were an old friend who might be offended. I listened while he read the whole poem, thinking there never was a man who knew so well how to live and what was important. I loved him and told him so.

There's more! In California he appeared on Ralph Edwards' program, "This is Your Life," and told about Piney Woods School. At the end of his story Edwards said, "Why don't we all send him a dollar?"

A million people did.

My last note from him said that of all the likenesses made of him, including many photographs, mine was considered the most exact, magic!

Mildred

Has ever man had such a wife? She's never wanted me to work harder than she, will not think of herself as a "kept woman." We pull one load like a matched pair, but we are not matched. I have often been fast when she was slow; at other times her speed is incomprehensible, especially with a pastel portrait. No one was ever unconscious of her beauty or her composure, but her humor could be missed. She saves most of it for me. She watches what people do on earth as if she were from another planet, and I am not always able to predict her reaction. That would be boring; she never bores. From the first our flesh grew to be one flesh, a mere touch transporting us beyond anything we could name.

After the house went up she wanted a lawn. "How do you make one?" She asked, and I referred her to the English, who've said it takes a century. She couldn't wait that long. With shovel and rake she flattened furrows left over from cultivation, then coaxed grass to grow, so we have a lawn—too big to get mowed often. She left a dense growth of trees around it. Now a four-lane highway roars by while we, except for the noise, exist peacefully in a forest over sixty feet high our only visible neighbors the birds whose singing in the misty dawn is as stirring as a ninety-piece orchestra.

Is it the "infinite" we are in touch with? (A learned man said we should be.) On moonlit nights we've walked, sometimes naked, through "verduous glooms and winding mossy ways— with shadows numberless." What was Keats in touch with? We have made what we exist in. "Four shovelfuls a day" became my unspoken motto, and fifty or a hundred made up for

the days that escaped my attack. How many terraces surprise me, six, ten? Did I really make them with my body? Did I raise the driveway three feet out of the mud. Where did the earth come from? Something inevitable exists here, as if things could not be otherwise—bushes, trees, paths, steps in the right places, whole areas seeming untouched. A great oak, branch tips touching earth, measures seventeen feet around its base. It grows on our fenceline beside a neighbor's wide lawn bright as neon against our dark trees. The oak's astonishing size is lost to those seeing only the geometric garden beneath it, or the view beyond, of blue distance and a bridge not quite Japanese. Forest is solid on the other side for a thousand feet, containing no human life.

The shack Mike still loves was built a little at a time by enlarging the first 8 x 8 hut I made. It is up the hill in a picturesque spot. During high school years we got Mike out of the house, which he seemed to mutilate every time he was in it, and he slept contentedly in the curious place he joyfully called Zanadu. It's exterior has blended into its natural setting as if it had been there forever. Serenity is what every visitor mentions, and that may be what we unconsciously strived toward, for everything was done by instinct except the drainage.

Work on the earth is endless, carpentry something else. As soon as I could, I glassed in the north wall in the part of the studio where Mildred painted. It was never satisfactory, but there was no way to raise the roof. Mildred needed a studio of her own and for this she saved her money. Meanwhile, her father promised to give her $2000 if she saved that much to build an addition to the house which had become more and more crowded. She saved more than $2000, and we got our addition, did all the finishing work on it, wore ourselves out, and had $750 left over. With this amount I bought second-hand lumber and carefully went to work on an additon to the studio— a room twenty by twenty-four feet with tall windows on the north side. I didn't think I could nail boards together and paint portraits at the same time. Fatigue was no longer something other people talked about; I was tired and I was fifty-five, but I

Mildred

did it. I broke my carpentry by painting three portraits, one an evanescent creation of a woman against a tree trunk, flower color all around her; another of a woman who had worked hard for the school that would get her portrait, the third, from a photograph, for the Mississippi Hall of Fame, a judge.

My combined work had become easier and easier. When the studio was finished after three months, Mildred was radiant, and I was loved—Seigfried.

While I worked on her studio Mildred's parents visited us. Mr. Nungester, one of the handsomest men I ever saw, had cornflower eyes that seemed to miss nothing and jet black hair that rose from his forehead like a cock's comb. His neck bent backward like a sword, his head poised high and straight. He was full of wit, intelligence, avid interest, and good humor. From the roof I could see him looking at me. He said, "Come down here a second."

Descending the long ladder, I looked into his eyes.

"I just want you to know I made a mistake about you; you're all right," he said taking in my sweaty, near-naked physique. It was like being knighted, but rain clouds were building up and I hurried back to the roof, "Don't let it bother you. That mistake's been made before," trailing after me.

There was no way for him to know me. I had only an inkling myself. I was what I was, an artist who had married his daughter, a man possessing little that could be called valuable. He'd never known an artist or thought about one, though his daughter was one. How did an artist make a living? I didn't know what he felt, but visiting his home in Alabama, with Mildred as my new wife, I had been received with open arms into an atmosphere of tolerance, kindness, and civility. No one there was ever called down or made to feel guilty. Mistakes were sympathetically laughed at, without derision. A gentle peace was there in a mature air of concern for whatever had real importance. Like Baucis and Philemon this man and his wife loved each other with deep and undeviating devotion. Cliff once remarked that "living with Augusta was like abiding by a gently flowing

stream." Yet he was full of a mischevious humor that danced in his eyes, never failing to sit down to breakfast with some new witticism, starting each day with mirth. He could walk in a row-boat on water as easily as he could through a forest, noiselessly. In his house, full of books, reading was like breathing. Once, in the living room with Mildred's sister, her mother, Mildred, and myself, eight eyes glued to print, he was suddenly in the midst of us, like a materialization, having crossed wooden steps, an old porch, through a front door, he had to unlock, without a sound. We were unaware of him till he spoke. That was to keep in practice for hunting, like an Indian—and for the heck of it. He was a great hunter and a renowned angler. He'd lived in a log house at the edge of primeval forest in Ohio. His father was a farmer, and Cliff grew up plowing—struggling for an education out of books he seldom saw until he bought them, though he managed to get two years of college where his record was brilliant. Farming was drudgery, Ohio winters bleak, so he toured the South as a drug salesman looking for a more ideal place to live in. He chose the beautiful Tennessee River valley. When the river was dammed it became even more magnificent, and almost everybody fished. In this territory his prowess became legendary.

I neither hunted nor fished, finding both sports boring. This in a male must have been puzzling, and I, enthralled by the stories he told in a continuous flow, had little inclination to say anything about myself. His stories were small jewels, polished by repetition, pointed and subtle, invariably informed with the vagaries of human or animal nature, for he was a man who had thought deeply about existence and its enigmas. There seemed at first to be no end to his stories, and only after I'd heard about a hundred on various visits did I realize he was repeating. By this time we were friends, regardless of my peculiarities, and we walked arm in arm about his part of town, invariably stopping at the old drugstore which he had operated with his brother for forty years. Now both men were retired. The store, fusty and old-fashioned, was being done over with red carpet, and he

shook his head over that, remembering how he had not fallen for this sort of gimmick, but had put his profits instead into drugs, watching shiny new businesses buy retail from him the items they couldn't buy wholesale, all their money spent on fixtures. Fish talk and politics were the attractions the old store held for cronies who met there, not to mention the affable courtesy and genuine interest of the two brothers, whose fast friends it would be hard to tabulate. Our walks often brought us in contact with Negroes, who invariably seemed old and purblind, starting eagerly at the sound of his cheerful voice to touch him; as dogs even on their last legs, with unseeing eyes will rouse themselves for one more caress, and he told me that these humble black people had saved his business; faithfully paying what they could on their accounts in the depression, while prouder whites ignored what they owed.

On one of these walks, I said, "You don't know anything about me, do you?"

"No, I don't," he replied.

"Do you want to know?"

"Yes, very much."

"Well, you stop talking and give me a chance."

I started at the beginning, intent on telling him everything, but halfway through my recital, he said, "Stop talking. I've got to tell you something."

By that time we were back at his porch, and what he spontaneously said then made me feel that I should kneel and let his sword blade touch my shoulder. "I want you to know it's wonderful to be so stimulated by someone as intelligent as you are."

No anthems rang, no bells pealed for the great generosity of this noble man, but liquid gold seemed suddenly to seep between the leaves of trees bordering his narrow front yard to spill its radiance on the grass up and down a modest street that now seemed the only fit place for one of nature's lords to reside. After that our friendship was unshakable, and he listened avidly to the rest of my saga finding in me no stranger, but a spirit kindred to all he respected.

Mississippi Artist

I could tell many stories about him. He lived to be ninety-four and stopped smoking the day before he died. He taught school ten years and loved it, sending his brother to pharmacy school out of his pay so they could eventually become owners of a drug business. The country school where he began teaching had an evil reputation. Its last teacher had been thrown through a window, and he left screaming. Boys taller than himself snickered in the back row the day Cliff began. Dismissing the other pupils, he asked them to sit in the front so he'd not have to shout. When they were settled, he said, "In a few more years you'll be running things in this county." Then he dismissed them and never had a minute's trouble.

When he was a bouncing young man just going into the drug business, he called on a bank president to borrow what would now be an inconsequential sum with which to buy supplies. The banker asked if he had security. Cliff said, "None at all."

The moneyman, who, like everyone else, must have found his charm irresistible, asked, "If I were asking you for a loan under those conditions, would you give it to me?"

"I certainly wouldn't."

The man laughed loud and long, so that two people came to his door to see if anything was wrong. Then he said, "I can't lend you the bank's money," and Cliff got up to leave, saying, "I kinda thought you wouldn't."

But the banker said, "Wait a minute, I'm going to lend you *my* money—I like you."

Into the minds of both his daughters—Frances, whose dynamic character has made her the outstanding school administrator in her state, and Mildred, whose poetic nature and brilliant mind sit behind an exterior that is at once peaceful, beautiful, and cheerful—Cliff poured his philosophy, both optimistic and doubting. The unruffled air of live and let live so evident in his home was largely due to the way he thought and to the wonderful marriage he had made. When we gathered there to celebrate their fifty-fifth wedding anniversary and grownups sat at a festive table with great-granddaughters, four and seven, nothing

114

Mildred

occurred to disturb the calm, and no table manners were corrected. In midafternoon, my darling grandchild, Lisa, Mike's daughter, who seemed both genius and saint at seven, asked for a pencil and paper because she had to write a poem. Sitting in a corner, her blue eyes lost in her mind, she wrote,

Love is good
It's good for young
It's good for old
It's good for everybody.

She had felt what was alive in that house.

Allison's Wells

•

After the war Dixie Art Colony was no more. There was no one left to carry on. Both Kelly Fitzpatrick and Sally B. Carmichael were dead. But we found a place where we thought an art colony might go, Allison's Wells, north of Jackson. Since it seemed up to me to teach classes at Allison's, my mind ran something like this:

Seeking perfection, Beethoven changed one note twenty times. Each change is visible, his original score, still in existence. Who would have known the difference? What was he after? Was he again that ancient Greek sculptor who said, "The Gods will see it" as he carefully finished the back of a figure destined to stand against a temple wall?

Wanting to share my admiration for things Greek with the people who came to Allison's Wells Art Colony; to tell them about the wonderful and cruel world one must live in to make art worth pursuing, explaining how an artist does not work for men, for prizes, or applause, but for the gods or God himself, despite all efforts, I didn't achieve my noble goal. Allison's Wells was interesting enough—an old watering place deep in the country, dating back to the nineties. When we saw it, we thought of Dixie Art Colony, which had only one rule—don't go swimming alone." In no time everything was superorganized at Allison's; classes, five o'clock tea at which no swim suits were allowed, dress for dinner, and lectures after dinner. We began to be sorry we started anything and felt some relief when, after ten years, the place, with all its out buildings, burned to the ground in an hour. It was a dreadful loss—in spite of our feeling. Not many real artists ever came, but crowds of assorted people did,

116

all wanting to start painting at the top. "Show me how to do a portrait," I heard, astonished, a dozen times. Most of the aspirants were housewives whose minds seemed bounded by recipes, and why couldn't a recipe for painting be followed as simply as one for a cake? I had no recipes, and wanted to talk about *art.* Could anything come out of such people? They must be given a chance. Anyway I tried, manfully, I think.

One Saturday night the pavilion, where lectures were spewed out, was crowded with weekenders. A busload of college students had arrived, and I'd wondered all day what I'd give them. I began: "Three authorities who've made deep studies of the Greeks, say the same thing. Will Durant, Edith Hamilton, and M. C. Bowra at Oxford are of the opinion that they knew nine-tenths of what we know." Resentment appeared on many faces, and a hand was raised. "Yes?" I said, pausing. A small man stood. He looked, I thought, as if a nervous breakdown sat on him, not realizing then that many people came to the Wells art classes for therapy.

"Jesus Christ came along and turned the Greeks and the Romans upside down," the small soul said and sat down. I did, too, as applause shook the walls.

"Is that all of your talk?" someone asked.

"Yep."

I left the pavilion and went to bed. I tried another time with a smaller audience that seemed more receptive.

"Art did not begin after World War II, did not begin at Allison's Wells; it existed in the cave, it thrived in ancient Egypt, and reached a glorious peak in Greece." But when I again said they knew nine-tenths of what we know, a woman asked, "If they were so smart, where are they now?"

"You really don't know?" I couldn't believe it.

"No."

"Well this time I do give up." My difficulty was that I am unable to communicate with people who know nothing of the past. When Mildred taught art history at Millsaps College, I saw a more basic level of this ubiquitous ignorance. Her mention of

Mississippi Artist

Homer to students about to graduate elicited no response. A teacher of French at Millsaps confronted a whole class who'd never heard of Aesop. How have educators managed to throw this all away? Do we know what we have lost?

Soon after the war, Jackson began to fill up with new churches. Remembering Chartres, I thought how barren and trite they seemed. I went to Sunday school for a while, but responded only with a longing to do something for worshippers who needed more than white plaster, dull pews, doleful song, and ugly glass that looked as if it had been bought by the yard. At Christmas my longing was acute. Christmas has always seemed like magic, and to me a Christmas tree was the most magically beautiful of all things till I saw Chartres where Christmas is celebrated at all times. I can't shake off the feeling I had as a child that when anyone said "What are you doing for Christmas?" they meant, "What will you do to make it splendid?" Mildred and I still begin every fall to make it so. This started in our house when small Mike was sick one December, and he and I made Christmas cards from colored paper. Mike became the champion of the babe who had to be born in a stable. The glory he joyed to put around him came from the silver foil inside cigarette packages. All of us got involved in the effort to make our flimsy material carry the elation we felt, and it was then we discovered Bebe's amazing talent, when she was not yet four years old. We embroidered the lovely myth with all our childish hearts while we sang the heart-felt songs that have embellished it for a thousand years. Then we couldn't bear to send our votives away in the mail but pinned them to the walls in our small house till it was transformed.

When we discovered mosaic, paper Christmas cards became brilliantly glowing designs in glass and tile. In three years we made and sold nearly a hundred mosaics, none casual. Mildred's "Head of David" decorates a chapel in the constantly growing University Medical Center.

118

Monsignor Josiah Chatham

I made a chapel for myself at Allison's Wells out of a chicken house built long ago of wide boards spotted with the grey-green lichen that once silvered the pale gold of Chartres. The shade of a large tree made the interior eerie. But when two doors opposite the entrance were opened, sun poured in from a small hedged area that backed up to uncontaminated forest. Between these doors, I hung from the roof a small altar sprayed dull gold and back of this a startling mosaic, a pieta with the Christ a powerful dead giant in his mother's arms. Theo Inman who made it was my best pupil at Millsaps College, where I taught, though I had to wring it out of her because she, like most people, backed away from her deepest emotions. When the piece was completed, there was no defense against its power. Almost nothing else was in the place save thirteen handmade chairs, primitive and uncomfortable. We decorated twelve, one for each apostle, and a Jewish girl, a guest, did the thirteenth in blue and white for her people. Once we had communion in the place, a superannuated minister in faded vestments giving us bread and wine with trembly transparent hands, his voice whispery with emotion, his large ears, pink luminous shells against the light pouring in back of him. It was beautiful; it felt sacred, and for once the poignant ceremony got to me.

Then I found a prince, Monsigneur Josiah Chatham, a prince of the Church. His new church, St. Richard's, just finished, and the school he ran were near us in Jackson. He knew more than a little about art, having lived in Rome six years while he studied canon law. He was at Allison's for a short rest, and I took him to the chapel. He was impressed by Theo's mosaic and delighted

with the oratorio, as he called the building. He was ebullient, full of juice and enthusiasm, and looked like he'd have little trouble in a fist fight or wrestling match. For his new church I suggested stations of the cross made by Mississippi artists whom I thought needed more challenge than could be found in picturesque old cabins, daisies in a bowl, or honeychile in a cute pose. It wasn't necessary to remind him of the historic role his church had played as patron of the arts, and when I guaranteed all fourteen pieces to be as moving as Theo's *Pieta*, he fell for my idea with enthusiasm. Each station was to be eight by thirty inches. He designed the frames, each with a cross on top, and he wanted the Christ dressed in red.

I tried to find fascination for this project among the Allison's colony people, but was forced to give up in the face of timidity or indifference, and the notion among the artists that it wasn't quite stylish. Mildred's interest in mosaic was alive, however, and since I'd found no one else agreeable, she promised to do all fourteen, if no one, including me, horned in. So the project was turned over to her and she began reading the New Testament. The great story fell on virgin soil. Her parents were devoid of religiosity in the midst of it. Right and wrong were distinct opposites. For them the source of integrity was not the Bible but the feeling in one's bones for the fitness of things; bred, one could believe, before Solon, Hamurabi, or Moses, from man's inner core. Where else could it have come from? The result of Mildred's study was fascination for Jesus as a gigantic hero who took of His own will the cross and the consequences of taking it. As she drew the cartoons for each station, one could see that for her the climax, the great climax, came when he told the women of Jerusalem, "Don't weep for me, weep for yourselves," and you could believe He said to Himself, "I know what I'm doing," as He raised the heavy cross above His head in a gesture of triumph.

Fairly itching to get into it, I begged permission to execute one station from her design, to experiment with how far scraps of glass and broken china would go toward a convincing per-

spective, which in the portraits I continued to paint was necessary. Mildred agreeing, I took one piece to Allison's in hope of arousing some interest in meaning, planning to complete my experiment there. Mildred had depicted Christ's poignant meeting with his mother. I laid the piece on the floor near the entrance of the pavilion, where it must be seen or stepped on. Three bosomy women from Waynesboro, unloading their painting paraphernalia outside, seemed to bring in one awkward thing at a time. They had no use for me, having received their lessons elsewhere. They came for a day's painting and a delicious Allison's meal, so I was not spoken to, but one announced to each of the others in a loud voice as they came in, "I'm going to make me one out of buttons."

The last one stopped, stared, and in a shrill voice asked, "How would you clean that?"

"You could shoot a hose on it, for all I care," I retorted, as furious as I've ever been.

Unperturbed, Mildred, wisely at home, extracted from her most private emotions exactly what she felt. It was fascinating watching her when she'd let me. Retreating into her innermost self, she created her images mentally, then with a minimum of lost motion whacked them out without change, so that her freshest impulse remained fresh. The finished pieces were moving beyond all our dreams and magnificent in color. It was almost impossible to view them without tears, not for their pathos; there was little of that; it was the courage, nobility and greatness of soul they depicted that swept you away. They made a sensation at the church, in the newspapers, and with everyone who saw them.

Sometime later a grand new church replaced the smaller one. Before it was completed, the Vatican threw out of the service the Gregorian music, that beautiful mysterious sound that made you long for heaven. The congregation sang as dolefully as Protestants, and along with other reforms, the stations of the Cross were declared to have no place inside the church so they glowed even more in an open arcade where they were hung. Then sud-

denly, one was missing, stolen, we thought.* The rest were taken down and stored in the basement, like a sudden eclipse. Father Chatham was very sorry, but he was obedient to the rules of his church. And he had much more to worry about. Multiple sclerosis, hateful, insidious, and unrelenting, had by this time confined him to a wheelchair. He had wept when his trouble was diagnosed, because, he had "nothing to offer God but weakness." Somehow he bowed to the inevitable. Mysteriously, it was very noticeable that as his body by degrees weakened, his spirits rose. We saw much of him while he still walked, Mildred making a Lamb of God for his old church, a St. Francis, and an exquisite anunciation all in mosaic. He never left our studio without saying "God bless you," to which I replied, "Thank you," hoping in spite of everything that He would. Someone gave Father Chatham's new church a charming thirteenth-century madonna, and somehow he acquired a seventh-century crucifix.

One afternoon after he had ceased walking, but had rigged a hoist to get himself into the car he still drove, he phoned to ask me to ride with him to the airport where he was to meet the dealer from whose collection the antique objects came. In the highest good humor he said, as we got under way, "I've never seen this man. His first name is Walter and his last is unpronounceable. He's written fifty papers on medieval art and must be beyond middle age. Do you bet he's tall and thin or short and fat?"

"He sounds tall and thin to me," I responded to his gaiety.

"O.K. I'll take short and fat. Has he got thick white hair?"

"No, my man is bald."

"All right. He's got to wear glasses. Do you think they're so thick they make his eyes look too small?"

"Yeah, sure."

"I'll take plain glasses then."

*The missing station was later discovered. All were shown at the Old Capitol at Christmastime, 1978.

Monsignor Josiah Chatham

At the airport we didn't wait long. Among the few passengers Walter was easily identified.

"That's him, he's got on a vest," said Father Chatham. You hardly ever saw a vest in Mississippi, in summer.

I got out, introduced myself, and Walter asked that I'd see his bundles, carried by two porters, safely stored in the trunk, saying he'd had a slight stroke the year before and was not completely sure of himself. I held the door open for him, but before he could get into the car, Father Chatham shouted gleefully, "I win, Karl, he's short and fat with thick curly hair. Turn around, Walter, and let me see your glasses. Yep, thin. You owe me a drink, Karl. I win all over." I climbed into the back seat, leaving a nonplussed Walter in front.

"You said you had a stroke, look here." And Father Chatham pulled up one trouser leg to reveal a steel brace that reached his knee. Before the car started, the priest looked intently at the city man's profile.

"Walter, you're Jewish, aren't you."

"Yes, I am."

"I'll convert you before you leave," and he started the car. Looking straight ahead, Walter said earnestly, "No, I can't go back on my people. Hitler killed too many of us. I love your church and your art but no . . ." and his voice shook a little. Father Chatham put his hand on the shoulder next to him and dropped his banter.

"Walter," he said quietly, "Karl and I don't care at all. Do we Karl?"

"Not a bit, I'm no Catholic, either."

Walter looked surprised, if a jerk of a head seen from the back tells you anything. "I never expected to meet such tolerance in Mississippi," he breathed.

"We're ashamed of Mississippi," I put in. Many of us were at that time. The abysmal comedy at Oxford had just been played out.

"Say that again, Karl, and say it loud," Father Chatham demanded. I said it again.

123

Mississippi Artist

It was dark as we neared the city's trashy outskirts, neon and joints lining the highway among numerous cross-roads.

"Watch carefully for me, Karl, I've got a confession to make. I don't see at all well at night," the priest called back to me as he ran a red light. I watched, but he drove all right after that, and when we were in the city he asked where we could buy beer.

"Drink beer, Walter?" he asked.

"Oh, about a glassful a year."

"I'll drink all you leave. Karl, tell me where to stop."

At a Tote-sum I got Budweiser, that being the only name my unfamiliarity recalled.

"Please serve it when we get home, Karl. The glasses are in a cabinet over the refrigerator, unless Queen Esther's moved them."

"Who in the world is Queen Esther?"

"Oh, she's the cook."

Shortly after, Father Chatham was removed from his too-active position to a quiet place miles from us, and we saw no more of him for some time.

Bertha Lee

The first thing we noticed about Bertha Lee was her caution. She asked us to pick up any loose change dropped out of our pockets so she wouldn't have to touch our money. She would also acquaint us with violence such as we'd never known. Working, she was efficiency itself, going every minute in spite of our telling her to slow down. Two younger half-brothers lived with her, Tom and Elbert, Her own son, Jimmy Lee, the delight of her life, painted, despite derision of classmates, with a color sense fresh and gay. I saw all his paintings and wracked my brain to tell him something constructive about each. I was fond of him; he pleased everyone. Joe, Bertha's common-law husband, was very black; Bertha's color was like the flesh of a ripe cantaloupe; and Jimmy Lee's was what was then called high yellow. Joe, a staunch character, had a son and a daughter of his own, and Bertha told us they weren't much good. They had come to stay in the crowded half of a house that five people already occupied. When I picked Bertha up one hot summer morning, I saw the big boy, an ebony Adonis in shorts, run through the small yard waving Bertha goodbye. She was uneasy. The girl, she said, was a real troublemaker. The boy loved Jimmy Lee, and Jimmy had begged his mother to let him stay; they had fun together. That morning I knew from her silence that Bertha was praying; and I could feel her unease.

It had not been easy to really know her. She seemed to pull a shade down between us every time I looked her way, but in the back of the car, not under my gaze, she invariably had something ludicrous to tell, and she told the slightest incident with superb style. She insisted on sitting in the back of the car

after a black man had shaken his fist at her for sitting in front with me.

That day she moved about the house with her usual speed, but her silence was marked and heavy. Writing letters, I was actually possessed by foreboding when the phone rang about 10:30 and a feminine voice said to tell Bertha to get home, Jimmy Lee had had a bad accident. I drove the five miles through the city as fast as I dared, telling her to watch for cops. There was a narrow porch across the front of Bertha's house, and from the ragged ends of its floorboards blood dripped red in long coagulant strings. A long knife lay in the grass, and a shotgun was on the porch.

Heat poured from the July sky as I tensed to hear Bertha Lee's scream or my own. Instead, time stopped. A mosquito whined by my ear in the waiting silence. Two dozen black faces, showing no horror or concern, stared at me from the perimeter of the small yard, and when my gaze found Bertha, she lay unconscious in the long grass. As in some arcane ritual, I motioned to two women to pick her up, and they moved with ritualistic slowness to get her into the house, seeming maddeningly resigned to the horror that was shaking my very core. Next door, Miss Anna, an angular, erratic woman I knew from Bertha's stories, rocked in her porch swing with her male boarder. She grinned when I looked her way.

"Don't touch nothing till the police come. That's what the television say," she said, and in her eyes I could see the insanity Bertha had described. I turned away, swallowing vomit. Across the street was a storefront with wide windows, through which I could see two young white men. They had seen a big boy carry a smaller one to a car and drive off—to "finish killing him," they figured. (It was the car Joe had bought Jimmy Lee for ninety dollars, so he could "enjoy life.") On the white men's phone, I called the hospitals, finally locating Jimmy Lee at University. When I returned to the yard a man had driven up in a big automobile. He looked like a lion with grizzled gray mane

and yellow eyes, into which I stared begging for something I could not name.

"He's at University Hospital," I said as evenly as I could. The yellow eyes looked into mine and voicelessly said, *You know nothing about this nigger stuff, white man, and I shook my head to say* No, *as if he had spoken.*

Women supported Bertha, now in her best dress, to the car. The driver asked if I would go with them, but I went home and phoned the hospital. They had done everything they could, but Jimmy Lee had received a blast of buckshot full in the chest and they couldn't save him. Five minutes later Bertha Lee called me and in a little girl's voice cried, "Mr. Wolfe, Jimmy Lee's dead." I leaned against a wall, weeping, whipped.

The two boys had been playing a game they called "bluff." Jimmy Lee outside with the knife I'd seen and Joe's boy inside the house, with a defective shotgun in his hands that Bertha thought she'd hidden from everyone. Somehow, beyond anyone's intentions, the gun had gone off, ending a life full of grace and cheer. The police took Joe's boy to jail where, between sobs, he begged to see Bertha Lee. But she would not go near him; the sight of him alive with her beloved Jimmy dead might make her hate him, and she would not take the chance. They let him go, finally, without trial; he could not eat.

After a month, Bertha returned to work, as efficient as ever, but with a numbness we could feel. We knew she was making a superhuman effort to accept her fate, and a deep change had taken place inside her. She seemed to have crossed some chasm between us. Now she looked at me as if I were a creature like herself, one who *could* feel the same thing as she did.

"The first time I saw a white man he pointed a pistol at me and said he was going to shoot me. I was four years old. We was in a corner of his field picking wild plums, and I begged him not to kill me there, cause my mama'd never find me."

She was explaining something; taking advantage of the time between her house and mine as we rode that distance together.

Mississippi Artist

She spoke deliberately as if I *must* understand what she told me.

"When I thought about it later it seem to me he'd been laughing, but I was so scared I couldn't look at any white man without shaking inside, till I come to work for you-all. You don't know what it mean to work in a heaven like your house is."

We didn't know. She could not remember how often she was unable to drive herself back to a job to collect her pay, having taken treatment no white person could endure. Each unkind word had thickened the wall around her, outside of which nothing but terror existed. When she got to Memphis years later on her way to a brother in Chicago, who had a responsible job, the wall collapsed and she could breathe without fear, for once. But when she came back she told how Chicago, too, had frightened her with people gone crazy on dope and alcohol.

Bertha Lee grew up with violence, the heritage Richard Wright described in *Black Boy*. Her step-father beat her mother to death, she thought, gradually, with a pistol. When Bertha was six, she peeped into their room to see her mother's head on a blood-soaked pillow, the man's arm over her body. Another time she followed her mother to Canton six miles from home, hiding in bushes behind her. Her mother had determined to buy Bertha shoes, against the mad-man's expressed wishes and threats. In the town she watched, still dodging her mother's sight till she saw her go into a store and not come out. Toward nightfall Bertha found her in a back alley beaten unconscious.

"Why didn't you kids kill him?" burst out of my anger.

"We was too little. We thought about how we might could shoot him with his pistol, but we never could git ahold of it. And sometimes he wasn't mean. He loved Elbert, who was his chile. Mama'd say 'Don't make him mad, you know how crazy he is.'" A woman with five children to feed. They had to work hard, but she worked hardest. She bought cheaply the runt from a litter of pigs each spring, washed him, greased him, fed him, petted him, gave him the run of the house, and ate him in the winter. Bertha could never eat the pig. She was the queer one, always dreaming, asking questions nobody could answer, or try-

ing to read any print from a world outside her own. What might she have been with education?

When she was fourteen, filled out, and probably pretty, the family worked on a Delta plantation. The white bossman said, seeing her comeliness, "Give me that girl, I'll make it easy for her."

"No," her mother answered, careful not to speak anymore of her mind to the man who was like a red-faced bull.

"What do you want for her?"

"She ain't for sale."

"I'll take her anyway," and he turned to do it, but Bertha had fled to the woods, where she lay, out of breath, behind a log. The man stepped right over her.

"Why he didn't hear my heart jumping, I don't know. Seemed like it would jump right out of my mouth."

At nightfall he gave up the search, came back to her mother, and said, "You'd better have her here tomorrow."

Desperately the two women packed their belongings, dragged them across cotton fields, crouching low between the plants, to a road, where, after midnight, a bus picked them up, for their last cent. They left the crop they'd started, the pay due them, and never went back.

The valiant mother died after some unnamed illness, her head beaten out of all human shape. The step-father had long since gone his mad way. How they were supported I don't know. Bertha must have been not more than eighteen, with a child of her own. She'd been married and deserted after immemorial fashion. Some twenty years later she'd saved enough for a divorce from the man she had not seen in twenty years. But she didn't marry Joe, with whom she lived and whom I cannot imagine unfaithful.

One could feel in Bertha Lee a fidelity as unshakable as her integrity. Perhaps in her they were identical qualities, parts of the same thing. Shortly before Jimmy Lee's death she got in my car in an agitated condition. She had heard Jimmy Lee planning to play hookey with a friend. He was gone before she could

catch him. She would think all that day about what she would tell him that night. Next morning I asked as soon as she was in the car what she had said to him.

"I fixed him. I told him 'bout one time when he was a little baby wasn't no food in the house. I had just thirteen cents. We was three miles from any store, but I walked three miles carrying him, trying to figger out what was the most I could get for my money. I decided it was oatmeal. I got the oatmeal and walked back, carrying him. For three days I didn't eat, but he did. He was cryin' by that time so I told him, me and Joe was holdin' the load for him, sending him to school so he'd be prepared to carry it hisself. But it was out there waitin' for him."

Thoughtful and thoughtless people are everywhere. It is easy to conclude that among all humanity the thoughtless constitute a vast majority. Most of us coast on established customs till some authority proves us wrong, and if you look into history you become convinced we've been wrong most of the time. One mistake is corrected by another fully as dire and that one replaced by another still worse. Try as we would it was difficult to think of the new problems posed by integration without some sort of prejudice. Real thought is accomplished sans tradition, sans feeling, sans inheritance as in a scientific laboratory. If two apples are added to two apples on a table before me, I will paint four apples because I see four. St. Augustine suggests that four would be seen in heaven by the same addition. The builders of Chartres Cathedral knew this theory and considered mathematics one area undefiled. Dimly we try to solve human problems with this same purity and sometimes it works, or seems to. But when everywhere the cry for justice beat against our long indifference we woke to resentment, pity, or the complaint of Moses burdened by the people he'd taken out of slavery. Examining ourselves we found no occasion on which we had been deliberately cruel or even discourteous to any member of a race we'd been brought up to think inferior. We subscribed to everything that would better their condition. Education might

130

be one of these and we approved when more tax money than they could ever pay was spent on their schools never dreaming that education itself could become the shambles it is now, though we could see it wasted on many of our own.

Somewhere I've read of an old Jewish belief that goes this way: If among all the children of Israel no sin is committed for just twenty-four hours, the kingdom of heaven will descend on earth. A breathtaking proposition, seeming quite impossible. but will heaven touch a small spot where animosity is absent and peace and good will prevail? There is much evidence that it does.

Shaw's Liza Doolittle says, "It's not what a girl does that makes her a lady. It's the way she's treated."

From our experience we know this does not always work, but from the number of times it has, we are sure that nothing else is worth trying. We'd never dreamed of an apprentice until Ronnie Lindsey, sent by his mother, wondered if we could "use" him. He was seventeen years old and lost. We took him on at one dollar an hour. He ate with us and for a time lived in Zanadu. He thought he should because his mother, who had a responsible job, brought breakfast to his room each morning before she left and he could see this was doing him no good. Ronnie had to keep track of the hours he put in; I would not be bothered by this petty police job. He could work when and if he pleased; he must tell me what I owed him.

"Why is the rest of the world so screwed up?" he asked one day, genuinely puzzled.

"Do you think I would lie to you?" I asked. We were looking directly at each other.

His "No" was decisive.

"Do you think I'd believe you could lie to me?"

"No," even more positive this time.

"Doesn't it feel good?"

He didn't answer for several minutes, then with a smile full of comprehension he breathed out "Yes."

Perhaps this has little to do with the integration that came to

Mississippi Artist

Mississippi dragging with it confusion, resentment, and violence, but it might. In Jackson, black students marched peaceably down Capitol Street. Once wasn't enough, they had to do it again and talked about it. A week of tension followed, during which I deliberately drove with Bertha Lee down streets lined with small yards full of flowers, where black people lived, telling any owner I chanced to see how pretty they were.

"You don't have to be scared, they likes you," Bertha said.

She told me that she had seen policemen sic dogs on Negro students playing on the campus of a colored school her bus passed. Children ran in terror "every which way." The principal hid in a broom closet, she said. Why? It was never in the papers. Why? Why? I begged Bertha Lee to see that Tom and Elbert did not join the demonstration that was threatened, but for which a permit to parade had been withheld. Anyone joining it would be jailed. Such things were likely to get out of hand with considerable damage to property.

"I don't know nothing 'bout NAACP," Bertha said. "All I wants is to pay my bills, but after what I've seen I can't blame 'em for protesting. I'll tell 'em though, I don't want 'em in jail. But Mr. Wolfe, can't nobody tell what a teenage boy's gonna do."

The jails overflowed. State Fair buildings were used to house the demonstrators among whom were Tom and Elbert. That was Thursday. Saturday afternoon Joe phoned to say Bertha, who had gone to try to get them, was in jail; it would take a hundred dollars to get her out. Mike brought me his money, Bebe brought more, but Mildred put a hundred dollar bill in my hand. She'd sold a painting that morning to men from Louisiana who said they had come to us because we painted things they could recognize. I hurried to the courthouse in the dirty shorts and torn shirt I had been painting in, paid Bertha's fine, and escorted her to Joe's waiting car, her eyes completely opaque, her face tight with suppressed anger.

"They stopped the elevator between the floors. That's where they beats you. They started taking off their belts, but I joined

my hands in solitary prayer and shut my eyes. They said something 'bout me acting so Christian, but I didn't move. After while they put their belts back on and took me up to jail."

"They didn't hit you!" My relief was measureless. "Who were they?"

"Two plainclothesmen."

The receipt that was given me for the hundred dollars was a thin piece of paper full of fine print. She was charged with inciting to riot. At home, I read it through. You could protest your innocence at the date specified. If you did establish innocence at the courthouse, of course, the fine would be refunded. I found a Bertha quite willing to tell me what happened. Saturday morning a message over all radio stations said the children incarcerated at the fairgrounds would be released into the custody of parents, who should come to claim them. Bertha was busy all day, but a friend urged her to go, and since Joe couldn't be found, she went, fearful of what she'd do. When the pressure of anxiety became too great, control of Bertha's senses left her, and she became unconscious, falling in a dead faint. Like a pressure valve. It had happened many times.

At the fairgrounds they let Tom, who was twenty-one, go without question. They brought Elbert into view, so that Bertha could run to clasp him, but something was not clear in the record they'd made on him, and he was pulled out of her arms and taken back to the building. What would they do to her mother's baby! The pressure was too much, Bertha fainted. In the truck taking her to the county jail she regained consciousness.

On the day of the hearing specified on my receipt, I dressed up—even put on a handsome Christmas tie—and waited for Bertha at the courthouse. The building swarmed with policemen all oppressively polite. Deferentially, I was told to stand here, stand there. When Bertha Lee arrived, we were ushered into the courtroom where we sat side by side. I was called out and politely asked if I represented NAACP. No, I didn't. I must wait outside the courtroom. Stand here please. Totally bewildered, I

stood there, wishing I'd see a familiar face in the busyness that was like a beehive, as sure of myself as a fish out of water. Then Bertha appeared, dismissed or postponed—indefinitely? They were about to have a massive hearing in the courtroom and we were in the way. When I got her into Joe's car, I went back. Nobody was still long enough to talk to, so I stood at the window where I'd paid Bertha's fine till somebody had to ask what I wanted. He was handsome as a movie star, young and neat, his uniform impeccable. Did the slip of paper in my hand really mean what it said? Could we get the money back, so Bertha wouldn't be burdened with paying it? She'd worked for me for some time and we trusted her.

"Most people don't come back after they pay a fine." He was neither polite nor interested.

"But Bertha has told me what happened. It seems to me she's innocent."

"I think she's guilty." He said loudly and angrily, as if he defended a holy altar, his dark eyes piercing mine. A half dozen faces in the office turned my way, sending me the same unrelenting stare. I felt bombarded as if by blows or arrows, but held on.

"What can I do?"

"Well you could talk to Chief Barnes at the fairgrounds—he made the arrest."

At the fairgrounds I asked where I could find Chief Barnes. A cop pointed to a pleasant faced little man. I said thanks, but not to the cop.

"My name is Karl Wolfe. I've lived in Jackson since 1932. I've just painted a portrait of the governor's wife, Mrs. Barnett, and hung it in the Mansion. I'm an artist, not a yankee lawyer."

"What did you say your name was?"

"Karl Wolfe."

"Any relation to Wiley Wolfe in Columbia?"

"Brother."

"Wiley's my best friend."

"If nobody was looking, I'd hug your neck," and I realized

when the air left my lungs, I'd been holding my breath. How long?

"I'm in a spotlight here. Been answering the phone all morning, New York, Chicago, California. One voice said, 'Is it true, Chief Barnes that you make the girls strip so the cops can look at them?' We got boys in one building, girls in another. What kind of mind hatches ideas like that? Girls have torn up everything we put in there for their comfort—all the beds—boys not half as bad. Girls started tearing up fixtures; had to tell 'em they'd be disciplined. You can imagine what that means. I don't want to whip 'em."

The little man's face was troubled. I told him about Bertha Lee.

"I remember Bertha. She screamed and fell completely out— flat. Looked like somebody knocked her down. I had to get her away before some kid looked out a window and saw her. He'd be sure we did it, and what a riot we'd have then. I sent her off with two plainclothesmen. Knew she'd be all right with them."

"But she was fined one hundred dollars and she'll insist on paying me."

There were lines of weariness around the smile he was trying to keep on his face.

"I've got two teenage boys of my own. Nobody knows what a teenager will do. I'll be glad to see the last of these kids, if somebody'd come get 'um. Let's see . . ." Wearily he ran a hand through his black hair.

"You bring Bertha to my office next Thursday, four o'clock, and I'll see what I can do. I've been up twenty-four hours."

"Thank you," and I shook his hand.

Thursday at four, Bertha and I sat side by side in his small office. Elbert was at home. Chief Barnes, looking at her across his desk said, "Bertha, you look different today."

Bertha even smiled as she replied, "I feel different."

"Bertha, you know anything about the NAACP?"

"No Sir, nothing."

"You're not a member."

"No Sir."

135

I went with him to the end of an empty corridor outside his office where in a whisper he said, "I can't refund all the money, but I can cut the fine in half. If that's OK with you, get Bertha and follow me."

He led us through policemen and officials, thick as bees in a swarm, to the central office. A woman with a careful blond hair-do and grim face put five ten-dollar bills into Barnes's hand through a small pay window, surreptitiously, I thought, and he, turning his body so no one had to see, handed the money to me. Then he led us as if through a maze out of the crowded building.

The Studio Fire
and the Troubled Sixties

No matter what we tried in the studio, it remained crowded and unkempt, even after Mildred joyfully installed her activity in her own realm. When we showed a customer paintings, it was against a trashiness that detracted drastically, so we began taking framed things to the house where they looked their best. Soon, one large closet was full of those we hadn't wall space for, and we built a shelf close to it for temporary display. Terra cottas we placed on all tables, and sales improved. We thought we worked hard. But was it really work? Many visitors said, "You play all the time." Maybe we did. But our play was deadly serious as in a tennis match or a foot-race. We never considered ourselves in competition with an opponent. Throwing a discus against any previous record we might have made is a better parallel to the effort that went into everything we did. The studio was more than a playground. Beset by worries that come with a family, sorely puzzled by trends we could not govern, there were times when we painted to ease tension. We found not only respite but clarification. The studio was the place where we spent our lives, our battleground, where we won or lost, the field on which we expended ourselves to the last drop. It burned to the ground, and all we could do was watch. I've tried hard to forget this trauma. Memory gives me no date to swing it on, except that Michael was still in high school. My memory still insists that glory is connected with the fire, this because I associate it with the physical love that has been glorious in my life with Mildred. When, at midnight Mike screamed, "The studio's on fire," I waked still saturated with transcendence and would have run naked as Alcibiades fighting his last enemies

to fight this fierce enemy of mine, had not some unconscious prudence reminded me to snatch bedroom slippers and jockey shorts out of my closet, getting the latter on as I climbed steps to the studio door three at a time. As the door swung open flames waved over my head like glowing serpents escaping a cage. Facing the source of conflagration, to the left was my part of the studio not yet burned. It was jammed with finished portraits that had come back for my inspection and a final varnish. There was one large painting I'd labored on and framed two weeks before. I felt no fear at all, though Mike and Mildred were both screaming for me to come back. When I opened the door to my studio, fire licked over my head. Like a drink of whiskey you can feel to the very bottom of your toes, one thought burned in me: my people, my painted people! There was no way to get them out, unless it was through the big north window; certainly not the front door I'd just entered; its frame was already burning, and as live coals fell on my bare shoulders I knew that my hair would quickly be in flames. Crouched as low as possible I backed out and ran to the north side of the building, picking up a brick to break the window. I was forgetting that it was too high to reach. There was a step-ladder close by—burning! I would kill that fire with the garden hose. The hose had burnt and no water came. Flinging it away I climbed stubbornly up the burning ladder, anyway. It fell out from under my feet. I was trying to breathe in a nightmare, the one that perenially haunted me, but one fixed thought kept me from giving up—my people! Firemen came. Hope surged back. I gave up the north window and bounded to the top of the steps just as two men, a powerful stream of water in their hands, were pushing open the front door of the studio.

"Let me in first and protect me with water while I get my people, my paintings, my people out," I shouted, just as the water died with a sickening droop, like a wilting plant. We sat and watched the studio burn.

Our loss was considerable. Insurance on the knocked-together building anticipated neither so many portraits in it at once nor

The Studio Fire

the equipment we'd gradually accumulated. Six giant trees were critically burned. I felt inconsolable. Portraits could be done over, but fifty years had gone into the trees' growth, and there were not fifty years left for me to watch them grow again. Black, still smoking ashes confronted us in daylight—all that was left of labor, high-hearted or menial, gone in minutes; Mildred's darling studio, all the melancholy fall days spent patching the roof against winter rains, boards pulled loose and nailed back again, white asbestos siding over them, now a mound of rubbish only inches above the soil. Our house would have gone too but for a new neighbor, on its roof with his garden hose, a silent wraith I only glimpsed and never adequately thanked. He died shortly after in a plane crash. If there is consciousness after death, may he feel my gratitude even now.

How did everybody learn about the fire? The newspapers must have been more than kind. Suddenly our house was full of people buying at half-price the paintings we'd stored there. Mildred's head went high. Her paintings would rebuild the studio. My small madonna full of Italy and Van Eyck painted in 1932 went to a friend the morning after the fire. It brought a substantial sum, but I had almost nothing else. Kindness was like a miracle and buoyed us. In two weeks, we sold at half price ten thousand dollars worth of art. To rake the ashes and see what they could find, the curator of the exquisite museum at Laurel, Mississippi, came with Mack Cole, a former Millsaps student of mine. The ceramic pieces they retrieved were curiously colored by reduction from wood flame (as when wood chips are added to the kiln), looked rare, and brought substantial prices. Some are in Laurel's museum now.

One portrait, the most recently finished, now ashes, had been added to the household insurance of the careful lady who'd sat for it. She had delayed getting it out of the studio, but had insured it. She was paid for it, but she insisted the loss was mine and gave me the money, with the stipulation that I paint her again and let her pay for the second portrait.

Before the fire, a large painting of her daughter-in-law was

brought to me the paint peeling in tatters—a sock in my stomach. I had painted it only ten years before. Parents and in-laws had watched my face to see how I'd react, but when the first shock was over, my pronouncement was unequivocal; a new painting must replace the old one, of course, at my expense, of course. Their satisfaction with this decision was plainly evident. The second portrait had been done and safely delivered before the fire, and now it was good to feel their generosity that, to some extent, must have resulted from my own fairness.

The canvas on which the daughter-in-law had been painted was double-primed linen, the best available. On examination, it was obvious that the final priming coat had separated from the first and peeled off, taking with it the paint. Any skilled house painter knows that wood should be covered first with a lean coat, that is, paint thinned with turpentine. The second coat should be fat, full of oil. This goes for canvas artists paint on, and it has been known for centuries that if you reverse this process making "lean" cover "fat" you can look for trouble. I called the company in New York, whose name was prominent on. the selvedge of the canvas and talked to their chemist with no satisfaction. In our sea of troubles, which began its steady rise, I forgot, till another portrait was brought to me in the same ruined condition, and another, and another, till in two or three years there were fifteen—fifteen portraits to be replaced at my expense.

There was no way to stop painting *new* portraits. Dr. Smith, a former president of Millsaps College must be done at once. I made a small study of him in Mike's shack, but there was not enough space for a large canvas there. The room I taught in at Millsaps, a former kitchen, had tall windows that flooded it with light. Its ceiling was fourteen feet high. My students met there twice a week, and no one else occupied it. When I asked permission to use the room as a studio, I was assured the school would like nothing better. A new model's stand got banged together, an easel, paint, brushes, and canvas bought; our neighbor loaned his truck, his yardman, and we got the stuff moved in. I had to learn to ask for favors and to accept them. It was hard.

The Studio Fire

Dr. Smith was my friend. It was he who, soon after the war, asked me to teach art at Millsaps. Later when times grew lean and the school, always in a precarious financial condition, became hard up, he suggested I take a sabbatical. I sensed it to be his polite way of firing me.

"Before you let me go, come see what I do," I suggested.

My best students' work had been mounted for exhibition. They'd managed to get on paper their innermost feelings. One remarkable drawing, beginning as an illustration of Cain and Abel, had ended in a malestrom of violently clashing elements. The girl who did it whispered, being too shy to speak aloud.

"Most of my students have no real interest in art; they merely fill their schedule, so I try to give them something they all seem to need."

"What's that?" asked Dr. Smith, showing interest.

"How to make up their minds."

"You can do that?"

"Yes, it's easy in an art class. Mathematics for instance, demands one right answer. When a student asks what I think of his work, I merely say, 'What difference does it make, what I think?' He says, 'But you're the teacher.' I say, 'But you're the pupil. You are the most important object at Millsaps.'"

"'Me, important?'"

"Of course, Wouldn't it be silly to have all this set up, buildings, faculty, cafeteria, gym, and no students?"

"'Hmm!'"

"What do you think of what you've done?"

"'Not so hot.'"

"Are you interested?"

"'Yes.'"

"Try it over."

"It's funny how trying it over seldom occurs to them. I guess they get pinned down to one answer on so many tests."

"You're right. Nobody, positively nobody else ever suggests that a student *can* make up his mind. They are robbed of that faculty. We *can't* lose you."

So I stayed on for twenty-five years. I must have become a

character. Other instructors told me of advising students to take
art to "experience Karl Wolfe." Conventional teaching methods,
academic lore, and language were unknown to me. My grades
were always late; I loathed grading. A handful of brilliant stu-
dents, through the years, compensated me. The salary didn't.
For a class full of frustrated or indifferent students, as Christmas
neared, I found myself recounting the magical story of "Our
Lady's Juggler" to a silence in which I could almost hear heart-
beat. This recital was invariably followed by furious activity.
When Christmas got closer, I read aloud Dickens' avalanche of
words and sentiment, "A Christmas Carol," plowing through
tears, losing my voice, finding it again, a husky whisper, blowing
my nose until at the end, girls stood eager to hug me, their
world far removed from what they longed to cherish. Boys es-
caped quickly in order not to give away their submerged feel-
ings.

But I must drag myself backward to the time of our disaster.
Now the roof of our house leaked. With the man who was
helping me clear the site for a new studio, Mike and I tore old
shingles off the worst side, nailing new ones on. What came over
my son then? I could not understand his surliness in the face of
my need. I felt alone and defenseless against the impersonal fate
inexorably bearing down. Bebe stayed sick, missing school.
Mildred was sick for three months. Mike wrecked two cars. For
several years our medical expenses were five thousand dollars a
year, eating up all we'd gained from our sale. My heart went
wrong, beating twice, then stopping; three beats and a stop,
four, then one. "Genetic condition triggered by stress," the doc-
tor said. But before I went to him, unaware of what the trouble
was, I could see myself an invalid, someone who had to be
taken care of! Did other people have these troubles too? "Yes,"
my doctor said, "but not in bunches."

I had by that time passed the despair my mind conjured up,
when there seemed no way to finance Mike at Duke University,
to which he had a partial scholarship. Pure despair is the black-

The Studio Fire

est of sins, denying help from any source. It was Willie Wills who jerked me away from the edge of it. when he found me face down. He enumerated my assets, nearly seventy-five thousand dollars! A life insurance policy almost paid up could be cashed in and invested. Interest on the investment would help pay premiums on a new policy and there'd be some cash for what was needed. But there was not enough for a new studio, so when my brothers offered a loan without interest, I accepted it and hired the salt of the earth to construct the building. He was big rugged, forthright, with arms as beautiful as the feet that entranced me in Italy; a hammer in his hands like a bow in Menuhin's. I paid him bit by bit as the long work was done. Rising prices drove the cost beyond our modest estimate. When his last bill was handed me, I read in my sick state, "$1,350." I could not look at it again, stuck it deep in my desk, but kept the figure flapping in my mind until I had that much in the bank. Thereupon I wrote and mailed him a check for that amount, ignoring other debts. He got it the same day and came immediately to say I owed him only "$350." I hugged him with all my heart, wrote a new check for the lesser amount, which even then I had to persuade him to take. What can replace such quality?

Wrapped in my own troubles, I didn't realize how deep were Bebe's. After I had replaced the last ruined painting, I told her we'd send her to Ochsner's Clinic in New Orleans to find out exactly what her ailment was. She wept and asked to see a psychiatrist instead. Her deep trouble started at thirteen when she was placed in a slow class at school because she could not spell. At the time, however, she had read college zoology, which interested her. A low fever, which seemed a constant accompaniment to her sinus condition, became a refuge. When the thermometer wouldn't show fever she found ways to make it show. We discovered allergies and latched on to that. How long did she hide in bed, the consciousness of herself as deceiver always with her? How hard it is to understand another person.

What the year was, I've tried to forget, as years for me grow

143

scarcer, but the month was December when we opened the new studio for our usual Christmas sale. We had fourteen pieces, mostly mosaics as I recall. Before Christmas came we had made sixty more. All sold. A studio, fire-proof, even to the cement beams roofing it, wide north windows in painting rooms for each of us, a big room for dirty work, and a small gallery I hanker to enlarge as it overflows with superb painting from Mildred's brush, is ours. Its completion must have done me good, for in a little time the last peeled or burned portrait was replaced. Then I felt like crowing from the highest place I could climb to, like a rooster.

Soon after that everything would change.

More Portraits

Few debutantes come to my door now, as I am called on more and more to paint prominent men and women. Most often my portraits are valued by people who contribute the money that pays my fee. This is something to think about, a "pinnacle and steep" that must be climbed to find the level of the value placed on them. How can I say what painting has meant to me? A sacred trust I can never betray—a joy beyond all joys, save love—an agony I must not succumb to, and a discipline as rigid and yet as relaxed as any a tightrope-walker might endure. That is the most difficult of all.

I have worked hard, maybe as hard as a man can. Once, long ago over a sawmill boiler under a tin roof, the heat was so intense my nostrils inside were blistered. But making a painting look like I want it to is harder on me than that was, harder than anything. People seem to imagine it might be simple to paint a portrait—just copy a person's face, his color, his suit, his tie. Many people would be satisfied with this much if a little flattery were added. This is only the beginning. Every inch of the canvas must say something succinct about the inner life of the subject, every brush stroke and color must be orchestrated to say how his life affects the painter as one integer in a whole community. One makes a sonorous abstract whole so that it is a beautiful painting first and incidentally a portrait. People change continually. In no time there will be no likeness and before a painting disintegrates there will be no one left to know if there ever was a likeness. Yet, more than anything else, a decent painter must strive to tell the truth if he can. Occasionally I am accused of flattering a sitter. Never have I consciously done so.

Mississippi Artist

Light itself can flatter. You pose a head so that light falls on it in a beautiful, entrancing way, on cheek, on nose, hair, on cool melting into warm, pink into green, on luminosity into shadow till what you see when you begin painting is not a person at all but the miracle of light. Suppose there were no light. Wouldn't we all die along with the plants, birds and animals? Light is a most casually accepted miracle.

Then, of course, I talk and listen. Soon I know what the sitter will cotton to, and this becomes a tool of the trade to pull him toward the revelation of the best he has. It's hard to believe, then, that there is not something good and noble in anyone. But a woman once offered me any fee I'd ask if I'd paint a beautiful likeness of her. Her sister's portrait was full of animation and good looks because she had both. But this lady was possessed of a homeliness as cruel as a briar, and her dissatisfaction with herself was quite offensive, as if all her energy were consumed in envy instead of the development of some compensating grace. I was young then and tempted by the money and the prospect of magically changing a hideous duckling into a glorious swan. But I knew that without perjury I couldn't; and the more I thought of it the more repulsive the prospect became. I'm glad I didn't try, though my refusal might have left her incurably despondent. Perhaps she found a less squeamish painter.

Dr. Ewing, president of Delta State College, was no beauty, either, but he didn't care. The college wanted his portrait, but he let me know he had no interest in the project. However, he did need directions to get him to my studio. Highway 51 had been laid with grinding noise just beyond our peaceful acres. A large reservoir, infamous now for its role in the 1979 Pearl River flooding of Jackson, had been made ten miles beyond us. For a while, lost and desperate souls knocked on our door asking for directions to once familiar places as interchanges tangled themselves around and within the city, which had become a metropolis. I drove Mike five days a week to a school on a new highway, then, after picking up Bertha Lee, drove back to sanctuary by a quieter route with more flowers for us to enjoy.

146

More Portraits

Getting Mike from school added five more times a week to the invariable route we took so that when new signs went up, they might as well have been invisible, and when Highway 51 became Highway 55, I was unconscious of and quite indifferent to the change. Dr. Ewing, whom I'd never seen, called from downtown for directions. Yes, we were near Highway 51, not 55. Was there a sign nearby saying Ross R. Barnett Reservoir? No, there wasn't one. Thirty minutes after his call, he stormed into the studio.

"You *do* live on 55 and there *is* a sign right by the stoplight saying Ross Barnett Reservoir." He was mad. But when I said mildly, "I'm not lost," he quieted down and almost smiled. During the sittings, he relaxed and mentioned his troubles: He wanted to be liked. His confrere, the dean, could say no a dozen times in one hour's conference with a student, who went away loving him. Ewing could say yes as many times but the student hated him. His manner, he rued.

"I like it," I said.

"I know you do, but you're no student."

When the portrait seemed finished, I told him, "I think you ought to look at it once."

"I want you to know," he said, rising from his chair, "I have no interest at all in this portrait, but" at an ordinary pace he walked past my easel, looking over his shoulder—"you've got one eye higher than the other"—and my door slammed on his final departure as he said "other." Sure enough, I had to correct the eyes. But I liked very much the honest irascible man, and the portrait was quite beautiful.

Mrs. Lane, was an elegant and determined woman who drove her car with a cast on her broken leg. While I painted her husband, who was eighty-five and reluctant to pose, she sat on my studio couch and without a bobble did Juliette in the tomb alone and afraid of death. I was electrified. We'd been spouting poetry at each other, after I found Dr. Lane read and spoke French. Sometimes poetry works to pull a model to his highest

point of response. Sometimes it doesn't, and I had learned by then whom not to try poetry on. The painting was little trouble; grey coat, grey background, florid face, and a touch of light yellow in the tie and where the chair showed. They were pleased and I was pleased. It would look well in Dr. Lane's clinic. Two months later she brought it back. I hadn't made him mean enough! The man had died; now Mrs. Lane felt responsible for a true likeness of him that would live.

"You want me to make him meaner?" I asked, incredulous.

"Yes, he was mean."

"But he had a sense of humor. When you said 'I've got so many wrinkles,' he said, 'they don't hurt do they?'"

"But he was mean."

"O.K. I've never had to do this before. You sit where you can tell me how to make him meaner, but don't let's lose that humor."

After a careful search I seemed to find something and after some surprisingly minute changes with the smallest brush I had, she was satisfied.

While Dr. Lane had sat, we discussed another doctor who flabbergasted just about everyone, Dr. Henry Boswell. He seemed twenty feet tall when I painted him, yet he laughed on my level, wholeheartedly and without condescension, falling to pieces as if topping your joke were the last thing he'd think of doing. I loved this generosity. When I mentioned the brotherhood of man to him as a beautiful idea, he said simply, "It's a reality, not an idea." For me his dimensions increased with every word he spoke, his seemed a life stretched as far as it would go. Concerning his accomplishments, he was neither modest nor immodest, doing things his own way, and making sense. I'm sure he never wondered if his way was conventional or unconventional, it was simply sane.

He had been a tubercular patient in Colorado. There he became convinced that proper diet was more effective in a cure of the disease than climate. To Mississippi, the most disease-ridden state, he came to see what he could do. As this is written,

148

More Portraits

I'm conscious that tuberculosis has been wiped out by miracle drugs. Its cure was once long, drawn out, and often hopeless. I'm also conscious that unselfish devotion to welfares other than one's own is a thing that seems now to belong to another planet, another country, another age. Perhaps I should stop reading news that comes out of New York—or Washington. Is unselfishness passing away too, like so many things—like polio and tuberculosis? Has it existed? Will it exist? My answer, when I think of some of the people I've painted, whom I still paint, is yes, it does exist, it will exist. Inhuman screech of highway, brutal architecture replacing grace, maze of blatant neon where green forest grew, trash wherever man is, expressionless automobiles like mechanized cockroaches menacing every stoplight are like the edge of a Kafka nightmare, but when you confront people in this up-to-date modern gunk, they seem almost as human as ever. So I stay with that and hope.

When I painted him, Dr. Boswell was there in the sky where I wanted him to be, and then I had few doubts. Twenty-five years later, Dr. Lane explained his colleague's magnitude.

"He was a genius," he said, "pure and simple."

(Here, Angie, is another great man for you.)

He presented a full-fledged plan for a tuberculosis sanitorium to the Mississippi legislature. When they readily adopted it, he said to them, "You will appoint a sanitorium board. They won't know a damn thing. I've got to find out now if they're going to run it or will I. Because if they do, I won't.

"You will," they agreed.

"O.K., they won't then. I'd better warn you." His administration was long and legendary. His gravelly voice could be gruff or infinitely reassuring. He'd learned when to be rough, when to go tender, sizing patients up with swiftness and accuracy in the eight-foot space they traversed between his office door and a chair by his desk. He thought he'd never missed; at least no one ever told him if he had.

"If you give the wrong patient tenderness, he'll go to pieces, then you can do nothing for him. But there are people you can

crush with a mean word. Sick people are susceptible to the way they are treated, and many people are sick in body or mind or both."

All kinds came to him with all kinds of troubles. Out of his Jovian amplitude he gave advice on everything from sex to finance. "Once a middle-aged couple came in, both weeping. He'd had a heart attack."

"I looked at them," he said. "'Yeah, you're going to die. Your wife will yell at your funeral, then she'll get another man, a better one.' They sat bolt upright and glared at me. That's what I wanted. Now they'd listen. I said, 'You don't have to die. If you do what I tell you, you'll have many more useful years. And you'd better pay attention to that word useful, or you won't have any life at all.'" Then he gave the man a regimen to follow. Thanking him profusely, they went away, arms around each other, humming a tune.

He explained his uncanny knack for reading people by way of his avid interest in genealogy—not the kind with family trees and such, but conjecture about bone structure, expression, build, and how they got that way. His fascination with people seemed endless.

One of his staff said, "Dr. Henry can run the hospital by himself. He just lets us help him." He ran everything within his reach. When bootleggers ruined his help with liquor, he held them up one night, and scared the daylights out ot them, with a flashlight instead of a pistol hidden in his pocket. Once a woman came to the hospital with seven trunksful of clothes. It was a Thursday afternoon, which for the doctor was held sacred for golf. Not that he cared about the game, but there had to be a break in his routine so he could stay efficient. No one should call him for anything. Great excitement met him that night. The many-trunked lady had demanded him and bawled out everybody else when he didn't come running. He let her fume all night and visited her on his usual rounds next morning. He slammed her door open and strode to her bed.

"I heard about the hell you raiscd when I was not here to

150

meet you. Six of your trunks have been stored in the basement, because you not only have to do what I tell you, you've got to wear what I tell you. You don't like this room. Well, I left the door open so you can see the room across the hall. It's a duplicate of yours and we have no other kind. What's more, the child who occupies it hasn't a cent, and nobody who's kin to her has anything. Every patient here gets exactly the same treatment. Make up your mind whether you want to stay or not."

And he walked out. She stayed. She stayed till she got well and then she didn't want to leave.

After a pause, he went on, "The child in that other room really impressed me. She was in terrible condition with an abscess in the pleural cavity. I told my surgeon he'd have to operate. 'She could never take ether,' he said. I told him he'd have to give her a local. He threw up his hands. 'She's only eight years old; she'd be so scared we'd never get anything done.' Look, I told him, there can't be more than one boss here. Either you do what I say or I'll get another surgeon. And leave the child to me. She'll be all right; I guarantee it."

Children may have been as mysterious to him as they seem to other people, but he had to have their complete confidence, and he knew this would be impossible if he ever failed one. So he carefully never lied to a child.

The big eyes in the little girl's wasted face must have looked back at him with more than love, when he said to her, "Honey, we've got to operate on you and I want you to be brave. I won't leave you for a minute." Then picking her up, he carried her to the operating table, lay down beside her and held her in his arms till it was over.

"She never moved or whimpered."

"Doctor," I said, "you are a wonderful guy, but that child matched you."

"Yes," he said heartily, "she was great, truly great."

1977: A Bad Year

1977. The direst beginning of any year I can remember. In January my brother Wiley died in agony. Unaware of the depth of my love for him, I felt a knot of sorrow form inside me that seemed insoluble. The day after his funeral, Mildred went to the hospital for a critical operation. While she was there, her aged mother died. Mrs. Nungester had lived in a wheelchair after a severe stroke and prayed for death as she grew weaker, without her mate of sixty-four years. Mildred's sister, Frances, determined not to have their mother in a nursing home, had cared for her until she herself came near the breaking point.

In the North people froze as the snow piled high. Cold clasped even Mississippi in a record-breaking grasp as fuel diminished and prices skyrocketed. Snow came, beautiful to see from inside. My cold was worse, my footing none too sure, the temperature was down to ten degrees. I stayed away from the hospital for fear of infecting Mildred with my cold. Her surgeon found her gallantry and constitution both impressive, and I wanted her recovery as uncomplicated as possible. There was a phone beside her bed, so I contented myself with calling her. In freezing weather she came home from the hospital to convalesce. I cooked, washed dishes, cleaned house and kept the fire going.

Every book in the house had been read, and, having no other focus, my puzzled thoughts reverted for the nth time to the 1960s with a persistence I recognized as obsessive. How could a thing true for centuries be suddenly untrue? "As the twig is bent, so the tree is inclined." Had I bent the twig in the right direction?

1977: A Bad Year

When Mike was seventeen, the walls of his shack were covered with rejection slips. People who should know said they were about the nicest you could get. At fourteen, he'd mumbled something about being broke.

"Why don't you get a job in a grocery store?" I asked mildly. His answer was belligerent. "You're against my writing."

Everybody was against him, he thought. Physically he was no match for boys at school; he despised girls; they didn't count; he couldn't fight. Polio had ravaged his right arm, leaving little muscle between shoulder and elbow. Mentally he shone like a new penny, absorbing print of any kind, from prehistoric animals discovered in old copies of *National Geographic* to horror comics that turned my stomach; and when his grandfather opened a door to literature, persuading him to read *Ben Hur*, writing did not seem strange for him, but natural. I walked away thinking furiously. What would I have given, at his age to find one person interested in what I wanted to do.

"You are serious about writing?" I was back again.

"Yes."

"O.K. I'll have the typewriter fixed, buy you paper, stamps, and envelopes, but if you take these things, you'll have to write."

"Will you read what I write?" It seemed important that I should.

"Of course, but you'll have to ask me, every time."

"Will you criticize?"

"Will you want me to?"

"Yes."

"O.K. But you have to ask for it. I will presume nothing." As if he'd found an unexpected friend, Mike relaxed.

"O.K. Daddy," he said, grinning, "A Wolfe Foundation, huh?"

"Yeah, a Wolfe Foundation."

Mike found another friend, a teacher at Murrah High School who returned his sixty-page term papers with *Superb* on their covers. Ignoring any schedule in his English class, he dug into grammar, syntax, parts of speech, usage, till he seemed letter-perfect—even in spelling. He read Conrad over and over. At fif-

153

teen he plunged into a novel with escape its sole aim; escape from pettiness and conformity, from unimaginative dullness into colorful adventure on the wide sea, himself, of course, as hero. He brought his writing bit by bit to my criticism, which remained completely objective, though he stormed and jerked like a wild colt against a bridle. Beyond the noise he made I could feel his satisfaction in finding a rigidity he had to come up to and prove himself the equal of. So he rewrote the whole novel eight times, till I was satisfied he could not do better. His novel got printed in serial form, with illustrations, in a student magazine that boasted national circulation. He'd reached the top of the heap; maybe it felt like the top of the world, for a while, anyway. Then he won first in a national contest for short stories. This he showed me after it was printed with acclaim, and I realized he was gone on his own beyond my opinion. Story after story he produced then, and when I was allowed to read them there was hardly anything to say save "interesting," which to me they were.

The high school he attended had achieved the top level of national recognition under Howard Cleland, a gentle man who seemed touched with genius, but Mike reached high school after Cleland was snatched up by Belhaven College. A former football coach had taken over, and now everything slid at once. Back of most of Mike's schoolmates was wealth and position and little impetus for anything but fun. Mike looked with a jaundiced eye at their capers, listened with sour ear when they told what happened beyond school hours. Feeling pariah, he became puritan, condemning even their innocent pleasures to which he was often invited, but invariably scorned. There was no way of knowing what was in his mind, no way of sensing his exaggerations; my hands were full, and Mike lived in a world of his own, a world swayed by books well over a teenager's head.

He wrote a monograph of criticism on deliquency, the police state he fancied himself in, on brainless conformity, and the school itself. Though exaggerated, it was masterly, full of irony, lambasting many undeniable faults in our whole system. The

students were gleeful. They mimeographed copies for themselves, which every student read. Finally the football coach-principal became alarmed, thought he ought to suppress it. That was the crowning touch. Mike's cup ran over. Here was complete revenge for the role he fancied, "the outcast." At his insistence, I talked to the coach, talked him down, citing the freedom each American supposedly has to express an opinion. To my surprise I discovered he'd not read the paper.

Murrah High had produced spectacular students of the well-rounded sort with high grades in all subjects. Mike's plunge into writing had left little time or energy for other studies. But for the handsome maverick there is a strange feeling. Mike had grown tall and handsome, with a voice as deep as a well. His English teacher, a veteran, said, "It's too late now, but if I *could* have a son, I'd want him to be exactly like Mike Wolfe." So they got him a scholarship at Duke University; Duke thought they ought to take a chance on him. There he won another prize for short story, got a first-rate piece in an adult magazine, and started a novel. But his overall grades were so low that his scholarship, after two years, was not renewed, so he chucked education and went to sea, on a freighter. Perhaps I never knew him, this idol of my heart. What had I lost? Himself, or the image of a son who'd stand on my shoulders and reach farther than either of us alone could? How many sons were lost in the sixties? Temporarily or forever?

"Bring up a child in the way he should go, and when he is old he will not depart from it." Had I been a fool to believe in words many thousands of years old? They had seemed reliable up to this time in history, which after all was certainly like no other time before it. Looking through old *Horizons*, I came on article after article written in the sixties that said the same thing again and again; prosperity was here to stay for everyone. Now was the time for new experiments in living; one had to change things in order to improve them. There was so much to improve, but why so wild a change? All at once marijuana, LSD, violence, group-grope, obscenity, and indiscriminate copulation? I'd just

read Tennyson's "Idylls of the King," and it was hard to see any improvement. Was this enough to explain the insults heaped on parents who, in spite of the much heralded prosperity, still struggled hard to support their young? Those lucky enough to have offspring a year or two older than ours assured me they had been spared our agony. What was it? an epidemic? an infection? caught the same mindless way influenza was? In a world grown unbelievable, this was the most incredible phenomenon one could think of. I tried to stop thinking, ran into a tangent of memory, and the next thing I knew was on our terrace with five young people under a summer moon with Bebe wanting me to hear a boy's touch on the classical guitar. I listened and admired but he knew only scales. After he quickly ran through his repertoire, an awkward pause followed. To break the ice forming around what should have been a pleasant occasion, I suggested we sing.

"What?" they asked.

"Stephen Foster. Everybody knows him."

"He's schmaltz." It was Tom, whom I'd known at Millsaps who said it, a boy bright enough to get a scholarship at Harvard.

"You mean "Jeannie," a little girl running in the sun, is schmaltz?"

"Yeah."

"How about 'I been workin' on the railroad?' The last time I heard that, strong men in the army were marching to it."

"That's schmaltz too."

"It is?" I was quite puzzled.

"Yeah. Whatever we think is schmaltz is schmaltz," the bright boy again.

This was the last of many straws, and I boiled.

"Lincoln, maybe you know who he was. Having trouble with his cabinet, he said, 'Gentlemen, how many legs has a cow?' They said 'Four!' 'Suppose we consider the tail a leg. How many will she have?' They answered, 'Five.' 'Gentlemen, no matter how we consider the tail, a cow can have only four legs.'"

1977: A Bad Year

I guess I hissed it, through clenched teeth, then stalked into the house, Mike following.

"Daddy," he said, "We want you. We've always heard those songs sung with schmaltz inches thick."

"Schmaltz is in the singer. Anything can be sung that way," I protested, following him back to the terrace, anyway.

"Tom," I said to the bright boy, "I won't apologize for being right, but I will for losing my temper. You were wrong."

"Yes, Mr. Wolfe, I know that now." After all, he was brilliant.

I listened to them sing, "Country road, take me home." It sounded innately schmaltzy, but they did it well. Then I got lost, trying to recall Foster's words, words I'd grown up with. "The head must bow and the back will have to bend, wherever the darkie may go." That reminded me of something just beyond my reach. "The sun shines bright in my old Kentucky home, 'tis summer the darkies are gay."—Keats! Had he ever been schmaltzy? I thought not. I joined in their singing "Summertime" and "Greensleeves," then Mike took over. He is deft, accomplished, subtle. He has a gift, but it is undisciplined, and most of his music has but one rhythm—a fast beat somewhere between country and low black. He'd dropped writing, was now practicing hours on end with a guitar. He wanted me to like what he played, but I couldn't. Long before, when he'd asked if I liked his music, I had said, "I like Beethoven better," thinking he'd unravel what that implied. He knew Beethoven very well, and Bach, Chopin, the Russian composers, Brahms, and Grieg; that is, he knew how they sounded, but my answer to his question kept him puzzled as I was puzzled by his preference, his indifference to the fundamentals of real music, his refusal to read notes, his obstinate rhythm full of redundance, so unlike his power with words. I had to give up trying to influence him and remained puzzled. Great music had become more than ever something to exist in, at my highest level. The gap between us widened until I gave up on bridging it. Mere difference in taste did not disturb me, but it seemed indicative of a deeper chasm between us, as if my values were incomprehensible to him. I

stayed an hour on the terrace, though, trying to understand, then gave up and went to bed.

To our astonishment, Tom materialized next morning in the kitchen while we were at breakfast, fried himself an egg, drank two cups of coffee, and chattered. He had slept uninvited on the living room couch, was determined to talk to me, followed me to the studio, and sat while I got ready to paint.

"Why were you so mad?" he asked.

It was an opening I had not even hoped for.

"I've staked my existence on your being wrong and you were insufferably smug. I had to knock you down. The world was round those centuries people thought it flat."

"I can see now what little difference opinion makes where reality is concerned. But you suggest how much difference it makes in what people do. Our ignorance is vast isn't it?"

"That's right. I was fascinated by something on TV showing how man developed telescopes; I was overwhelmed by the mental power it has taken, the mathematics figuring things out. For once I could conceive the moon as a sphere smaller than the sphere we call Venus. At the end of the film I went out and looked at the sky. There was the moon, a flat disc, no bigger than my thumb nail, and Venus, a pinhead of light as I'd seen them for years, and as I'd paint them now—earthbound. Our minds can be convinced, but our physical apparatus, reflexes, and so forth, must take some drastic, Pavlovian treatment to make us really change."

Tom was gazing at the studio walls aglow with Mildred's subtle and luminous paintings.

"Mike showed me in here last night, but by day this stuff is wonderful. You're both so good I wonder you're not in New York."

"People said that in the thirties. Then, you could starve in New York as easily as you could here. Look at those trees out the window. A learned man once said I should be in touch with the infinite here. Would I have the same thing in New York?"

"You've got a paradise. But just what is the infinite?"

1977: A Bad Year

"I guess I never tried to define it. But I think it has nothing to do with fashion, the latest thing, *le dernier cri*. All I can figure out is that two plus two equals four. . ."

"You said that last night."

". . . and I can't see any reason why two plus two will ever be any different or ever has been different. The people who planned Chartres Cathedral believed two plus two make four in heaven too, which may account for the feeling of reality at Chartres."

"That seems infinite."

"It may be all I'm sure of, outside myself."

"But you must have learned something from painting so many people."

"I did. Everybody's alike and everybody's different—and that seems infinite. Each person defines himself by what he loves and what he hates."

"But here in Mississippi, don't you sometimes feel you're working in a vacuum? You are very good."

"I hope I'm good. I hope I've not painted hundreds of bad portraits like you see in Washington—I've always wanted to work in a vacuum though—always wanted to be the miller on the Dee."

"Who's he?"

"Sorry. You had Dick and Jane. The miller sang, 'I envy no one, no one envies me!' But the king who heard him said, 'I envy you'—fifth-grade reader, I think. You were cheated. You should see McGuffey's fifth-grade reader. I was cheated out of that, too. But I found heroes to identify with. I guess heroes are schmaltz to you, maybe. But don't you think the loss of identity your generation complains about may be related to your loss of heroes?"

"I don't know; that sounds reasonable. Who are your heroes?"

"I admire anyone who makes a fetish of integrity. I love Keats and Beethoven, and, since I was King Arthur in a third-grade play with Christmas tree ornaments in my crown, I seem unable to get away from *him*. Must have been a Pavlovian experience."

159

"But Arthur can't be real like your other heroes. Whoever writes about him attributes his own ideas."

"It's wonderful that there are in existence noble ideas that can be attributed. You've got to give the human race credit for that. But Jesus is probably unrecognizable, too. I love my idea of Him—but I don't give a damn about saving my soul, if I've got a soul to save."

"Can you describe your Jesus?"

"Well, He's elemental, so in tune with what's real and true, it's impossible to grasp Him. Maybe no one has. Big physically, too, not like Sallman's consumptive Rotarian. And heart—the biggest that ever existed."

"Real and true. Is anything real and true or is everything relative? I want to hear what you have to say about right and wrong. Mike thinks they are both matters of opinion. I hate to say *we* again, but my generation is seriously questioning everything."

"Your generation as a whole is as mindless as mine was. How can I take as serious people who roar down a street destroying private property? My generation did that, too, spasmodically, but nobody confused that sort of thing with crusade or the search for truth. Let's throw away the word *we* and stop hiding behind it. You are you, different from every soul on earth."

"O.K., O.K. I'm squelched, but Mike says . . ."

"I'm not surprised at what Mike says, but I'm apprehensive of what he might do if he thinks there is no right and wrong— Mike has a load of guilt, and this might be his way of escaping it."

"What's he guilty of?"

"I should have said guilt-feeling; he was cruel to Bebe."

"Was it that serious?"

"Well, see what you think. Mike was jealous when Bebe was born and we were ignorant. While she was still crawling he'd hurt her, step on her. He was in Mrs. Frank's school and Mrs. Frank was supposed to be an expert. She said we'd have to teach Bebe to hit back. But Bebe was like an angel on earth. One of my heroes I didn't mention threw his gun down in the

army and wouldn't pick it up. I couldn't let Grasso down, and I couldn't implant an evil where I felt nothing but good, but Bebe took matters in her own hands while I watched. Mike made her cry—she crawled to him and kissed him. He was helpless after that. When he was teenaged, instead of beating on her, his jibes were incessant. That, coupled with what she was doing to herself, nearly ruined her."

"How is she now?"

"Very much confused by your damned revolution, but one of the sweetest people I ever knew. So you will understand how I hate cruelty. Do you?"

"I guess I do."

"That's too tepid. Think of horrible cruelty. Think of Dachau and Belsen."

"I shudder."

"The whole world of decent, sane people shudders. You have to say *sane* to eliminate those who are stoned. All of us shudder, and there you have evil, bad, wrong, whatever you want to call it. It's genetic, that shudder, not an opinion. This antipathy for cruelty is in our genes. I think it's shared by animals But I want to give you another shudder. Imagine an atomic weapon one thousand times as destructive as the one dropped on Hiroshima."

"The Russians have it?"

"No, it's ours."

"Ugh."

"Yes. It's a wonder there's any sanity left. We do these things against the peace in our genes."

"We're schizo! What about right?"

"Think how good you feel when someone does you a kindness. You *feel* good. You don't have to look for an opinion. When you pet a dog, you can see the same thing in his reaction; he likes it, but he has no words."

"You are very convincing."

"Did Mike put you up to talking to me?"

"Yeah. He said you were a guru."

"He loves those exaggerations. Did you ever hear of Inkidu?"

"No. Who's he?"

"Centuries before our story of Genesis, the Sumerians had a hero called Gilgamesh. I don't know what was wrong with his behavior, but the gods decided he needed not a mate, but a friend. So they made him one and named him Inkidu. These two strong men loved each other and together rid their world of many monsters. What do you make of that?"

"What's your interpretation?"

"Friendship of some sort; regard for others of our kind is in our bones from way back, Father Chatham, a friend of mine, loaned me a book he studied in seminary, on how to be a saint. I've forgotten most of it but the gist was 'don't try too hard, let it come naturally,' and it seemed to me most of it had to do with one's relation to other people. You know what St. Francis said?"

"Not exactly."

"He didn't phrase it so, but he meant, 'Let me love, I won't ask to be loved.' I believe that may be the key to happiness."

"Do you think love is the most desirable thing in life?"

"No, you miss the point. The most important thing is to be able to love. If you are loved in return, there's no heaven beyond the skies; heaven is where you are—infinity a common place."

"I wonder how many people feel as you do. You've got that kind of love, haven't you?"

"Yes, and I almost married the wrong woman. She did me a favor and married another man. Nineteen years later he wrote to ask me if I wanted her. He could take no more of her infidelities and I was the only man she never talked about."

"That's fantastic. What did you reply?"

"That I loved my wife."

"I don't have to ask if you believe in marriage. You obviously do."

"Of course. We are lucky. We live in the same world. We're

162

not only lovers but friends. Something vital seems lacking in most arrangements without marriage; as if the focus were on escape, instead of union as in real marriage. Everything you do then gets better and better."

"Sex too?"

"Especially sex."

"Don't tell Mike. I've never had sex, but I sure do want it. You got any advice for a young innocent, who's getting to be an old one?"

"Yes. Don't take any sex revolution too seriously. Be perfectly honest. Let things come naturally, as in sainthood. You won't understand this at first, but hang on to the belief that sex at sixty-five can be more wonderful than ever, if rarer."

"Thanks."

Tom got up and took a long look in the show room. I put the last touch of color on the background I'd been painting all the while. He leaned into my studio door and said earnestly, "You were young and afraid once, I guess. There is so much to be afraid of. Do you have fear now? Things change so fast."

"Who isn't afraid of what some criminal will do to someone you love. For myself, no. I used to be afraid I wouldn't do my best—now my best is a habit. That's something that can't be taken away from you; that and honesty. You cut your fears in half when you finally become honest. Change is a reality that never changes. Truth doesn't change.

"Why do you say 'finally become'?"

"It's a long process. Some people never seem to make it. I have a notion that honesty and maturity go hand and hand. In my case it did. Try it."

"I will try. Thanks for talking to me. You've had a very special life."

"Yes. A very special life," I agreed. Then he was gone.

A year later he came back with a wife, but I had no opportunity to talk to him. Now in the unwonted white stillness,

stopping all traffic on the highway and filling the lonely house with ghosts of silence, the conversation with Tom came back to me, so vividly that I set my mind on another experience, the details of which I should hate to forget, for I must write it here.

Miracles

I didn't go to Mildred's hospital when I had a stroke, but to St. Dominic's, a Catholic one. I didn't go, I was taken, in an ambulance. Two men carried me on a stretcher. The day before, I could have changed places with either of them and would have been glad to. Now it was strange to be feeble and supported, but without pain—and stranger still to be without worry. *Stroke* did not frighten me. My oldest sister, gay at seventy-six, had had a stroke when she was a beautiful girl of twenty. My Dad's face when I saw it for the last time still sagged slightly from a mild stroke, and one of my greatest patrons, Joe Ellis Love, who'd had nine paintings done of members of her family, lived in bed, having survived stroke after stroke. I loved her for her gallantry, and for more gallantry there was Father Chatham. Years had passed since we went to the airport to meet Walter of the unpronounceable surname. Then just a week before my trouble, the good priest had given me a job to do. He would perform last rites for Catholics who were dying at the hospital; he could still be of value. Would I label the two small cups he'd found; one to hold bread of life, the other oil of the sick?" They just fit into a small wooden box with a hinged lid. Would I paint a crucified Christ inside the lid, it being necessary for the priest to see Christ crucified while performing the ritual? Please deliver the box to him at St. Dominic's. He would move there the next day. I would do everything and gladly—a Renaissance artist again.

I sanded the box, so the cups slid out easily, made a tray to hold his manual, painted the interior a beautiful red, his favorite color, and with all my heart's solemnity breathed inside the lid a naked and crucified Christ.

Mississippi Artist

Now as my body was shunted from stretcher to cart, to a bed in intensive care, I wondered why for the first time within my memory I felt so completely free of worry. Even the happiest days of childhood could be darkened by the consciousness of some misdemeanor to hide. Since I had no pain, I felt nothing but curiosity about what might happen next, about the things being done to me, and about the beautiful people who were doing them. I was unaware of Mildred's anxiety then. Hers is a still face, almost a poker face, which I fail to read after thirty years. She masked her trepidation, and, unconscious of her fear, I thought with deep gratitude of her unfailing kindness, her honesty and the peaks of ecstasy we'd scaled together. It seemed to me there was nowhere higher to go. My work seemed done; nearly seven hundred portraits in forty years, each one the farthest extension of my reach. Perhaps a thousand other paintings could be counted, paintings that had sustained us; they were all gone, and I thought of patrons who had told everyone to save family portraits I had done before anything else, in case of fire. That gave me a fine feeling.

Phenomenal kindness and tenderest concern attended me. My first days were filled with fantastic tests in rooms that seemed miles from my bed. Elegant felt Christmas banners hung in the corridors where I was wheeled on a table, the holidays not yet over for Catholics. One of the sisters made them, I was told when I asked, and I wondered if she would come to my room so I could tell her how good I thought they were. Beautiful as a farm-fed angel she was when she came, and I showed her the box for Father Chatham. She named him Saint and my painted Christ, beautiful. Mildred had brought the box to the hospital, and to get my last loose end tied up, I asked the nun to deliver it to him. That same day, he wheeled into my room in a battery operated chair. His hand's weight pressed the starter button, his fingers having become too weak even for this. But his voice was as booming as ever.

"I'm going to say a prayer for you, Karl Wolfe." And I wept as he began it, but when he said, "restore him to his former use-

Miracles

fulness, if it takes a miracle, just give us one," I bent double and flooded my pillow with tears, every defense forsaken. Could I be worth a miracle? Had I really been useful?

A surgeon replaced with plastic a stopped section of artery when one of those fantastic tests found where it was, a routine surgical miracle. In a flash I was gone under ether, in a flash was back—in bed! They'd operated! Six times that night voices said I could have anything I wanted for the pain. There was no pain, and that seemed to cause a mild sensation among the nurses. Instead I had an experience Jung should have examined. For the first time in my memory, a dream told me in real words, "Everything is all right."

Once wasn't enough. The same dream came back three other times repeating itself. Its details were wierd and reasonable at the same time as in most dreams, but I never before dreamed the same dream four times over. Usually they are frightening. The morning after he'd operated, the surgeon removed the bandages and was amazed to find his incision in my neck already healing. I left the hospital five days earlier than my schedule called for. Perhaps a miracle in a hospital like St. Dominic's is a commonplace. Father Chatham may be a saint, if you can define one. Casually, it seemed to me he asked for a miracle. He might have said, "How's about lending me a buck, old buddy?" I like it that way. But what makes a miracle? Is it love? I think it is.

But was it a miracle? Two weeks out of the hospital came a night of such magic—unearthly bliss like a climax of love, long drawn out, infinite, holy, eternal, yet fleeting as a shadow. Two weeks out of the hospital sitting on the living room floor I made a painting of our sweet-gum tree, its elegant branches glistening in rain. It sold immediately. Within three months I found myself climbing a scaffold to reach the top of a six-foot canvas on which I painted Carroll Waller, the governor's lady, for more money than I'd ever received for a commission. Able to stand not longer than ten minutes at a time, I wondered if it would get done. It was grueling work, but when completed people

looked at it in silence as if stunned. Painting has not stopped since. Sometimes I sit to paint which is new to me and awkward. The demand for portraits has not slackened, and my new awkwardness seems to have added a new dimension to them, a subtle unreality, haunting, which perhaps I see when no one else does.

To the hospital when I was there, my confused Bebe came, to weep and say she loved me. She was really balled up, and I cursed again that senseless revolt the young carried on against themselves, and I cursed the stupidity of schools. It has not been easy for her, but she has changed from a lost soul into a vibrant artist piling success on success with stained glass. Mike came too, but I could not tell where he was.

Later Laney, Mike's wife, phoned from Baton Rouge, where they live. Mike was in a hospital. The old house they rented had burned to the ground. While it fiercely blazed Mike, who had been away, came home and unable to see any of his family, safe in a neighbor's house, plunged into thick smoke to find them. His hair caught fire, He slapped it out with his hand. His hand was badly burned but he continued his search till every room was ransacked. By that time his face was seared like a baked potato, but he spent only one night in hospital. When he phoned and said with a lost boy's voice "Daddy," I said, "I love you," and he said, "I love you too," and a great gap was closed.

Come April, they would feature me, at last, in the annual Arts Festival. "They" were the Junior League and the Art Association, a combination that had turned art in Jackson into a social affair, something that interested me not at all. Since I had publicly exhibited no portrait for twenty-five years few gallery goers knew how my painting went. More than one visitor had asked if I'd seen "the beautiful painting of Carroll Waller at the Mansion," the governor's lady I'd sweated over after my stroke. In a handsome brochure for the carefully restored Man-

sion, nine of my paintings were reproduced with no mention of my name anywhere. This barbarity I should have been used to, but I felt peeved and thought I ought to "show 'em" while I had a chance. I could borrow a dozen impressive portraits, especially the one of Lawrence Jones, now twenty-five years old. I was both anxious to and fearful of seeing it. Suppose it was not as good as I'd dreamed.

Objects I was author of were scattered throughout the state; a cast stone memorial to Will Percy's mother in Greenville, a stained glass window in Columbia, a large bronze grille on the façade of the library at State University in Starkville, four governors in the Capitol, Carroll Waller, Mrs. Ruth White in her mother's yellow dress at the Mansion, Dr. Boswell at University Medical Center, Andrew Jackson in City Hall—I could claim them all in a montage of photographs for at least a small part of the world to see. There was plenty of time to prepare everything.

I opened the box containing the Lawrence Jones painting. It was beautiful; the head solid and round, deep with soul, the eyes looking inward, the coat someone had given him too big for his small body. Love welled inside of me as if the man himself were there beyond the frame. With a surge of joy I knew I could paint; what other opinion mattered?

April came with lilies. Bebe hung my show in beautiful rooms at the newly refurbished Mississippi Bank, working all day at it. Her arms were around me that evening as she said, "I don't care what other people see. I know now you are a great artist." I wept.

REQUIEM, I GUESS

Do leaves a brave defiance show
In face of winter's blast?
Science says no, no.
But in my mind, we're two of a kind
And I would bravely go.
When Winter blows his horn for me
I fain would gorgeous glow.

Wrap me in splendor, cloth of gold
Dazzling as sumac or sweet-gum tree.
Wrap me in damask, the color of fire
Burning air like a prince's pyre.
I'll sleep defying winter's wind.
No need to grieve, there's not an end,
There's only change that changes toil
Like leaves I'll exist, pregnant soil.

KARL WOLFE